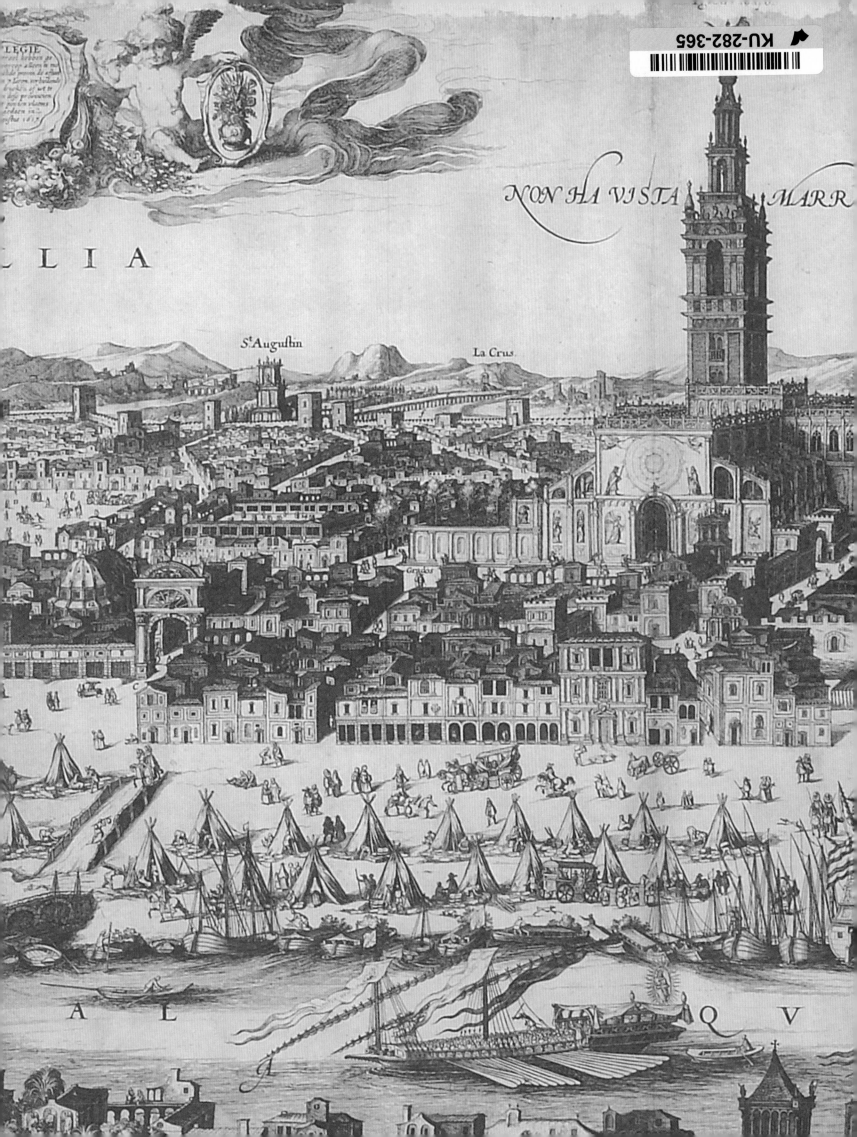

NON HA VISTA MARR

LLIA

A L

QV

St Augustin

La Crus.

Grados.

Murillo

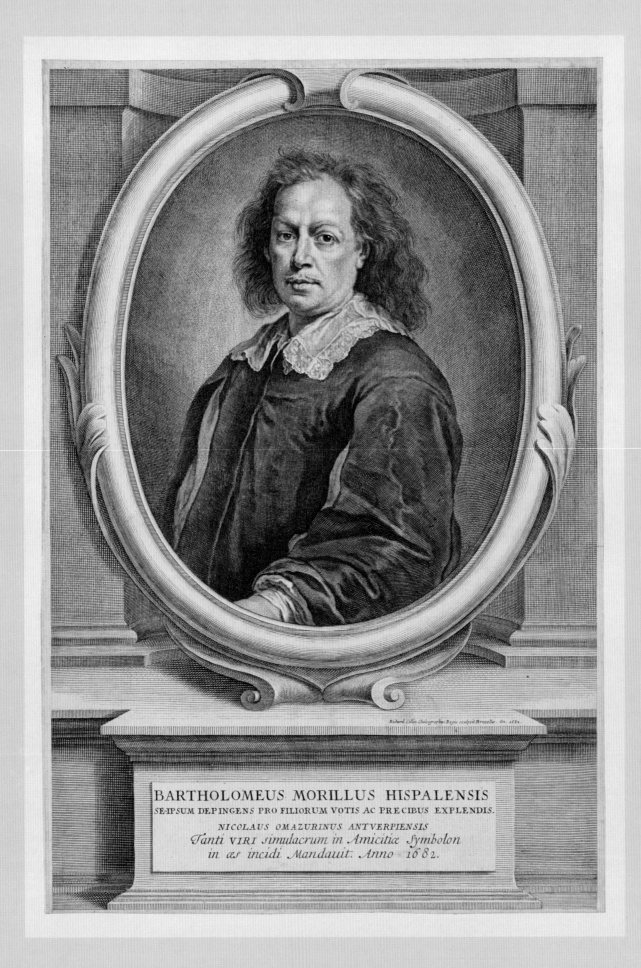

BARTHOLOMEUS MORILLUS HISPALENSIS
SE-IPSUM DEPINGENS PRO FILIORUM VOTIS AC PRECIBUS EXPLENDIS.

NICOLAUS OMAZURINUS ANTVERPIENSIS
Tanti VIRI *simulacrum in Amicitiæ Symbolon*
in æs incidi Mandauit. Anno 1682.

Murillo

THE SELF-PORTRAITS

Xavier F. Salomon and Letizia Treves
With María Álvarez-Garcillán, Silvia A. Centeno,
Jaime García-Máiquez, Larry Keith, Dorothy Mahon,
and Nicole Ryder

THE FRICK COLLECTION, NEW YORK
IN ASSOCIATION WITH
YALE UNIVERSITY PRESS, NEW HAVEN AND LONDON

This catalogue is published in conjunction with the exhibition
Murillo: The Self-Portraits, on view at The Frick Collection, New York
(October 31, 2017–February 4, 2018), and at the National Gallery,
London (February 28–May 21, 2018).

Principal funding for the New York exhibition is provided by an
anonymous gift in memory of Melvin R. Seiden. Additional support is
generously provided by The Peter Jay Sharp Foundation, Marianna and
Juan Sabater, the families of George and Michael Eberstadt in memory
of Vera and Walter Eberstadt, Mr. and Mrs. Michael J. Horvitz,
Aso O. Tavitian, and the Spain Tourism Board, Consulate General
of Spain in New York. The catalogue is underwritten by Colnaghi.

The Frick Collection
Michaelyn Mitchell, Editor in Chief
Hilary Becker, Associate Editor

Yale University Press
Patricia Fidler, Publisher, Art & Architecture

Designed by Luke Hayman and Jenny Hung, Pentagram
Typeset in Rongel by Mário Feliciano
Printed and bound in China by 1010 Printing Group Limited

The Frick Collection
1 East 70th Street
New York, NY 10021
frick.org

Yale University Press
302 Temple Street
P.O. Box 209040
New Haven, CT 06520-9040
yalebooks.com/art
yalebooks.co.uk

Cover illustration: Detail of Bartolomé Esteban Murillo, *Self-Portrait*,
ca. 1650–55 (fig. 24) | Frontispiece: Richard Collin, after Bartolomé
Esteban Murillo, *Bartolomé Esteban Murillo*, 1682. Private collection,
New York (cat. 7) | Endpapers: Detail of Simon Wynhoutsz Frisius,
View of Seville, 1617 (fig. 1) | Page 8: Detail of Bartolomé Esteban
Murillo, *Self-Portrait*, ca. 1650–55 (fig. 24) | Page 68: Detail of Manuel
Alegre after Bartolomé Esteban Murillo, *Bartolomé Esteban Murillo*,
1790 (fig. 46)

Library of Congress Cataloging-in-Publication Data

Names: Salomon, Xavier F., 1979– author. | Treves, Letizia, author.
 | Jaime García-Máiquez, Jaime, writer of supplementary textual
 content. | Centeno, Silvia A., writer of supplementary textual
 content. | Álvarez-Garcillán, María, writer of supplementary textual
 content. | Keith, Larry, writer of supplementary textual content. |
 Mahon, Dorothy, writer of supplementary textual content. | Ryder,
 Nicole, writer of supplementary textual content. | Frick Collection,
 host institution. | National Gallery (Great Britain), host institution.
Title: Murillo : The Self-Portraits / Xavier F. Salomon and
 Letizia Treves ; with María Álvarez-Garcillán, Silvia A. Centeno,
 Jaime García-Máiquez, Larry Keith, Dorothy Mahon, and
 Nicole Ryder.
Description: New York : The Frick Collection ; New Haven :
 In association with Yale University Press, [2017] | "This catalogue
 is published in conjunction with the exhibition Murillo:
 The Self-Portraits, on view at The Frick Collection (October 31,
 2017–February 4, 2018) and at the National Gallery, London
 (February 28–May 21, 2018)." | Includes bibliographical references
 and index.
Identifiers: LCCN 2017004616 | ISBN 9780300225686
Subjects: LCSH: Murillo, Bartolomé Esteban,
 1617–1682—Self-portraits—Exhibitions.
Classification: LCC ND813.M9 A4 2017 | DDC 759.6—dc23
 LC record available at https://lccn.loc.gov/2017004616

Directors' Foreword

We are delighted to commemorate the four-hundredth anniversary of Murillo's birth with a publication and exhibition that unite the arresting self-portraits by which the artist's appearance is known. One of these masterpieces, in The Frick Collection, is a youthful portrayal; the other, in the National Gallery, London, depicts the mature artist. Both incorporate the masterful illusionistic effects found in several of the portraits by this great painter of the Spanish Golden Age. The earlier canvas has been in the Frick family since its purchase by Henry Clay Frick in 1904, when Murillo was the most sought after Spanish painter in America, more so than Velázquez, El Greco, or Goya. Thanks to the generosity of Mrs. Henry Clay Frick II, the portrait recently entered the permanent holdings of the Frick, occasioning this exhibition. The later work has been in the National Gallery since 1953, one of the earliest paintings by Murillo to make its way to Britain.

Our deep appreciation goes to Xavier F. Salomon, Peter Jay Sharp Chief Curator at The Frick Collection, and Letizia Treves, Curator of Later Italian, Spanish, and French 17th-Century Paintings at the National Gallery, London, curators of the exhibition and principal authors of the catalogue, for their characteristically thorough and astute scholarship. We also want to acknowledge the writers of the technical studies for their important contributions: María Álvarez-Garcillán, Silvia A. Centeno, Jaime García-Máiquez, Larry Keith, Dorothy Mahon, and Nicole Ryder.

At the Frick, thanks are also due to Adrian Anderson, Michael Bodycomb, Rika Burnham, Tia Chapman, Diane Farynyk, Allison Galea, Lisa Goble, Caitlin Henningsen, Rachel Himes, Anita Jorgensen, George Koelle, Adrienne Lei, Genevra LeVoci, Alexis Light, Jenna Nugent, Gianna Puzzo, Heidi Rosenau, Stephen Saitas, Jeannette Sharpless, and Joe Shatoff. The Frick's Editor in Chief, Michaelyn Mitchell, oversaw the production of the catalogue and, with Associate Editor Hilary Becker and editorial volunteer Serena Rattazzi, edited the text. We would also like to acknowledge the elegant work of Pentagram's Luke Hayman and Jenny Hung, who designed this book.

Many thanks go to the lenders for their generosity, as well as to an anonymous donor for a gift in memory of Melvin R. Seiden that provided principal funding for the New York venue of the exhibition. Additional support was generously provided by The Peter Jay Sharp Foundation, Marianna and Juan Sabater, the families of George and Michael Eberstadt in memory of Vera and Walter Eberstadt, Mr. and Mrs. Michael J. Horvitz, Aso O. Tavitian, and the Spain Tourism Board, Consulate General of Spain in New York. The catalogue was underwritten by Colnaghi.

At the National Gallery, we are deeply grateful to The Elizabeth Cayzer Charitable Trust for its support of the exhibition and to Samantha Cox, Alan Crookham, Jonathan Franklin, Jane Knowles, and Francesca Whitlum-Cooper.

Ian Wardropper, Director, The Frick Collection, New York
Gabriele Finaldi, Director, The National Gallery, London

Acknowledgments

The authors would like to thank the following individuals:

Roberto Alonso, Hilary Becker, Rachel Billinge, Andrew Blackman, Jonathan Bober, David Alan Brown, Rika Burnham, Aviva Burnstock, The Duchess of Cardona, Andrea Cavaggioni, Peter Cherry, Susan Chore, Jorge Coll, José Luis Colomer, Nicolas Cortés, Diane Farynyk, Francis Ford, Giulio Dalvit, Alessandra Di Croce, John Elliott, Miguel Falomir Faus, Gabriele Finaldi, Susan Grace Galassi, Allison Galea, Véronique Gerard Powell, Peggy Iacono, Julie A. Ludwig, Hilary Macartney, Manuela Mena Marqués, Mark McDonald, Michaelyn Mitchell, Benito Navarrete, Aimee Ng, Jenna Nugent, Nadine Orenstein, Javier Portús, Serena Rattazzi, José Riello, Joanna Russell, Tim Schmelcher, Jeanette Sharpless, Joanna Sheers Seidenstein, Sarah Symmons, Marika Spring, Pippa Stephenson, Zahira Veliz, Ian Wardropper, Francesca Whitlum-Cooper, Miguel Zugaza Miranda

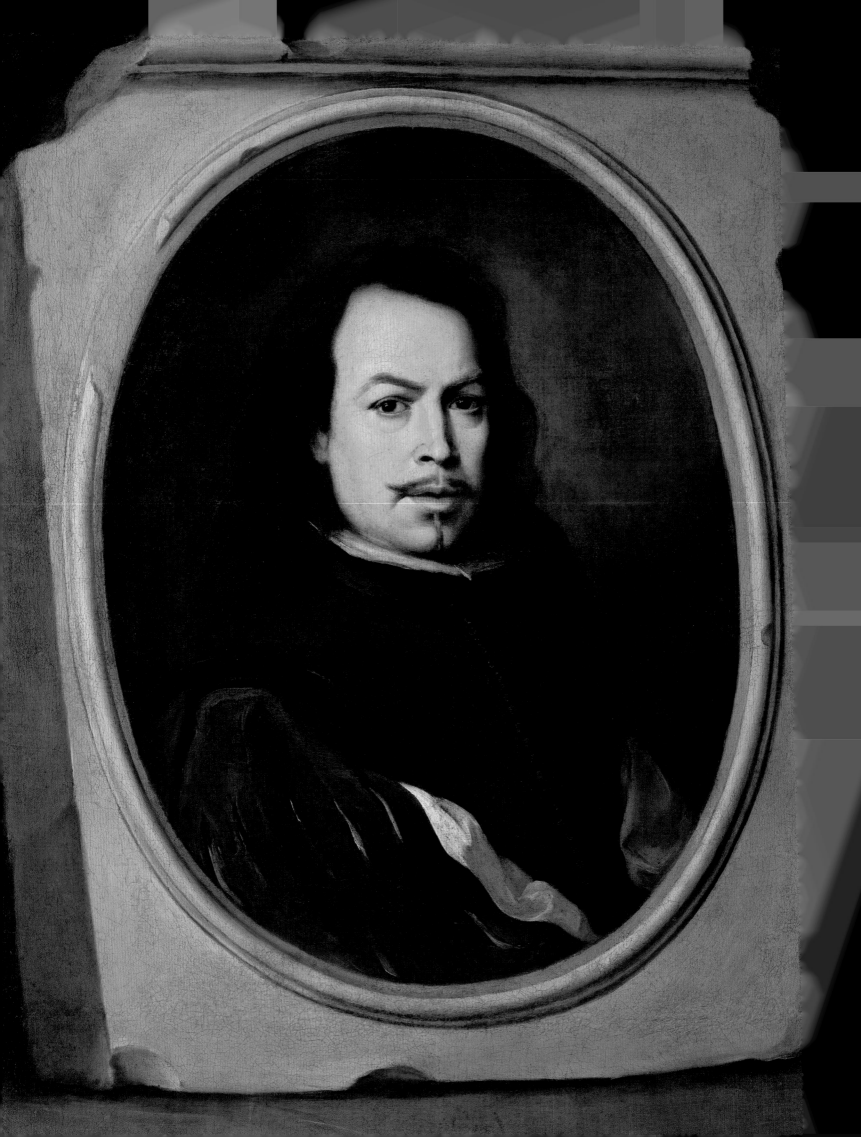

Murillo's Self-Portraits: A Sketch

Xavier F. Salomon

Between 1715 and 1724, the Spanish painter Antonio Acisclo Palomino de Castro y Velasco published a three-volume book on the art of painting and its practice. Among the biographies of Spanish artists included in the final volume of *El Museo pictórico y escala óptica* is one on Murillo that is one of the earliest and most significant texts on the painter. While describing Murillo's career and his work, Palomino states, "He also painted his own portrait at the request of his children, a marvelous thing that was engraved in Flanders for Nicolás Omazurino, and another one with a *golilla* [a stiff white collar, typical of Spanish fashion in the seventeenth century], which remained in the hands of his son, Don Gaspar Murillo."[1] On May 15, 1709, soon after Gaspar's death, an inventory of his possessions was compiled. Prominent on the list are two paintings:

Item. Another canvas of the portrait of Don Bartholome Murillo with its legend below and its frame completely gilded at three hundred *reales*.

Item. Another portrait canvas of said Don Bartholome Murillo made by his own hand of a *vara* and a third with its frame of gilded adornments and with a concave molding with small punch holes at three hundred and seventy five *reales*.[2]

Only two self-portraits by Murillo are known today, one at The Frick Collection in New York and the other at the National Gallery in London; while it is impossible to prove, it is likely that these are the self-portraits mentioned by Palomino and owned by Gaspar Murillo. They are the main images that have, through the centuries, memorialized the features of one of the most important artists active in Spain

9

at a time traditionally described as the Golden Age of Spanish art, as well as two of the most extraordinary self-portraits ever produced in Spain.

A Life in Seville

In the seventeenth century, Seville, the city of Murillo's birth, was one of the great urban centers of Europe (fig. 1).[3] Along the banks of the Guadalquivir River, a sizeable harbor provided one of the main access points from Europe to America and the New World, and for this reason, the city had been, since the sixteenth century, one of the most important economic powers of the western world and an extremely cosmopolitan center.

At the beginning of a new year, on January 1, 1618, a boy was baptized in the parish church of Santa María Magdalena.[4] Gaspar Esteban, the father, was a moderately affluent barber-surgeon, who lived with his family near the convent of San Pablo. His wife, María Pérez Murillo, came from a Sevillian family of painters and silversmiths. The boy, born at least a few days earlier, in the last days of December 1617, was the youngest of fourteen children and was given the name Bartolomé. In seventeenth-century Spain, it was customary to use both parents' surnames; therefore the boy's full name was Bartolomé Esteban Murillo. He seemed later to have preferred his mother's surname, in adulthood using Murillo rather than Esteban. The boy's youth was marked by tragedy. By the time he was ten, both of his parents had died, Gaspar in 1627 and María in 1628, within a month of each other. Bartolomé grew up with his older sister Ana and her husband, Juan Agustín Lagares (who, like his father-in-law, was a barber-surgeon) and lived with them until his marriage.

The artistic connections of his mother's family provided the foundation for Murillo's career as a painter. About 1630, he entered the workshop of the painter Juan del Castillo, who seems to have had family ties to María Pérez Murillo, and spent much of the decade with him. In 1633, Murillo planned to leave Seville to seek his fortune in the Americas, an interest that may have stemmed from patronage opportunities there.[5] Palomino recorded that "after having learned enough to support himself by painting for the fairs [something that was very frequent then], he did a batch of paintings to be sent to the Indies" but

although some foreign authors [like Joachim von Sandrart and an Italian] have said that he went to the Indies as a

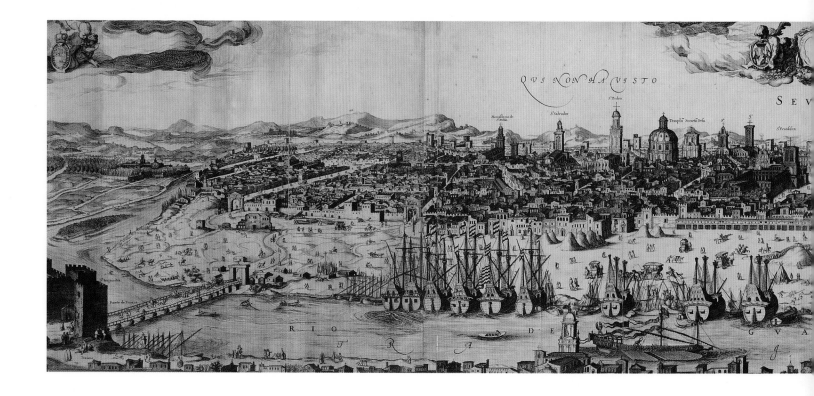

youth and then to Italy, they were badly informed, for I have investigated this point with great diligence from very old and totally trustworthy men who knew him intimately, and there was no such thing… the person who did indeed go to the Indies was his son, Don José Murillo, a man of great ability at Painting and even greater promise, and there he died while still very young.[6]

Murillo did not make the trip to America; some of his early works probably found their way there, but none have been identified so far. No travels in this early part of his life are documented, and while Palomino suggests Murillo visited Madrid then, there is no evidence to support this.

In February 1645, the twenty-seven-year-old artist left his sister's home and, in the church of the Magdalena (the same he was baptized in), married Beatriz de Sotomayor y Cabrera, who was five years younger and lived in the same parish. The couple moved to the house in which Murillo was born, near San Pablo, and there their first two children were born: María in 1646 and José Felipe in 1647. As he achieved more success as a painter in Seville, Murillo moved house, to the calle Corral del Rey, near San Isidoro, in 1647, and here two more children were born: Isabel Francisca in 1648 and José in 1650. Between 1651 and 1663, Murillo resided with his family in a series of houses in another parish of the city, that of San Nicolás. In 1651, he was in a house on the calle de la Escuela, in 1657 he moved to the calle de Madre de Dios, and soon after to calle de la Botica (now calle Guzmán el Bueno). While they

were living in the parish of San Nicolás, three more children were born: Francisco Miguel in 1653, Francisca María in 1655, and Gabriel in 1657. These births were, however, followed by a series of deaths. Murillo's sister Ana died in 1654, and her husband Juan Agustín two years later; the painter's young son Francisco Miguel also died around this time.

In 1658, Murillo made his only documented trip to Madrid. In April of that year, he was in the capital, where he met with fellow painters, among them, Velázquez, Francisco de Zurbarán, and Alonso Cano. The visit to Madrid, however, seems to have been a brief one. By the end of 1658, Murillo was back in Seville and a resident in the parish of Santa Cruz, where, in 1661, another son, Gaspar, was born. Two years later, in 1663, the artist moved again, to the calle de San Jerónimo in the parish of San Bartolomé, where he remained for about twenty years. The birth of a daughter that year caused the death of Murillo's wife. At the time of Beatriz's death, five of their children were still alive: José (fourteen years old), Francisca María (nine), Gabriel (eight), Gaspar (two), and María (just a few days old).[7] Of the couple's nine children, only four survived into adulthood: José, Francisca María, Gabriel, and Gaspar. Murillo's only surviving daughter joined the Dominican convent of La Madre de Dios in 1668 under the name Sister Francisca de Santa Rosa. Two of his sons, Gaspar and José, also followed an ecclesiastic career. José, however, died in 1679, and Gabriel left for America in 1677. The last years of Murillo's life were spent in the company of his only remaining son, Gaspar, who had become a canon in the Cathedral of Seville.

Fig. 1. Simon Wynhoutsz Frisius, *View of Seville*, 1617. Engraving, 19 7/8 × 89 5/8 in. (50.5 × 227.5 cm). The British Library, London

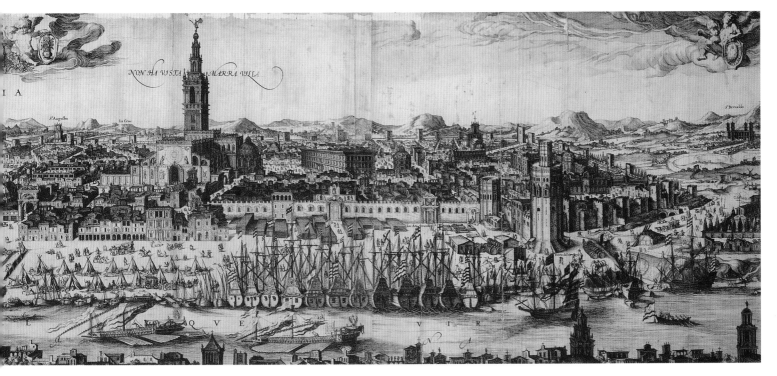

Murillo's Self-Portraits: A Sketch

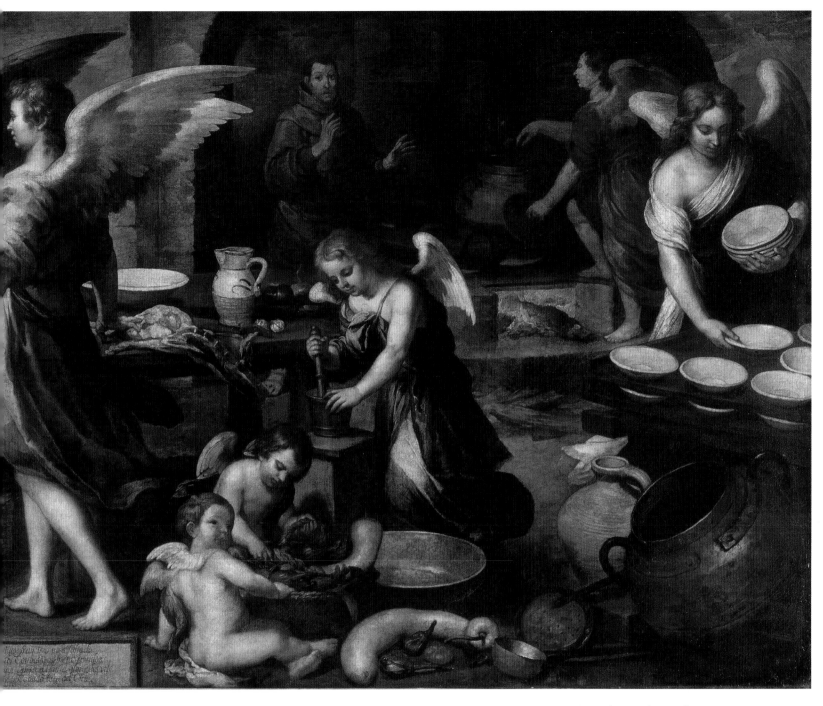

Fig. 2. Bartolomé Esteban Murillo, *Friar Francisco and the Angels' Kitchen*, 1645–46. Oil on canvas, 70 7/8 × 177 1/8 in. (180 × 450 cm). Musée du Louvre, Paris

In 1681, the artist moved one last time, from the parish of San Bartolomé to that of Santa Cruz. Murillo's last commission, a series of canvases for the Capuchin church of Cádiz, was the cause of his death. According to Palomino,

> our Murillo was also so modest that we can say that he died of pure decorousness; for being up on a scaffolding in order to paint a very large picture of St. Catherine that he was doing for the Capuchin Convent in the city of Cádiz, he stumbled going up this scaffolding, and because his intestines were ruptured, they came out; and so as not to manifest his weakness or allow himself to be examined he died of this unexpected accident in the year 1685, at seventy-two years of age, more or less.[8]

It is possible that the hernia caused by the fall led to his death; he died in his house on April 3, 1685, and was buried in the local parish church of Santa Cruz.

A Career in Seville

Murillo's lifetime in Seville was colored by numerous changes of residence and the births and deaths of the various members of his family; his career as a painter should be viewed against this biographical background. With the exceptions of the 1658 trip to Madrid and the final commission for Cádiz, Murillo lived and worked in his birthplace and was deeply embedded in the life of Seville. Even though he also painted allegorical and genre scenes, the majority of his production was for religious organizations, and he painted canvases for most of the prestigious ecclesiastic institutions of his city. After a decade spent in the workshop of Juan del Castillo, Murillo stepped into the public arena around the year of his marriage, in 1645. In 1644, he began one of the most ambitious projects of his early career, a cycle of eleven large canvases for the cloisters of the convent of San Francisco el Grande (now destroyed).[9] Over the next two years, he produced the full cycle, which centered on the lives of Franciscan saints. These early works were still indebted to the art of Sevillian painters of the previous generation, such as Zurbarán and Francisco de Herrera el Viejo. The figures emerge from tenebrous backgrounds as divine light bathes them and gives shape to the narratives that would have appeared as a series of visions under the arches of the small cloister. In the so-called *Angels' Kitchen* (fig. 2), one of the paintings from the series, many of the features of Murillo's art are already established. The angels, with their elegant and sweet features, are the predecessors of many later religious figures by the artist. The rhythm of the composition—with its slow tempo along the horizontal canvas and with each figure, or group of figures, clearly placed in space—became a characteristic of Murillo's art. Elements of still life and portraiture also begin to appear in such early religious work.

The exquisitely represented kitchen in the *Angels' Kitchen*—with its large cooking range and its copper pans and ceramic dishes and jars—is indicative of Murillo's attention to detail. Only a few years after the conclusion of the San Francisco cycle, Murillo began to paint canvases representing street urchins, still some of the paintings for which he is best known. The *Urchin Hunting Fleas* (fig. 3) is among the first of these paintings, followed only a few years later by *Two Boys Eating Melon and Grapes* (fig. 4).[10] These images of poverty, of ragamuffins, hawkers, and rogues, are some of Murillo's most extraordinary and typical works. The three boys in the two paintings are observed with painstaking attention, one in the act of delousing himself, the others greedily eating grapes and melon. They are set in neutral spaces—a barely defined room and an outside site, against a large wall—and in both cases, the human figures are surrounded by a wealth of still-life details. Murillo delicately paints the surface of the earthenware jug and the baskets from which apples and grapes spill. The dirty feet of the boys are pushed into the foreground, into the viewer's space, but the eye wanders to other details, such as the clear light pouring through the open window and the flies resting on the white melon pulp. Murillo continued to paint works of this kind for most of his life though little is known of the patrons and purpose of such subjects.

In 1656, Murillo received the most prestigious ecclesiastical commission he could hope for: a large public painting for the Cathedral of Seville. For the baptistery of the cathedral he painted an oversize canvas representing St. Anthony of Padua and the Christ Child (fig. 5).[11] The angels he had portrayed in the *Angels' Kitchen* ten years earlier have now taken over most of the canvas and create a heavenly surround for the Infant Christ appearing to St. Anthony. The saint kneels at the bottom of the composition, looking up to the vision. To any seventeenth-century viewer, the painting itself would have appeared as an angelic vision taking place in the dark

Fig. 3. Bartolomé Esteban Murillo, *Urchin Hunting Fleas*, ca. 1645–50. Oil on canvas, 52 3/4 × 43 1/4 in. (134 × 110 cm). Musée du Louvre, Paris

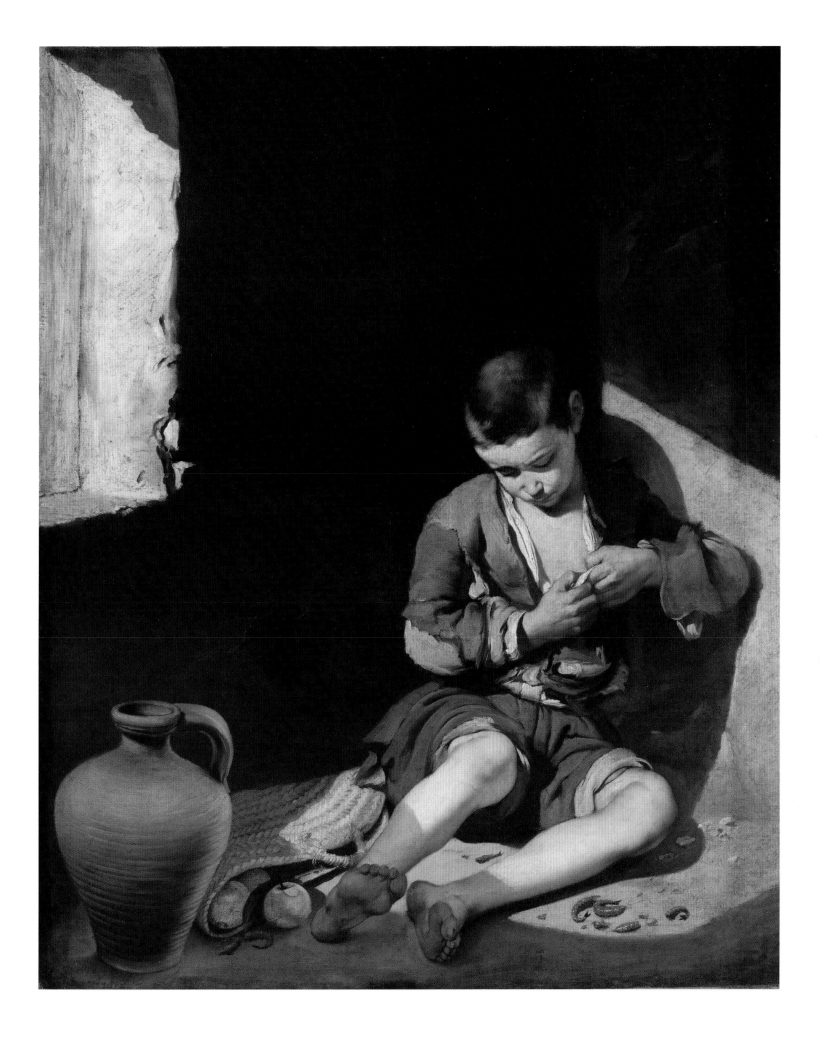

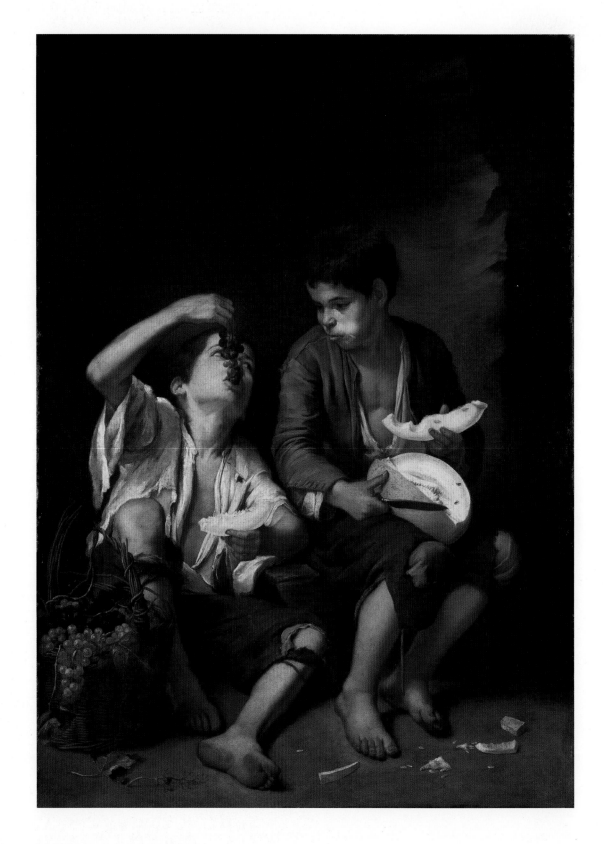

Fig. 4. Bartolomé Esteban Murillo, *Two Boys Eating Melon and Grapes*, ca. 1650. Oil on canvas, 57 1/2 × 40 3/4 in. (145.9 × 103.6 cm). Bayerische Staatsgemäldesammlungen, Alte Pinakothek, Munich

Fig. 5. Bartolomé Esteban Murillo, *St. Anthony of Padua and the Christ Child*, 1656. Oil on canvas, 220 1/2 × 145 1/4 in. (560 × 369 cm). Cathedral, Seville

Fig. 6. Bartolomé Esteban Murillo, *The Immaculate Conception*, 1664–65. Oil on canvas, 67 3/4 × 117 3/8 in. (172 × 298 cm). Musée du Louvre, Paris

chapel of the cathedral. This remains one of Murillo's most celebrated works; it is not surprising that pictures like this secured his preeminence on the religious art scene in Seville.

The 1658 trip to Madrid allowed Murillo to get to know the work of his contemporaries, Velázquez and Zurbarán, both of whom had spent significant parts of their careers working in Seville. But, as Palomino mentions in his biography, this trip was also invaluable for becoming acquainted with the works of other masters—Titian, Rubens, and Van Dyck above all—that he would have seen in the royal collections.[12] The influence of these artists could be seen in Murillo's work, and the 1658 journey provided a new impetus to the painter's stylistic choices.

Back in Seville, the 1660s was probably the richest and most rewarding decade of Murillo's career. Between 1662 and 1665, he worked on a series of canvases for the parish church of Santa María la Blanca. These were commissioned by Justino

de Neve, one of the painter's closest friends throughout his life.[13] Murillo painted four lunettes for the small church, one of which represented the Immaculate Conception (fig. 6), a subject for which Murillo was to become particularly well known and which he replicated on a number of occasions.[14] His large altarpieces of the Immaculate Conception with multitudes of angels and putti were widely admired between the seventeenth and twentieth centuries. At the center of the canvas, the young Virgin appears standing on the moon, her hands clasped in prayer, surrounded by angels. Two of them hold a scroll with the inscription IN PRINCIPIO DILEXIT EAM (In the beginning He delighted in her). To the left are two portraits, one of which is probably of the patron himself, Justino de Neve. The mid-1660s saw Murillo at work on a number of canvases for two other churches in Seville, San Agustín and the Capuchinos.[15] These were followed by a series of eleven canvases for the Hospital de la Caridad, which

Fig. 7. Bartolomé Esteban Murillo, *St. Thomas of Villanueva Distributing Alms*, ca. 1665–68. Oil on canvas, 111 3/8 × 74 in. (283 × 188 cm). Museo de Bellas Artes, Seville

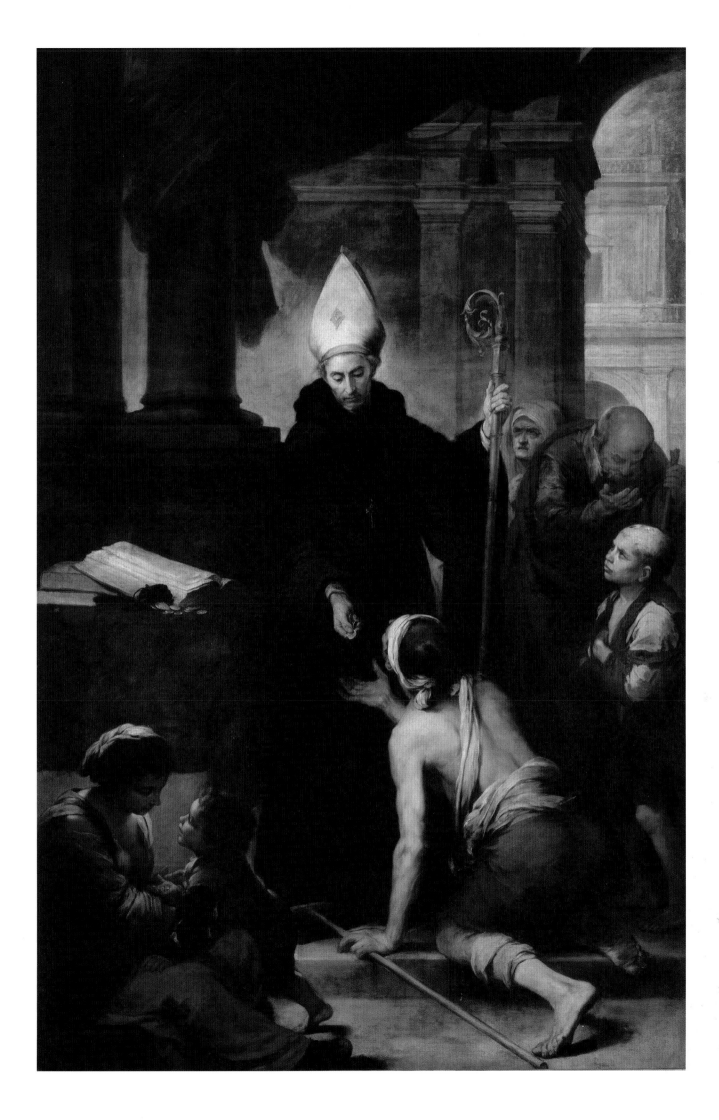

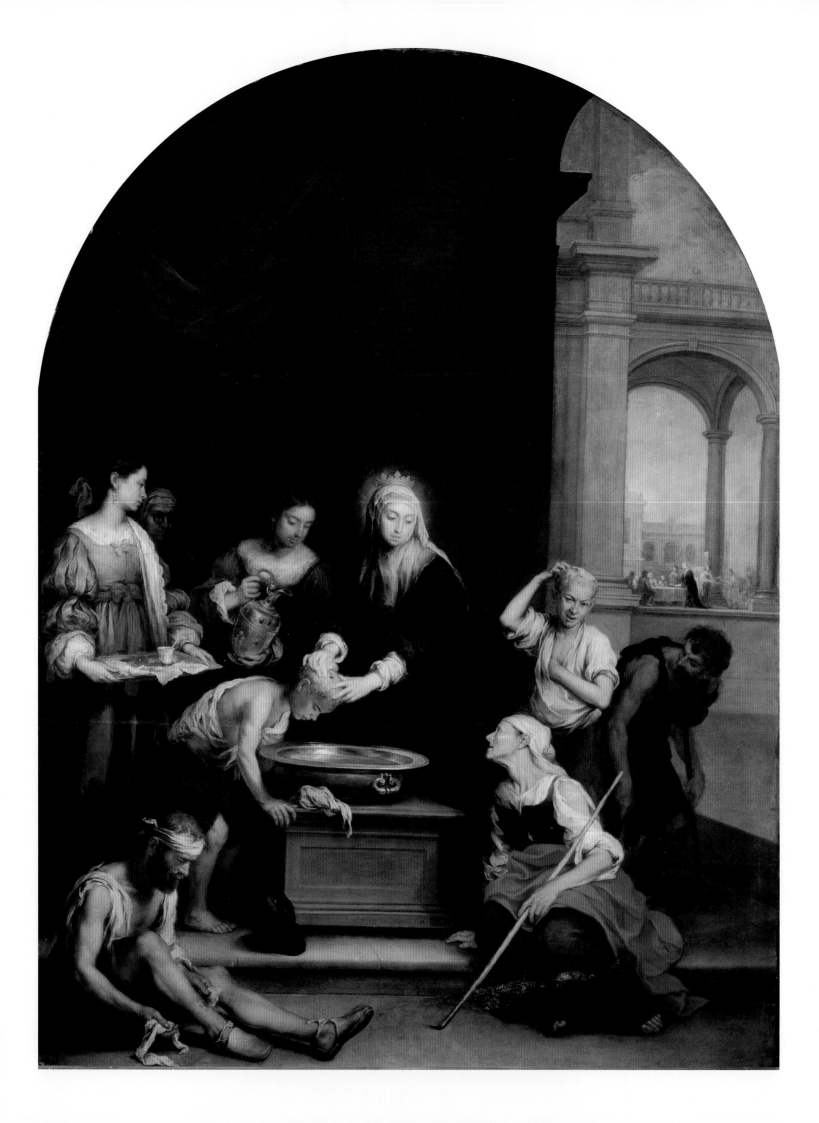

Murillo began in 1667.[16] The large works for the Caridad focus on biblical subjects relating to the Seven Acts of Mercy. Both Capuchin friars and the brothers of the Hospital de la Caridad focused on charitable acts in Seville, and their activities are echoed in Murillo's paintings. *St. Thomas of Villanueva Distributing Alms* (fig. 7) for the Capuchinos and *St. Elizabeth of Hungary Tending the Poor* (fig. 8) for the Caridad are among Murillo's most touching and profound religious narratives. Palomino describes the latter canvas fondly, pointing out its most human aspect: "He also has another one there of St. Elizabeth, Queen of Hungary, where there is a poor little scurvy boy who is having his scurf removed, and he shrugs his shoulders and makes such a grimace of pain that only his screech seems to be missing, for everything else is there."[17] Both paintings show the saints attending to the poor, distributing alms or physically tending to them. The aristocracy and the clergy of Seville were particularly keen on promoting and performing such charitable acts.

During the final decade of Murillo's life, before the last commission for the Capuchin church in Cádiz, he was busy producing a large number of devotional images. In the paintings from this period, Murillo's colors became lighter and his palette softer, as exemplified by *The Virgin of the Rosary* (fig. 9), from about 1675–80.[18] But overall, his art, over three decades, did not change radically. He is still best known for his religious paintings—for his saints and Immaculate Conceptions—and for his genre scenes of street boys.

Murillo and Portraiture

Biographers and scholars of Murillo have paid little attention to one aspect of his artistic production: portraiture. Palomino concedes that "he was also an eminent portrait painter" but does not discuss his portraits in any detail.[19] In the first catalogue raisonné of Murillo's oeuvre, Diego Angulo Íñiguez reflects that portraiture is the genre in which Murillo did not provide any innovative solutions for seventeenth-century

art.[20] There has yet to be a full consideration of Murillo as a portrait painter.[21] It cannot be denied that, unlike his religious and genre scenes, Murillo's portraiture remained principally within the limits of what his contemporaries were producing, but he developed a recognizable style and artistic language for his portraits. Only about fifteen portraits by him, or attributed to him, have survived, but we know that more existed. Inventories of the time provide evidence for now lost portraits of Diego Ortiz de Zúñiga, Ambrosio Spínola, Archbishop of Seville, and the Marquis of Leganés, among others.[22]

Murillo's earliest portrait, dated 1650, is of Juan Arias de Saavedra (fig. 10).[23] Juan Arias de Saavedra y Ramírez de Arellano was born in Madrid in 1621 but seems to have spent most of his life in Murillo's city, the home of his father's aristocratic family. Only four years younger than Murillo, Saavedra was painted by the artist when he was twenty-nine years old. The portrait itself provides most of the information on the sitter and his relationship with Murillo. Saavedra is represented half-length and in three-quarters within an oval niche. He sports long hair and a moustache and goatee, as was the fashion at the time. He is somberly dressed in black, with a white *golilla* collar. On his proper left shoulder, the red cross of the Order of Santiago is visible, and the insignia appears a second time on his chest, over a scallop shell, the emblem of St. James and of his order. The cross is also behind the family coat of arms, at the top of the painting, held by two putti. Saavedra's pride in belonging to this prestigious order is reflected by the reference to his presence in the ranks of the order in the Latin inscription below the portrait. The effigy of Saavedra sits within a larger, painted, stone frame. The oval is surrounded by an elaborate cartouche and two palm branches. The two putti who sit atop the frame hold, in the middle, the Saavedra coat of arms and, on each side, a tablet. The tablet on the left records the age of the sitter (twenty-nine) and the one on the right the year the portrait was painted (1650). At the bottom of the painting, a long Latin inscription identifies the sitter as Juan Arias de Saavedra, provides biographical information on him, and praises his royal blood (through his grandparents) and his natural gifts. Saavedra was a senior minister of the Holy Inquisition in Seville, particularly commended for his skills in punishing criminals. On a positive note, he was celebrated for being a "profound connoisseur of the liberal arts, and of painting in particular." The inscription concludes with a dedication from the artist to the sitter. Murillo had "painted this shade of his body and this idea of his soul" as a gift, with his eager brush, as a sign of devotion and gratitude.

The inscription suggests that Murillo and Saavedra were close or at least that Murillo was seeking the nobleman's patronage. Fifteen years later, on September 6, 1665, Saavedra

Fig. 10. Bartolomé Esteban Murillo, *Juan Arias de Saavedra*, 1650. Oil on canvas, 53 1/8 × 38 5/8 in. (135 × 98 cm). Collection Duchess of Cardona (cat. 3)

VIRO SVPRA OMNEM LAVDEM POSITO REGALI PROAVORVM SANGINE CLARISSIMO, NATVRÆ
DOTIBVS VSQVE AD INVIDIAM ORNATO, PVRPVREO D. IACOBI STEMMATE IN SIGNITO, PRO
ARCENDIS COERCENDIS QVE, INFIDVM CRIMINOSIS SACRÆ HISPALENSIS INQVISITIONIS
MAIORI MINISTRO INGENVARVM ARTIVM, PICTORIA PRÆSERTIM, PHILOSOPHO, D. D.
IOANI DESA AVEDRA, HANC SVI CORPORIS VMBRAM ET ANIMI IDEAM SD QVID NI
ALIVD NISI SE SIBI SVVS BARTOLOMEVS ANVRILLO AVIDIS POTIVS QVAM VIVI
DIS PENECILIS AECTVS ET GRATITVDINIS ERGO DELINEABAT,

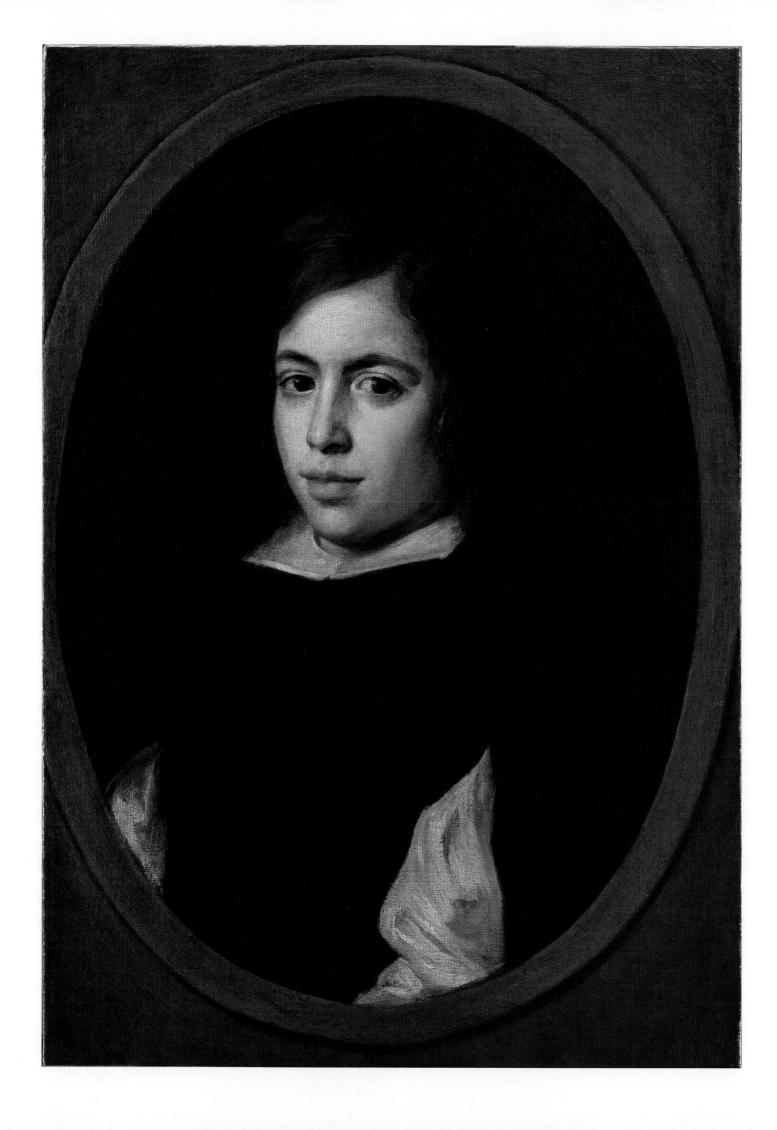

joined the Brotherhood of the Caridad, of which Murillo was also a member. In 1681, he acquired the title of Marquis of Moscoso. He died six years later, in 1687. The inventory of Saavedra's possessions records at least two paintings by Murillo.[24] Murillo's first known portrait fits within a tradition of aristocratic half-length portraits, but it is extraordinary in terms of the complex design of the fictive stone framing elements. The Latin inscription, most likely provided by a literary figure in Seville, is a prominent part of the composition.

In the mid-1650s, Murillo painted another, virtually unpublished, portrait, this one of a young man (fig. 11).[25] There is no attribute that could help with recognizing the sitter, and he remains unidentified. Stylistically, the portrait is close to that of Saavedra and the Frick self-portrait, particularly in the rendering of the flesh tones, the red pouting lips, and the broad, strong brushstrokes that define the white shirt. The painting could be dated anytime in the 1650s, but the middle of the decade—before Murillo's trip to Madrid in 1658—seems the most reasonable option. It is tempting to identify the boy as one of Murillo's own sons and see the picture as a private work made for his family. In 1655, Murillo had only two boys, José Felipe, who was eight years old, and José, who was five. José Felipe died before the age of ten, but we do not know exactly when.[26] It is equally possible, however, that the portrait was of a young aristocrat from Seville. His long hair, black outfit, and *golilla* would place him at the high levels of Spanish society. The canvas appeared on the market in 2009 with a provenance from a French private collection and was then sold as an anonymous Spanish work. Close examination of the picture, along with its recent restoration, make an attribution to Murillo likely. However, because of the lack of provenance, it is impossible to hypothesize for whom the portrait was painted. The young man's effigy is captured, like Saavedra's, half-length and in three-quarters and within a fictive stone frame. The painting has been cut on all sides, slightly more on the left than at top, right, and bottom; it is unlikely that it originally had a fictive frame with a design as complex as Saavedra's. It was probably a simpler stone oval around the sitter's features.

One canvas from the 1650s seems to be the first known full-length portrait painted by Murillo during this decade (fig. 12).[27] In the nineteenth century, it was thought to represent the painter Pedro Núñez de Villavicencio, one of Murillo's pupils, but since Núñez was born about 1635, the identification seems unlikely. The costume of the sitter points to a member of the aristocracy, and the cross hanging from his neck identifies him as a knight of the Order of Alcántara or the Order of Calatrava.[28] It is possible that the portrait is of another member of the Núñez de Villavicencio family, which was of noble origins. Pedro was a Knight of Malta but was never awarded either order. The sitter is shown full-length, in a black costume with elaborately embroidered sleeves. His gloves have matching embroidery, and in his right hand he holds a broad-rimmed hat. The hilt of his sword is visible under his left arm. The nobleman stands in a neutral space, barely defined except for the difference in color between the floor and the wall behind him.

The portrait of Diego Félix de Esquivel y Aldama (fig. 13) is almost identical in composition to the portrait of the knight.[29] The sitter stands with his legs slightly apart, one foot facing the viewer, the other turned to the side. Instead of holding his hat in one hand and his glove in the other, Esquivel holds both in his right hand. His left hand rests on a chair placed next to him in an otherwise empty room. Esquivel's sleeves are also richly embroidered, and the red cross of the Order of Santiago is stitched on his chest. In this case, the sitter is identifiable by his coat of arms, painted at top right. He was born in Vitoria, to a local aristocratic family, and baptized there on June 4, 1628. When he was twenty-five years old, he was knighted into the Order of Santiago, and this provides a date *post quem* for Murillo's portrait. It seems likely that this portrait also dates from about the mid-1650s, and its execution should not postdate Diego Félix de Esquivel's entry in the Order of Santiago by more than a couple of years. A third portrait from the 1650s represents an unidentified knight (fig. 14).[30] The pose of the nobleman is slightly different from the other two canvases, but he stands, yet again, with glove and hat in one hand and his other hand resting on a table. No coat of arms or order permits an identification. It is clear that in the 1650s Murillo had produced a number of portraits of the Andalusian aristocracy, following a well-established prototype. These knights stand in bare rooms, dramatically lit, in their patrician austerity and their black clothes.

Murillo's journey to Madrid in 1658 seems to have had a lasting impact on his portraiture. While in the capital, the artist would have been able to tour the royal collections and admire works by both his contemporaries and Old Masters. He would have been able to see, probably for the first time, Velázquez's court portraits of Philip IV and of his family. In the royal palaces, he would also have admired paintings by Rubens and Van Dyck and the earlier portraits by Titian and Antonis Mor. All of Murillo's subsequent portraits, in the 1660s and 1670s, seem to have been strongly influenced by this experience. His portraits change drastically in style and mood after 1658, and the first in this new typology was a painting probably started in Madrid, of Íñigo Melchor Fernández de Velasco (fig. 15), dated 1659 on the back of the original canvas, where the sitter is also identified.[31] Fernández de Velasco was born in Madrid in

Fig. 11. Bartolomé Esteban Murillo, *Young Man*, ca. 1650–55. Oil on canvas, 25 3/8 × 17 3/4 in. (64.4 × 45.2 cm). Private collection (cat. 4)

Murillo's Self-Portraits: A Sketch

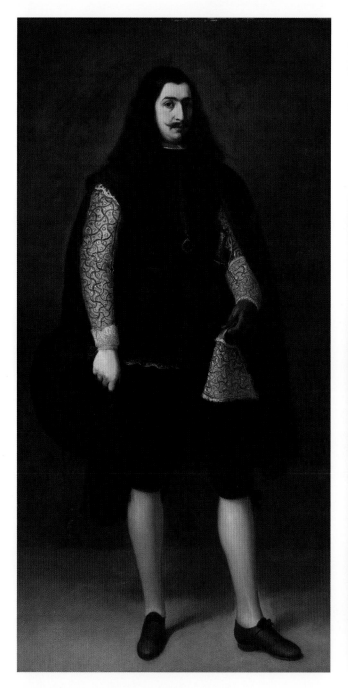

Fig. 12. Bartolomé Esteban Murillo, *A Knight of Alcántara or Calatrava*, ca. 1650–55. Oil on canvas, 77 × 43 3/4 in. (195.6 × 111.1 cm). The Metropolitan Museum of Art, New York

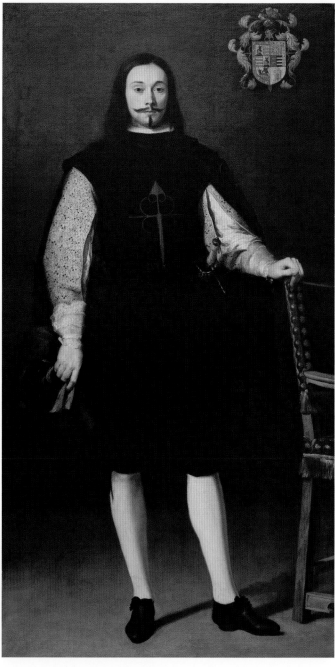

Fig. 13. Bartolomé Esteban Murillo, *Diego Félix de Esquivel y Aldama*, ca. 1655. Oil on canvas, 80 1/2 × 42 in. (204.5 × 106.7 cm). Denver Art Museum

1629 and remained there. He was a prominent member of the Spanish army, eighth Constable of Castile, and seventh Duke of Frías. In 1661, he became a knight of the Order of Santiago, and between 1668 and 1670 he was governor-general of the Spanish Netherlands. In 1676, he was appointed head of the household of King Charles II. He died in Madrid in 1696. It is probable that Murillo met Fernández de Velasco in Madrid in 1658 and received the commission for the portrait on that occasion. There is no evidence that the sitter was in Seville in those years; it is likely that Murillo brought the unfinished painting to Seville with him and completed it in 1659

or painted the entire portrait in Seville, basing it on sketches made in Madrid the previous year. In any case, the portrait must predate 1661, as the Order of Santiago does not appear in it. The stance of Fernández de Velasco is analogous to that of other sitters in Murillo's portraits from the 1650s. Dressed in black, with a white *golilla* collar, sword at his side, glove and hat in his hand, the sitter appears in the pose of all other full-length portraits by Murillo. In this case, the costume's sleeves are elegantly striped in black over white. Two main differences, however, are introduced in this portrait. The first is the setting. The Duke of Frías has abandoned the gloomy

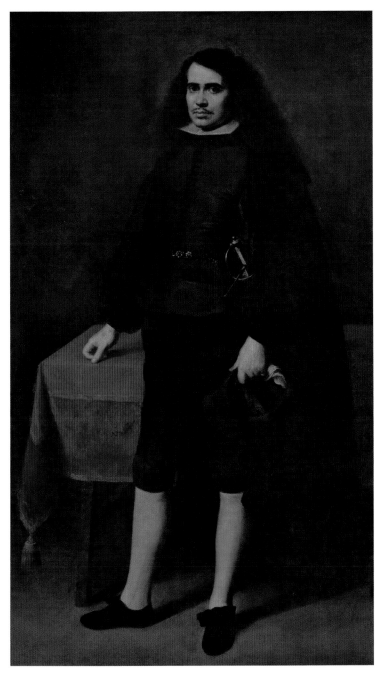

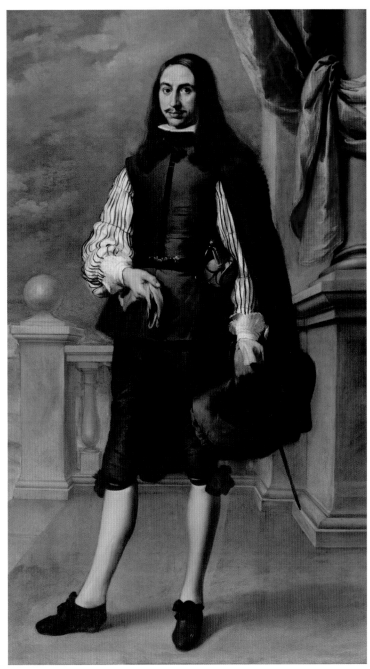

Fig. 14. Bartolomé Esteban Murillo, *Knight*, ca. 1655. Oil on canvas, 78 × 50 in. (198 × 127 cm). Museo Nacional del Prado, Madrid

Fig. 15. Bartolomé Esteban Murillo, *Íñigo Melchor Fernández de Velasco*, 1659. Oil on canvas, 81 7/8 × 54 3/8 in. (208 × 138 cm). Musée du Louvre, Paris

rooms inhabited by his predecessors and stepped outdoors, a detail that gives the portrait a distinctive tone and character. Suddenly, Murillo's portraiture has become grander and more impressive. For this grandee from Madrid, the painter creates a new image of courtly glory, in line with his contemporaries at the royal court. Behind the duke, Murillo paints a balustrade and a column with a red drapery wrapped around it, a particular feature of Rubens and Van Dyck portraits. Steps lead out to an open landscape, and the silhouette of the sitter is clearly cut within a cloudy sky. Drawing from the example of his Flemish forerunners, Murillo creates an imposing image

of aristocratic authority. More important, this portrait, when compared to earlier ones by the artist, has a more subtle psychological reading of the sitter, and more attention is lavished on the duke's hands and face. Judging from this portrait and those that followed, Murillo's paintings in the genre were deeply transformed by what he saw in Madrid. In both his depiction of sitters and their settings, Murillo never returned to the austerity of the 1650s.

A sheet now at the Metropolitan Museum of Art (fig. 16) is one of Murillo's very few drawings for portraits.[32] Only five preparatory drawings for portraits are known by him, two

Murillo's Self-Portraits: A Sketch

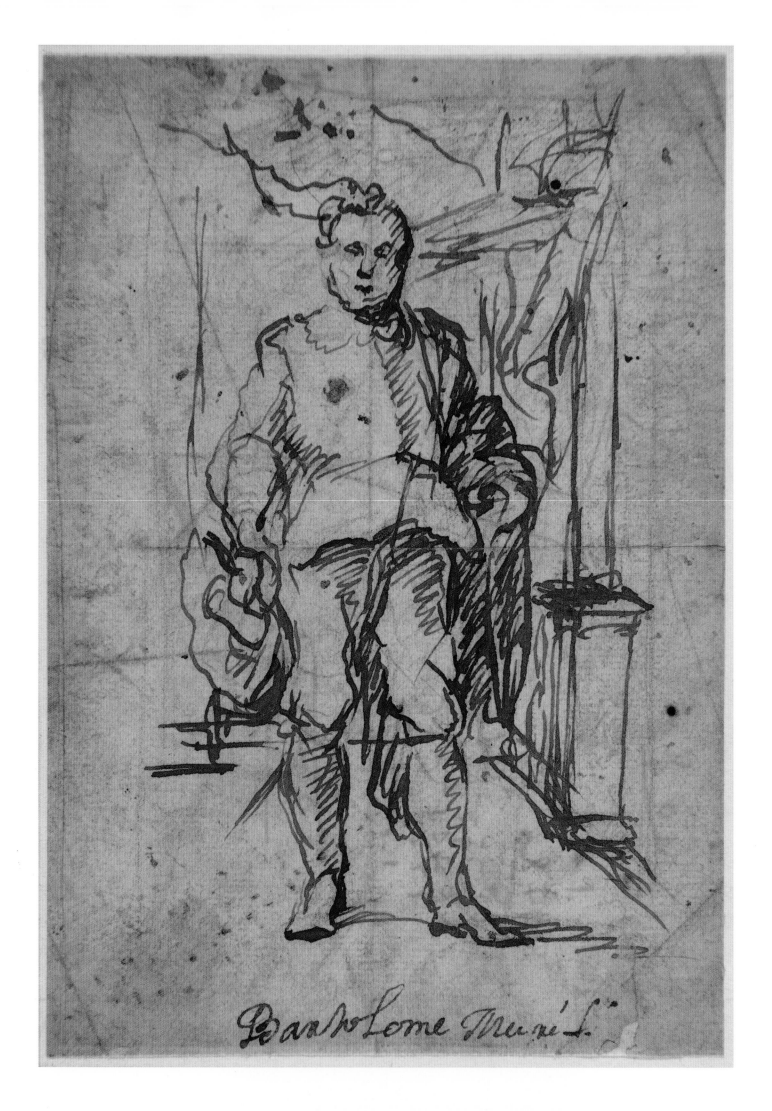

Fig. 16. Bartolomé Esteban Murillo, *Standing Male Figure: Study for a Portrait*, ca. 1660. Pen and brown ink over traces of black chalk underdrawing on off-white paper, 5 5/8 × 4 in. (14.3 × 10.2 cm). The Metropolitan Museum of Art, New York (cat. 5)

Fig. 17. Bartolomé Esteban Murillo, *Andrés de Andrade y la Cal*, ca. 1660. Oil on canvas, 79 × 47 in. (200.7 × 119.4 cm). The Metropolitan Museum of Art, New York

full-length and three of heads.[33] In quick pen lines, over a first, basic drawing in chalk, Murillo sketched the composition for a full-length portrait. Stylistically, this drawing has been reasonably dated to the early 1660s; yet again, the painter places his sitter standing with his hat in one hand. The architectural background and the large swag to the right suggest that this sheet was drawn after the Madrid trip. Notwithstanding various attempts to link the sketch to finished portraits, it seems that the related painting was either never executed or lost. The stout man in the drawing does not correspond to any known Murillo portrait, but the typology of the drawing is typical of the 1660s. It is probable that more drawings like this existed, created quickly to plan the portrait on canvas and maybe also used to seek approval for the overall composition from the sitter.

Soon after returning to Seville, Murillo painted another full-length portrait (fig. 17).[34] From the inscription on the base of the pilaster on the left and the family coat of arms at the top of the same pilaster, the sitter is identified as Andrés de Andrade y la Cal, the marshal of processions of the Cathedral of Seville. Stirling in 1848 memorably describes the sitter as "a personage chiefly remarkable for his prodigious crop of coal-black hair and his bad legs, and attended by a white mastiff yet uglier than himself."[35] The mastiff seems to be the first animal included by Murillo in a portrait. Instead of the chairs and tables he had used so far as props, he adds the fierce dog as yet another attribute of nobility. Stirling's harsh assessment seems particularly undeserved for this, one of Murillo's most beautiful full-length portraits and the essence of Spanish aristocratic aloofness. The addition of a mastiff to Don Andrés's portrait can also be explained by Murillo's study of works by Titian, Mor, and Velázquez in Madrid. By the mid-seventeenth century, the image of a standing individual accompanied by a large dog had become a standard for portraits of rulers and aristocrats in Europe.

In the 1630s, Velázquez painted a series of portraits of King Philip IV, his brother the Cardinal Infante Fernando, and his heir, the Infante Balthasar Carlos, in hunting costume and accompanied by dogs. These three portraits were no doubt the models for Murillo's most ambitious, and by far largest, portrait, that of Antonio Hurtado de Salcedo y Mendoza, first Marquis of Legarda (fig. 18).[36] Here, he used the theme of the hunt to create a powerful image unlike anything he had produced before or after. Hurtado de Salcedo was the secretary of state for King Philip IV, and while he spent part of his life in Madrid, he had a house in Seville, in the parish of San Bartolomé, and was therefore a neighbor of Murillo's in the early 1660s. On October 11, 1665, he also joined the brotherhood at the Hospital de la Caridad, as had

Murillo and a number of other patrons of the artist. The date of the painting must be placed between 1647, when Hurtado de Salcedo was knighted with the Order of Santiago—which prominently appears on his coat—and 1664, when he became Marquis of Legarda. His family coat of arms appears on the right, behind his gun, carved on a stone, and does not have the marquis's crown above it. It is extraordinary that the figure is placed within an Andalusian landscape, with buildings in the background. Don Antonio stands, holding a cap and a gun, dressed in a hunting costume. He is accompanied by three of his hunting dogs and a servant, who gathers on the floor the bounty of the hunt, a large number of partridges. The birds and the dogs become a large still life within the painting, almost as if they represented a series of creatures—human and animal—that belong by right to the nobleman. By placing Hurtado de Salcedo in the open countryside, Murillo defines him as an aristocratic landowner, whose power and health are connected to his lands. While the condition of the painting is not perfect, it is easy to imagine how remarkable it must have been, the elegant sitter standing in the barren landscape with the details of his embroidered sleeves as beautifully rendered as the blue feathers and the coral red feet of the partridges. The tender exchange between the young man and one of the dogs is another wonderfully observed moment in Murillo's art, close in spirit to his depiction of the street urchins of Seville.

When Palomino describes Murillo as an "eminent portrait painter," he uses as an example a specific portrait:

> as is attested to by that of Don Faustino [sic] de Neve, Canon of Seville, who left it at his death to the Venerables Sacerdotes and which is outstanding for the likeness and for how well it is painted. But best of all is the little English bitch that he has by his side, which other dogs usually bark at and which looks as if she would like to charge them, so that one is surprised when she does not bark back, so lifelike does she seem.[37]

This extraordinary portrait of Justino de Neve (fig. 19) was painted by Murillo in 1665.[38] The coat of arms in the background of the painting and the accompanying inscription identify the sitter and his age (forty) and specify that the portrait was a gift from Murillo to his friend.[39] Neve was born in 1625 to a family of Flemish origin; he had become a priest in 1646 and a canon of the Cathedral of Seville in 1658. He was to remain one of Murillo's closest friends and most important collectors until the painter's death.[40] Neve owned at least eighteen paintings by Murillo and was instrumental in securing significant commissions for the painter in the 1660s and 1670s, in particular, the lunettes for Santa María la Blanca

Fig. 18. Bartolomé Esteban Murillo, *Antonio Hurtado de Salcedo, Marquis of Legarda*, ca. 1664. Oil on canvas, 93 3/4 × 53 1/8 in. (238 × 135 cm). Colomer Collection, Madrid

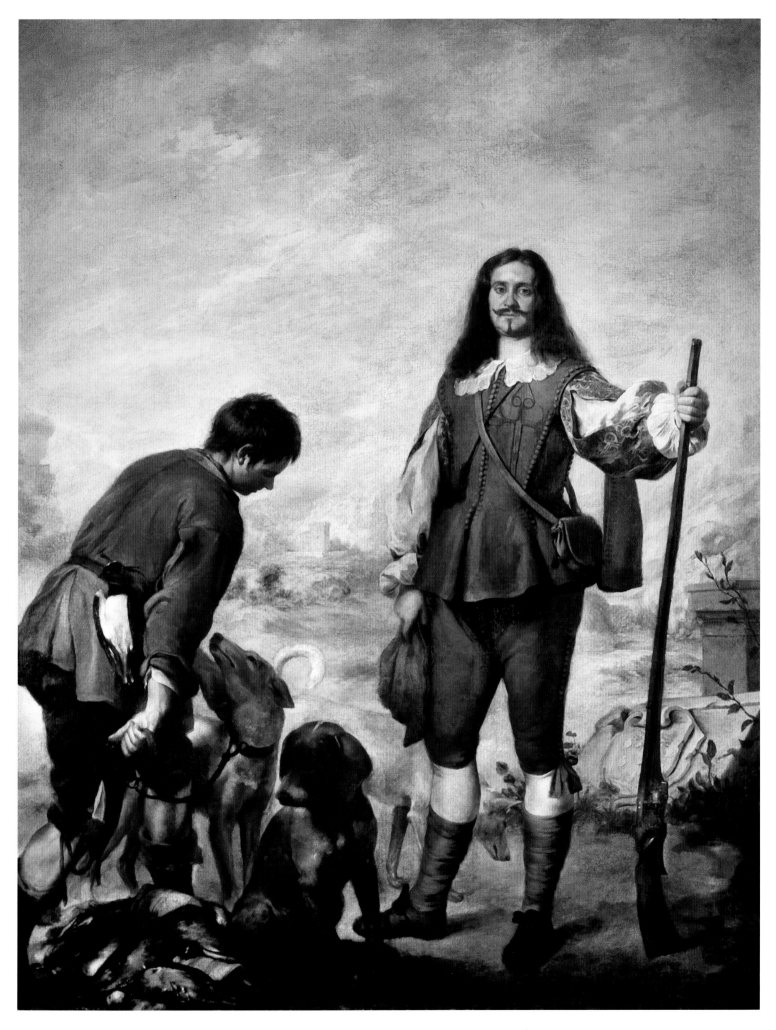

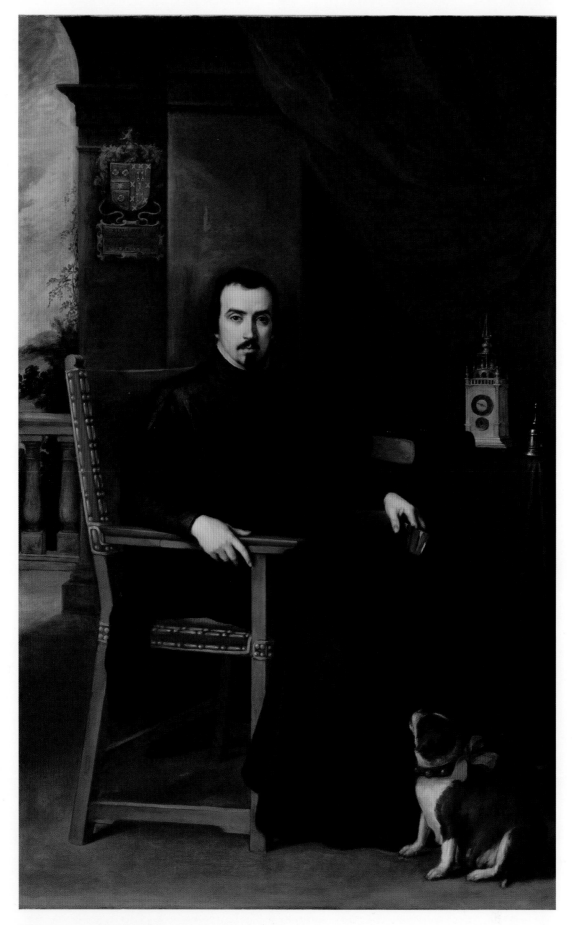

Fig. 19. Bartolomé Esteban Murillo, *Justino de Neve*,
1665. Oil on canvas, 81 1/8 × 51 in. (206 × 129.5 cm).
The National Gallery, London

and paintings for the Hospital de los Venerables Sacerdotes. The portrait was, in fact, painted at exactly the same time as Murillo was at work on the Santa María la Blanca pictures. Murillo was clearly moved by a deep sense of friendship, and the sitter appears less distant than in other full-length portraits of aristocrats by the painter.

As is appropriate for an ecclesiastical figure, Justino de Neve is shown seated. From the sixteenth century, bishops and cardinals were traditionally depicted this way, and Murillo followed the convention by showing Don Justino, in his black priestly robes, seated in a chair upholstered in red velvet and gold trimmings. The sitter is placed in a liminal space, a room open onto a garden, or possibly a loggia. A red curtain covers the top right corner of the portrait, and a still life of a clock, bell, and book is on the table next to him. Murillo gives the impression that Neve has been interrupted during his prayers, as he has just closed his prayer book and keeps his index finger in it to resume his reading after the sitting. It is an effective and sophisticated solution. The little pug with a red ribbon, likely Neve's pet, may also have been painted to signify devotion—that of Justino to God and of Murillo to Neve. Murillo's fondness for Neve is also shown by the inclusion of his portrait in the almost contemporaneous lunette of the Immaculate Conception for Santa María la Blanca (see fig. 6).

In the 1670s, Murillo seems to have returned to half-length portraiture with newfound enthusiasm and attention. The portrait of Joshua van Belle, dated 1670, provides a striking contrast to the portraits from the 1650s (fig. 20).[41] Van Belle was a prominent merchant from Rotterdam and an art collector (he owned a painting by Vermeer), who lived between Seville and Cádiz. The original canvas is inscribed

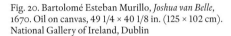

Fig. 20. Bartolomé Esteban Murillo, *Joshua van Belle*, 1670. Oil on canvas, 49 1/4 × 40 1/8 in. (125 × 102 cm). National Gallery of Ireland, Dublin

Murillo's Self-Portraits: A Sketch

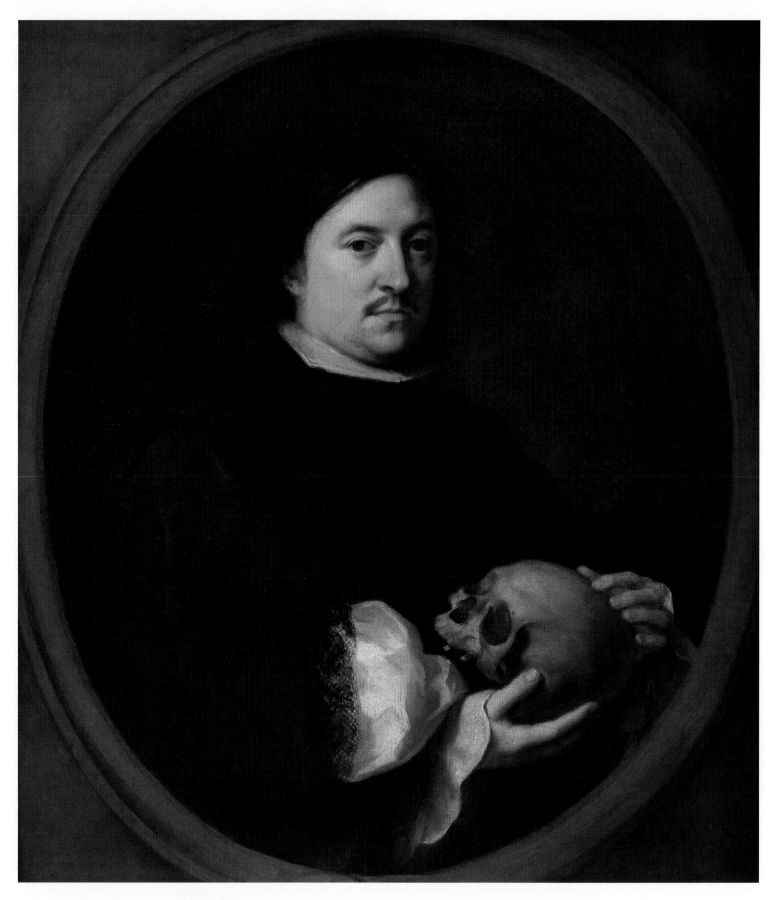

Fig. 21. Bartolomé Esteban Murillo, *Nicolás Omazur*,
1672. Oil on canvas, 32 5/8 × 28 3/4 in. (83 × 73 cm).
Museo Nacional del Prado, Madrid (cat. 6)

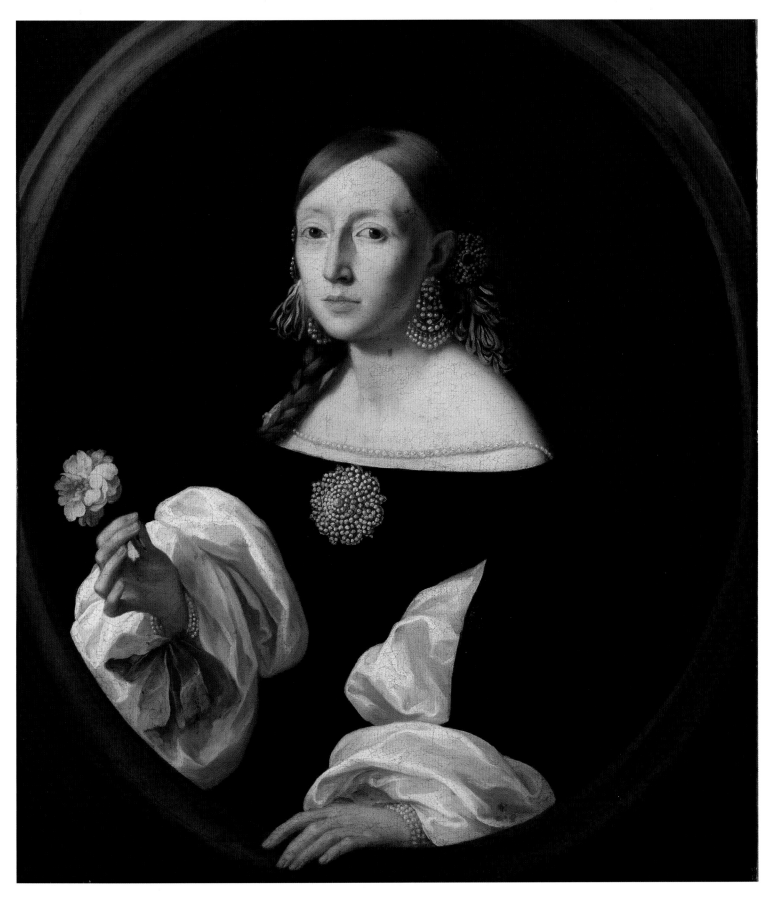

Fig. 22. Attributed to Bartolomé Esteban Murillo,
Isabel Malcampo, 1672. Oil on canvas, 32 1/2 × 28 3/8 in.
(82.6 × 72.1 cm). Private collection

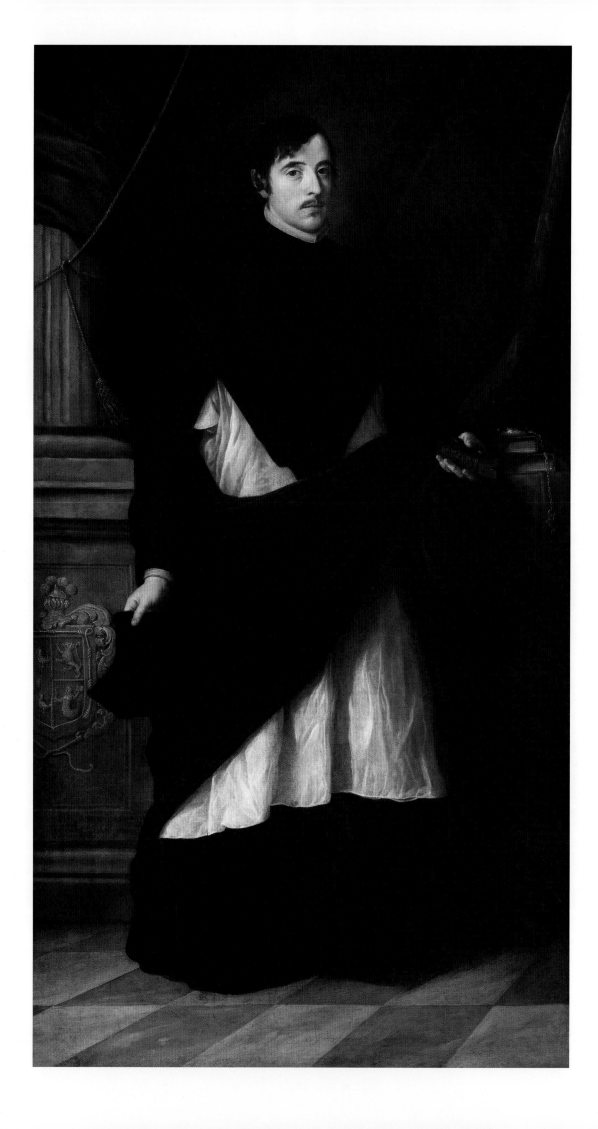

on the back with the artist's and sitter's names and the date of execution. For this painting, Murillo seems to look more than ever at Dutch and Flemish models. It is as if he had executed another full-length image and then cut it down, as the pose of the sitter, gloves and hat in his hands, is the same used in most of Murillo's previous works. The red curtain, balustrade, and sliver of landscape have, by this date, become standard in Murillo's portraits. It is, however, not only Van Belle's pale features and his Dutch lace collar that give the portrait a northern flavor but also the looser and softer manner in which it was painted.

Another important patron of Murillo's, Nicolás Omazur, was also of northern origins. He was born in Antwerp about 1630, and in the late 1660s moved to Seville, where he was one of the preeminent Flemish silk merchants.[42] On August 2, 1672, he married Elizabeth Maelcamp—born in Ghent in 1647 and known in Spain as Isabel Malcampo—in Seville's church of San Isidoro.[43] The couple had five children, their first, like his father and grandfather, named Nicolás, and their second, Pedro, born deaf and mute. Isabel died on December 21, 1689.[44] A year later, in 1690, Nicolás married Elena Luisa Victoria de Keyser, from Brussels, and the couple had two children. Omazur died on June 2, 1698, in Seville.[45] He came from an intellectual background: his father was a literate man. He assembled in Seville an impressive collection of more than two hundred paintings. Like Neve, he was a close friend of Murillo's and owned thirty-one works by the artist. His collection of paintings, sketches, and works on paper is fully documented in two inventories, the first compiled on January 15, 1690, and the second after his death, between June 26 and July 8, 1698.[46] The 1690 inventory mentions, among Murillo's works, the following: "Item. Two portraits, one of the said Don Nicolás Omazur, and the other of the said Doña Isabel Malcampo his wife, both original of the said Murillo."[47] Eight years later, they appear again in his postmortem inventory.[48] The two portraits were subsequently mentioned, in 1806, by Juan Agustín Ceán Bermúdez in the collection of Bernardo de Iriarte in Madrid.[49] They are currently identified with the portraits in the Museo del Prado in Madrid (fig. 21) and in a private collection (fig. 22), respectively.[50] While there is no doubt that the portrait of Nicolás Omazur in Madrid is the original work by Murillo, doubts have been cast about the portrait of his wife. It is unclear if Isabel Malcampo's portrait is also by Murillo or a copy of a lost original; it has been impossible to establish its status.[51] It is said to have been acquired in Paris by William Stirling, in July 1847, from the Spanish bookseller Salvá, who had purchased it from the widow of the man who bought the painting from Iriarte.[52] While Omazur's portrait is a typical work by Murillo from the 1670s, Isabel's

has a flatter surface and seems more rigid in the handling of the brushstrokes. This would be the only known female portrait by Murillo, and it is possible that he chose to represent Omazur's wife in a different manner than her husband. Several options cannot, at this point, be excluded. The painting could be by Murillo but damaged and repainted, a workshop painting, or even a copy after the lost original.[53]

The sitters in the two portraits are shown half-length within oval stone frames. Omazur is dressed in black, with a *golilla* collar. Unlike Van Belle, in his Dutch collar, Omazur is represented in full Spanish fashion. He looks out at the viewer while holding a skull with both hands. Isabel is also dressed in black and white, but her wrists and hair are decorated with pale blue ribbons, and her body and dress are adorned with pearls. One hand rests on the parapet of the stone frame, while the other offers a rose to the viewer. Close examination of Omazur's portrait reveals that the painting has been cut on all sides and the corners heavily repainted. At the bottom of the picture, the barely visible top of a fictive stone cartouche suggests that the portrait had an inscription of some kind.[54] The 1698 inventory of Omazur's collection gives the dimensions of the paintings as one and a half *varas* high and one and one quarter wide.[55] This would mean that the paintings were originally 126 by 105 centimeters wide. This is more or less the format and size of Murillo's self-portrait at the National Gallery, meaning that the portraits of Nicolás Omazur and Isabel Malcampo were cut down and have lost about 40 centimeters in height and 30 in width. That the paintings were larger and had more complex fictive stone frames is confirmed by Ceán Bermúdez's *Carta* of 1806.[56] He describes the portraits of Omazur and Isabel Malcampo in the collection of Iriarte as being already cut to their present format, but he adds that Don Manuel María Rodriguez, the chaplain of the Royal Chapel in Seville, owned at the time two copies of the portraits. These were larger and had inscriptions around the stone frames. In the portrait of Omazur, over the portrait, around the oval frame, was the Latin inscription OMNIA IN UNO TRINOQUE DEO.[57] Below the portrait was a second inscription, SIC PEREUNT OMNIA IN UNO MORTIS ASPECTU.[58] Below the stone oval was a socle that included a very long Latin inscription.[59] The first two inscriptions are religious statements, one linked to the Trinity ("All things are in God, one and triune") and the other to human frailty ("Thus all things die in the same appearance of Death"). The longer text identifies the sitter as Nicolás Omazur from Antwerp and includes Murillo's signature and the date 1672, stating that the portrait was painted in Seville. The text refers to the skull held by Omazur and invites the viewer to gaze at both Omazur and the face of Death, exhorting posterity

Fig. 23. Bartolomé Esteban Murillo, *Juan Antonio de Miranda y Ramírez de Vergara*, 1680. Oil on canvas, 77 1/2 × 42 1/2 in. (197 × 108 cm). Fundación Casa de Alba. Palacio de Liria, Madrid

Murillo's Self-Portraits: A Sketch

to look at the skull as a future image of themselves, as all human bones are destined for the womb of the earth. Isabel's portrait had matching inscriptions. Above her effigy was IN UNO MANENT OMNIA and below QUASI FLOS EGREDITUR ET CONTERITUR. This portrait also had a longer inscription at the bottom, in a socle.[60] Two further inscriptions were added, apparently subsequently: JOB, CAP. 10, VERS. 4 (identifying the biblical source of one of the inscriptions) and OBIJT 20 DECEMBR. 1689 (Isabel's date of death). The first two inscriptions were meant to match the two in Omazur's portrait: "All things are in One" and the passage from the book of Job, "He cometh forth like a flower, and is cut down."[61] The longer inscription includes a complex play on words relating to Omazur's and Malcampo's surnames and also discusses how roses are born among thorns and are symbols of the brevity of human life. It continues with praise for Murillo as a new Apelles, who captured in his painting, thanks to his line, the conjugal peace in the olive branch, the life in the rose, and the death in the thorns, and makes the viewer understand all of this in one image.

According to the inscriptions reported by Ceán Bermúdez, the Omazur portrait was dated 1672, while Isabel's was dated 1674. This must be a mistake of transcription, or the second date must refer to the date in which the copies were made. The portraits were probably made for the couple's wedding in 1672, and the two images, with their inscriptions, were no doubt conceived to go together. These are wedding portraits celebrating the couple's love and union, but at the same time, in a typical northern fashion, they are *vanitas* paintings, commenting, through the attributes of the skull and the rose, on the brevity of human life and, therefore, of happiness. The two images were extremely complex in their meaning and must have been cut down at some early date, making the message less clear and the paintings more appealing. None of the previous aristocratic images painted by Murillo were charged with such profound significance, and it is probable that it was Omazur himself who, together with the artist, devised the iconography of the portraits.

In his late years, Murillo continued to paint full-length portraits of the aristocracy of Seville. His last known portrait depicts Juan Antonio de Miranda y Ramírez de Vergara (fig. 23), dated 1680, two years before the artist's death.[62] Miranda's coat of arms appears on the base of the column, above an inscription that dates the portrait and gives his age as twenty-five.[63] Born in 1655, he was almost forty years younger than Murillo—the youngest sitter the artist ever portrayed. His uncle was Fernando de Miranda, a canon of the Cathedral of Seville and a powerful figure in the ecclesiastical life of the city. Through him, Juan Antonio was appointed prebendary

of the cathedral and in 1679 became a canon himself. It is likely that the portrait was commissioned to celebrate the appointment of Miranda and his new role. In the nineteenth century, the sitter in the portrait was believed to be Murillo's son Gaspar (also a canon of the cathedral) because of the canon's costume. But the coat of arms allowed for the correct identification of the sitter. For his last portrait, Murillo brought the sitter back into an interior space, albeit keeping the grand architectural features of the marble base and column. The space is further defined by a lavish black and white marble checkered floor and the heavy green velvet curtain, draped around the column. Unlike Justino de Neve (see fig. 19), also a canon of Seville's cathedral, Miranda stands in the room, dressed in his white and black ecclesiastical habit. Next to him, a table is covered in red velvet, and on it are books and a silver watch. The young Juan Antonio holds his black biretta in his right hand and in the left, like Justino de Neve, holds his prayer book.

Murillo's portraits, as Angulo Íñiguez commented in 1981, are not among his most inventive and groundbreaking works. Yet, in the formula that he devised and refined over more than thirty years, he found an authoritative solution for the portrayal of the nobility and clergy of Seville and close friends, such as Neve and Omazur. More sympathetically than most art historians, Albert Calvert wrote: "Murillo's portraits will remain as a monument to his genius, an unanswerable argument to all who would challenge his claim to a niche in the Temple of Art."[64]

The Frick Self-Portrait, ca. 1650–55

When Palomino describes Murillo's self-portraits, the second one he writes about is the one currently in The Frick Collection (fig. 24). The painting is easily identifiable by his description; the "one with a *golilla*, which remained in

Fig. 24. Bartolomé Esteban Murillo, *Self-Portrait*, ca. 1650–55. Oil on canvas, 42 1/8 × 30 1/2 in. (107 × 77.5 cm). The Frick Collection, New York (cat. 1)

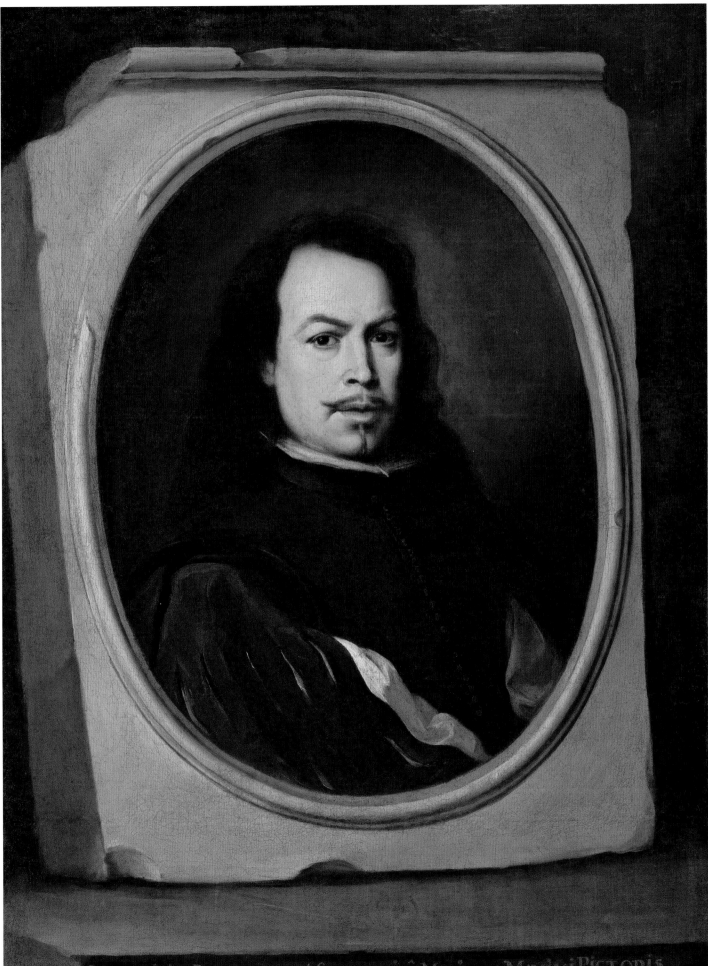

VERAEFIGIES BARTHOLOMÆI STEPHANI â MORILLO MAXIMI PICTORIS,
HISPALI NATI ANNO 1618 OBIIT ANNO 1682 TERTIA DIE MENSIS APRILIS

the hands of his son, Don Gaspar Murillo."[65] Gaspar owned two portraits of his father, both described in his postmortem inventory of May 1709. One of the two is likely the Frick portrait, but it is unclear which one. The first is described as being a portrait of the painter, with a legend below, and worth 300 *reales*.[66] The description matches the Frick self-portrait; however, it can be argued that the second self-portrait by the painter, at the National Gallery, London, also has an inscription below. The inventory does not specify the painter of the portrait. The second Murillo portrait in Gaspar's collection is instead specifically "por el mismo" (by his own hand), and the dimensions would seem to match those of the Frick canvas.[67] The one-and-a-third *varas* recorded in the inventory would be approximately 112 centimeters, which is close to the height of the Frick self-portrait. This second portrait of Murillo was worth more than the first one, 375 *reales*. However, if the dimensions refer to the width, rather than the height, the National Gallery canvas could have been described. It is impossible to firmly determine which two paintings Gaspar owned. He may well have had both self-portraits, and the first one described in the inventory (with the inscription and the value of 300 *reales*) is the Frick one, while the second (larger and therefore valued at 375 *reales*) is the National Gallery one. Or he may have owned another portrait of his father by another hand (the first one) and the Frick one as the only self-portrait by his father in his possession. Even though it cannot be firmly determined whether one of the two descriptions refers to the Frick portrait, we know, thanks to Palomino, that in the early eighteenth century the Frick canvas—the portrait with the *golilla*—belonged to Gaspar Murillo.

The first of the two self-portraits painted by Murillo was an early work, one of the earliest portraits he ever painted, dating to the first half of the 1650s, when the painter was in his mid-thirties and the father of five children.[68] Stylistically, it must be placed soon after the 1650 portrait of Juan Arias de Saavedra (see fig. 10) and around the time of the *Young Man* (see fig. 11). As recent technical analysis has shown, Murillo started to paint his portrait in the center of an approximately square canvas, and only while working on it did he conceive the stone frame around it. To achieve this, he had to add a piece of canvas at the bottom.[69] We do not know for whom the self-portrait was intended, but it is likely to have been a private work for his own family, as supported by the fact that by 1709 it still belonged to his one surviving son. In concept, the painting is less grand than the Juan Arias de Saavedra portrait and its fictive frame simpler in design.

Murillo represents himself in a black outfit typical of an upper-class Spaniard of the time, a *hidalgo*. His sleeves are slashed to reveal the white shirt underneath, and the white and rigid *golilla* appears under his head. Murillo's hair is long, over his shoulders, and he has the moustache and goatee typical of the time. No attributes or objects identify him as a painter. He is identifiable only from the long inscription in red letters, which names the artist as a famous painter (MAXIMI PICTORIS) and gives his birthdate as 1618 (instead of 1617) and his date of death as April 3, 1682. Clearly, the inscription was added posthumously and was not included in Murillo's plan for the painting. Technical analysis confirms that the inscription did not replace a previous one but was added later in the seventeenth century. If the self-portrait was indeed conceived as a private, family object, there would have been no need to inscribe it with the identity of the sitter, and the inscription could have been added after 1682, on Gaspar Murillo's orders.

Like the portraits of Saavedra (see fig. 10) and Omazur (see fig. 21), Murillo's self-portrait is inset in a stone frame, not a decorative frame but rather a hollowed-out stone block, chipped and battered by time. The block, in turn, is leaning on top of another stone slab and was probably originally set outdoors, against a bluish sky.[70] This type of fictive stone frame is unique in its concept, not to be found elsewhere in Murillo's oeuvre or in the work of his followers.

The National Gallery Self-Portrait, ca. 1670

After Murillo died, on April 3, 1682, an inventory of his possessions was compiled under the watchful eyes of the three executors of his will: Gaspar Murillo, Justino de Neve, and the painter's pupil, Pedro Núñez de Villavicencio. The inventory was begun a day after Murillo's death, on April 4, and completed on May 23.[71] It is precise and lists all the deceased painter's belongings—his furniture, crockery, cutlery, maps, books, and paintings. No author is mentioned next to the descriptions of the pictures, which were for the most part religious scenes, with a few still lifes. The two self-portraits, later described by Palomino, are not in this inventory. By 1682, they must have left Murillo's home. The Frick portrait was probably already in Gaspar Murillo's house, a present from his father during his lifetime.

As discussed above, by the time Gaspar died, in 1709, he may have owned both self-portraits. However, on September 29, 1685, he had acquired from Justino de Neve a portrait of his father for 550 *reales*.[72] This portrait, whose author is never named, had appeared in Justino de Neve's postmortem inventory a few months earlier, on June 28, 1685: "Item two portraits, one of Murillo and the other of

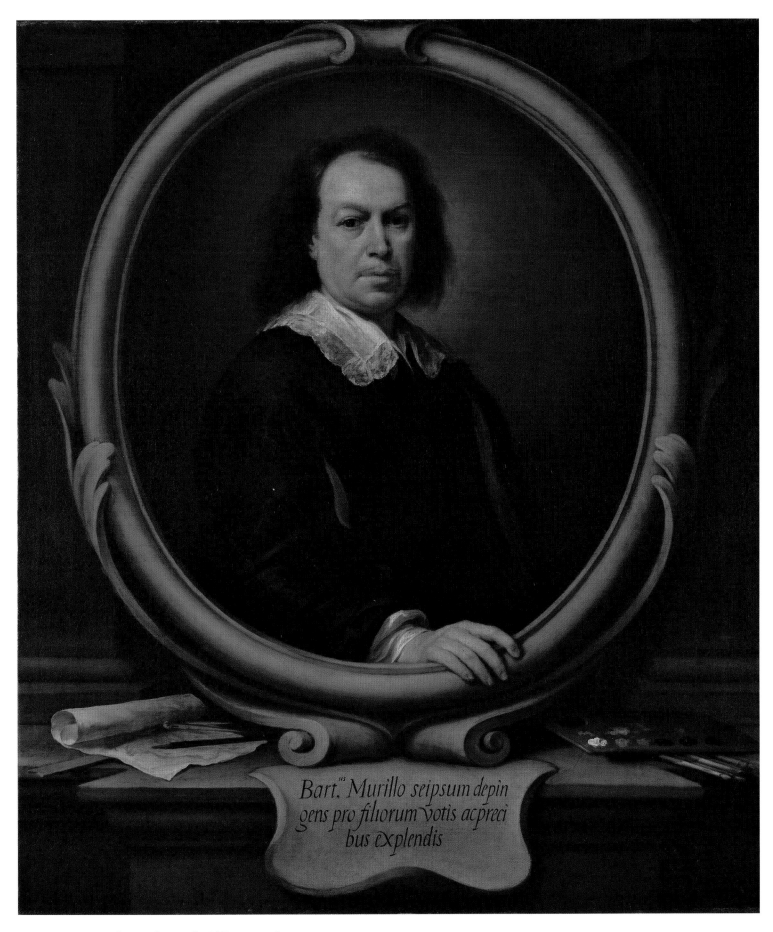

Fig. 25. Bartolomé Esteban Murillo, *Self-Portrait*, ca. 1670.
Oil on canvas, 48 × 42 1/8 in. (122 × 107 cm). The National
Gallery, London (cat. 2)

Juan Martínez Montañés, the same [size] with their gilt frames which are each one and three quarter [*varas*] high."[73] The portrait of Murillo was valued at 800 *reales* and the one of Martínez Montañéz at 500 *reales*, substantial amounts for portraits at that time. The image of Murillo was about 150 centimeters high, closer in size to but significantly taller than the National Gallery self-portrait. If the portrait owned by Justino de Neve and bought by Gaspar is one of the two described in Murillo's son's inventory of 1709, it remains to be explained how this portrait, which was valued at 800 *reales* to begin with in 1685, was then acquired for 550 and valued in 1709 at 375 or 300. The National Gallery self-portrait does not appear to have been cut down significantly, and it is therefore unlikely that it was the portrait owned by Justino de Neve.

When, later in the eighteenth century, Palomino describes the two self-portraits, he is clearly referring to the National Gallery one when he says, "he also painted his own portrait at the request of his children, a marvelous thing that was engraved in Flanders for Nicolás Omazurino."[74] Palomino, however, does not specify, as he does for the Frick self-portrait, that it belonged to Gaspar. His sentence is not specific enough to determine whether he is referring to both paintings as belonging to Gaspar or just the Frick one. Both references to the dedication to his children and to the print after the painting, however, unmistakably identify this self-portrait as the National Gallery one (fig. 25).[75]

This second portrait was probably painted about 1670, after the death of Murillo's wife, in 1663. By this date, Murillo was the most important and celebrated living artist in Seville, as well as the single father of four children, all of whom were teenagers or in their early twenties. The inscription below the portrait—BART.US MURILLO SEIPSUM DEPIN/GENS PRO FIL-IORUM VOTIS ACPRECI/BUS EXPLENDIS (Bartolomé Murillo portraying himself to fulfill the wishes and prayers of his children)—in large and elegant letters, undoubtedly dedicates the portrait to his children. It has recently been suggested that by *filiorum* (children), Murillo did not actually mean his own sons and daughter but rather the pupils of the academy in Seville of which he was a founder.[76] This seems unlikely, and it is more probable that the portrait was intended for the painter's three sons—José, Gabriel, and Gaspar—as his thirteen-year-old daughter Francisca had entered a convent in 1668. In format, the portrait is similar to the first self-portrait: Murillo appears again in a three-quarters pose, looking out toward the viewer. Naturally, he looks older, and his expression is somewhat forlorn and weary. By this date, Murillo was in his fifties and had lost not only his wife but also five of his nine children. An orphan himself, he must have been particularly close to those who remained. In the canvas, the painter wears an outfit similar to the one in the 1650s self-portrait, a black jacket over a white shirt. Instead of the *golilla*, he wears another type of collar, wider and suppler, which falls over his shoulders and is decorated with lace. This was a northern type of collar, known in Spain as a *valona* (Walloon collar). The skin on his face has sagged, his hairline receded, and his moustache turned gray.

The fictive stone frame around the portrait, however, is much more elaborate than the one in the Frick portrait. The oval frame is inset in the niche of a wall and rests on another stone ledge. The frame is decorated with scrolls and foliage. On each side of the frame are groups of objects: to the left, a sheet of paper with a drawing, in red chalk, of human legs; below it, a wooden ruler; and on top, a compass and a red chalk-holder. On the opposite side are the painter's brushes and his palette. Drawing and painting—*disegno* and *colore*, as the Italians would have it—are included to portray Murillo as a painter. While the Frick self-portrait could be mistaken for the portrait of a nobleman, if not for the subsequent inscription, the National Gallery self-portrait clearly depicts an artist. The still life of drawing, brushes, and palette is an assemblage of attributes that helps identify the painter, who names himself in the inscription.

According to Palomino, as we have seen, the self-portrait dedicated to Murillo's own children was "engraved in Flanders" for Nicolás Omazur. The print disseminated the image of Murillo across Europe and was, as far as we know, the first image of the painter to be produced in print form (see fig. 67).[77] One year after the print was produced, in 1683, Joachim von Sandrart published his *Academia Nobilissimae Artis Pictoriae* in Nuremberg, which included an engraved portrait of Murillo clearly based on the 1682 print.[78] When Ceán Bermúdez described the Frick self-portrait in the collection of Bernardo de Iriarte in 1800, he also mentioned the print after "another portrait in which the sitter is older with a Walloon collar, and was sent to Flanders, where a good print was produced from it, which I own."[79] The print is signed by its author, Richard Collin, and dated 1682. Collin specifies that the print was made in Brussels and identifies himself as "engraver to the king." Born in Luxembourg in 1626, Collin studied with Sandrart in Rome and worked in Rome and Antwerp. He was, in fact, the same printer who produced the artists' portraits in Sandrart's *Academia*. He moved to Brussels in 1678 and started working as the royal engraver for Charles II of Spain. He died there in 1698. Below the portrait in the print, a tablet has an inscription identifying Murillo and repeating exactly the dedication to his children in the London self-portrait (SE-IPSUM DEPINGENS PRO FILIORUM VOTIS AC PRECIBUS EXPLENDIS). The inscription further explains that the print was commissioned by Nicolás Omazur from Antwerp, that it was made as a symbol of his friendship with the painter, and that he had sent a portrait there to be engraved, in 1682. Since Collin worked, and signed the print, in Brussels, but Omazur described himself as from Antwerp, it is unclear whether the model from Spain was sent to Brussels or to Antwerp. It is also unclear what the model was. It is generally assumed that the National Gallery self-portrait was sent to Flanders so Collin could engrave it, but this seems improbable given the canvas's relatively large size and value. It is much more likely that a drawing after it, commissioned by Omazur and made by another artist—possibly even Murillo's pupil, Pedro Núñez de Villavicencio—was sent to Collin in Brussels.

As expected, the print reproduces the National Gallery portrait in reverse. The format of the portrait, however, was

not copied exactly by Collin. The oval frame is narrower and higher than the one in the canvas. The still life on the ledge, with the drawing and brushes, has been omitted in the print, and the inscription has been transferred from a stone cartouche to a proper tablet, with capital letters carved in it. In its format, the print resembles tombs and monuments in churches all over Europe, in which a carved bust was placed in a niche over an inscription. This aspect should not be too surprising, as Omazur most probably commissioned the print immediately after Murillo's death, in 1682, to commemorate his friend.

The Deceit of Art

The main difference between Murillo's self-portrait at the National Gallery and the Collin print after it is Murillo's hand. In the painting, his right hand protrudes out of the fictive stone frame, into the viewer's space, and clutches the frame itself, effortlessly resting on it. In the print, the hand—now the left one, because of the image's reversal due to the printing method—is barely visible and rests behind the frame outside the viewer's grasp. It is surprising that Collin did not include the trompe l'oeil effect of the hand in his engraving. This detail may not have been included in the drawing that was sent to Collin from Seville to Brussels, or Collin may have decided to omit it. However, the projecting hand is one of the most striking and innovative features of the National Gallery self-portrait.

Many of Murillo's portraits, all of which were half-length, were compositionally set into painted stone surrounds. His first known portrait, the one of Juan Arias de Saavedra, was set in one of these complex frames (see fig. 10) and the *Young Man* (see fig. 11) in a simpler one. Later, in the 1670s, the portraits of Nicolás Omazur (see fig. 21) and Isabel Malcampo (see fig. 22) were also inset in stone frames, more elaborate than what remains after the paintings were cut down. We know that other lost portraits by Murillo were probably painted within stone frames. One of these, possibly created in the mid-1660s, was the portrait of Diego Ortiz de Zúñiga, a nobleman from Seville who had written a history of the city and was a well-known historian.[80] In the sitter's will, in 1680, a "half-length portrait of Don Diego Ortiz de Zúñiga by Murillo" is recorded.[81] Two paintings in the town hall of Seville and at Penrhyn Castle in Wales (fig. 26) are likely to be copies of the lost original by Murillo. Once again, Murillo

seems to have placed the sitter's image within a fictive frame, held by two stone putti, with his family's coat of arms above and an inscription below.[82] But of all of these portraits, the only one in which Murillo used the idea of the hand resting on the frame, apart from the self-portrait, is the portrait of Isabel Malcampo (see fig. 22), where her left hand protrudes out of the frame and into our space. It seems that this was a conceit invented by Murillo in the late 1660s or early 1670s and applied for the first time in the National Gallery self-portrait. A portrait of Archbishop Ambrosio Spínola, which is known in three versions, adopts the same conceit of the protruding hand.[83] One of these (fig. 27) has been attributed to his pupil Pedro Núñez de Villavicencio.[84] The paintings are all dated 1670, and a print after it, by Richard Collin, of 1681, attributes the portrait of Spínola to Núñez de Villavicencio.[85] However, the 1687 inventory of the collection of Juan Arias de Saavedra, Marquis of Moscoso, lists "a portrait of señor Ambrosio, Archbishop of Seville, by Murillo."[86] It is possible that the original portrait of the archbishop was by Murillo and that other versions, on which the print was based, were painted by Núñez de Villavicencio. After all, the archbishop of Seville was one of the most important ecclesiastical figures in Spain, and the many versions of his portrait would have been used as gifts. Furthermore, no other portraits are known to have been painted by Núñez de Villavicencio. In any case, in about 1670, with the self-portrait and the portraits of Spínola and Malcampo, Murillo invented and used the conceit of the protruding hand in three portraits, if not more.

Where the idea for the hand came from is unclear. Susanne Waldmann astutely proposes that Jan van de Velde II's engraved portrait of Johannes Acronius (after a design by Frans Hals) and Rembrandt's etched portrait of Jan Cornelis Sylvius (fig. 28) could have provided prototypes known to Murillo.[87] Both show the sitters within oval frames with inscriptions, their hands projecting out of those frames. In the case of Sylvius, his head and hand protrude out of the pictorial space and cast shadows on the print itself. Northern prints had a wide circulation in Seville, and it is likely that Murillo knew the portrait of Sylvius or at least a similar print. Spanish printmakers, however, used similar visual solutions, such as, for example, Pedro de Villafranca's engraved portrait of José de Casanova of 1649 (fig. 29).[88] Murillo's self-portrait and his other portraits in which he used the protruding hand became particularly popular in Seville after 1670. A number of portraits by contemporary and later artists in the city—Juan de Valdés Leal and his son Lucas Valdés, among others—used the same conceit in the last thirty years of the seventeenth century.[89] A series of family portraits on the main staircase and upper floor of the Palacio de Lebrija in Seville, probably from the early eighteenth century, includes examples of sitters resting their hands on fictive stone frames remarkably similar to the one in the National Gallery self-portrait. Another portrait by a follower of Murillo, representing a boy of the Larra family (now at Kiplin Hall in Yorkshire), also shows the fifteen-year-old boy with a hand resting on the rather large and

Fig. 26. After Bartolomé Esteban Murillo, *Diego Ortiz de Zúñiga*, ca. 1665. Oil on canvas, 44 1/2 × 37 in. (113 × 94 cm). Penrhyn Castle, Wales, The Douglas Pennant Collection (National Trust)

Fig. 27. Attributed to Pedro Núñez de Villavicencio, *Ambrosio Spínola, Archbishop of Seville*, 1670. Oil on canvas, 35 1/2 × 25 5/8 in. (90.2 × 65.2 cm). Private collection

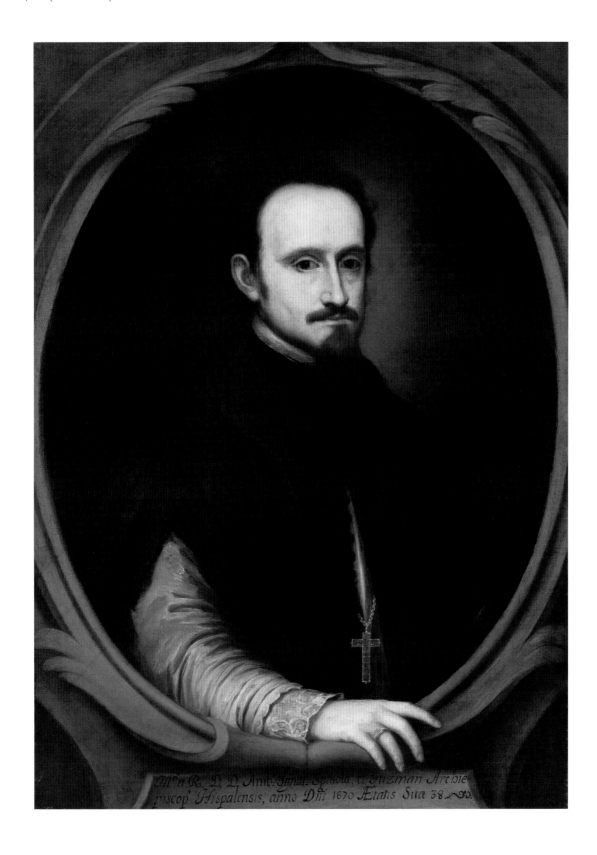

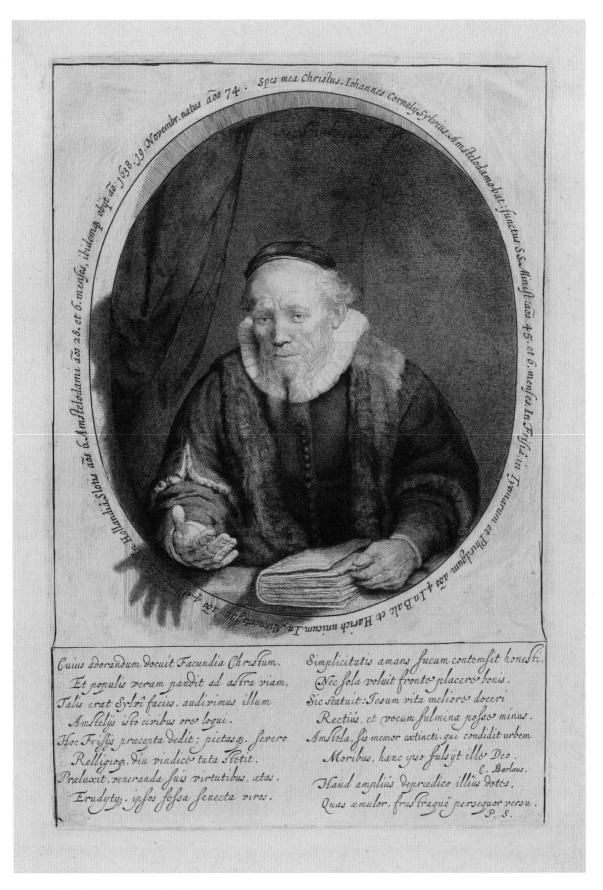

Fig. 28. Rembrandt van Rijn, *Jan Cornelis Sylvius*, 1646.
Etching, engraving and drypoint on paper, 11 × 7 3/8 in.
(27.8 × 18.8 cm). The Morgan Library & Museum, New York

monumental surrounding stone frame.[90] In 1857, Gustav Friedrich Waagen mentioned two portraits by Murillo in the collection of Lord Caledon in London.[91] He described the male portrait as the "portrait of a man in an oval, of very brown colour, but too high and darkly hung for an opinion." The companion piece was a "portrait of a lady of pretty features, and in rich dress. This hangs more favourably. It is of very transparent colouring, but, in my opinion, too empty in the forms and too smooth in touch for Murillo. It shows, however, a good Spanish painter, but one unknown to me." These two portraits (figs. 30, 31), traditionally believed—incorrectly—to represent the Count and Countess of Ávalos, are in fact signed by Cornelis Schut III, a Flemish painter active in Seville, and dated 1682. Both figures, again, project out of the sculptural frames, and their hands rest on the carved stone.[92]

Fig. 29. Pedro de Villafranca, *José de Casanova*. From *Primera Parte del Arte de Aserivir Todas Formas ole Letras* (Madrid: 1650). Engraving, 9 7/8 × 6 3/4 in. (25 × 17.3 cm). Biblioteca Nacional de España, Madrid

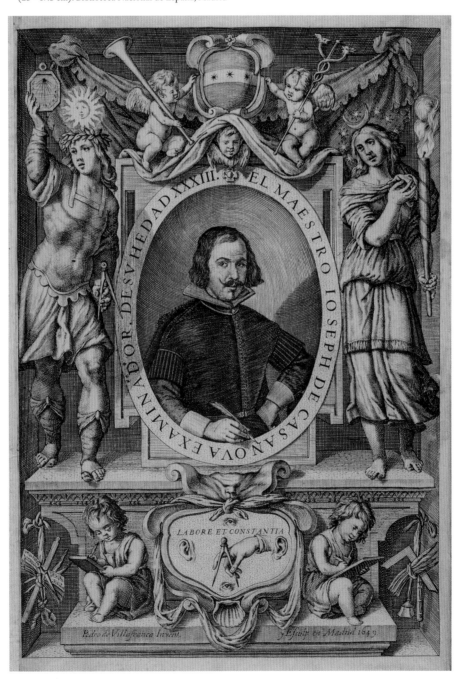

Murillo's Self-Portraits: A Sketch

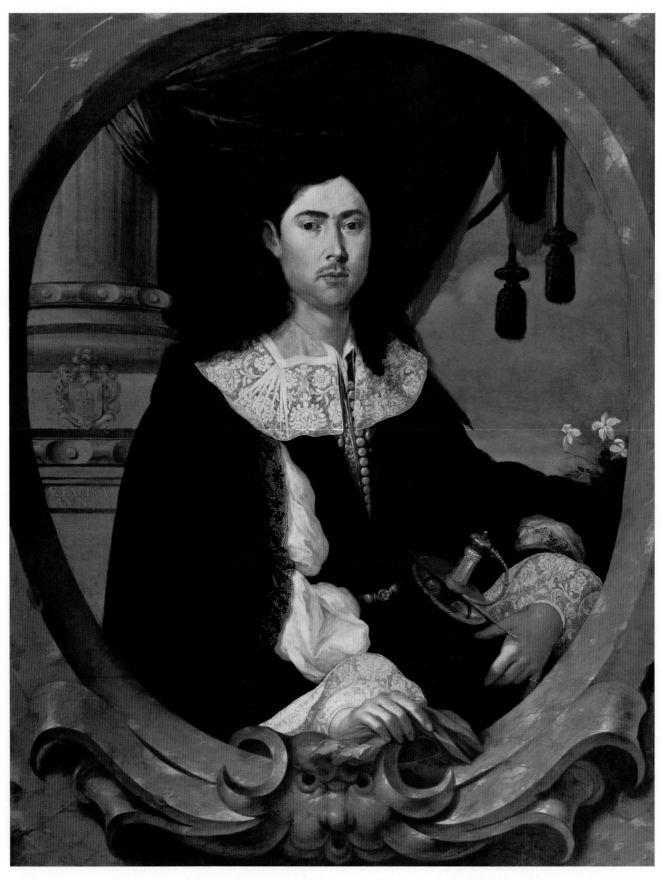

Fig. 30. Cornelis Schut III, *Portrait of a Gentleman*,
1682. Oil on canvas, 49 5/8 × 38 3/4 in.
(126 × 98.3 cm). Torrente Collection, Madrid

Fig. 31. Cornelis Schut III, *Portrait of a Lady*, 1682.
Oil on canvas, 49 3/4 × 38 7/8 in. (126.3 × 98.8 cm).
Private collection

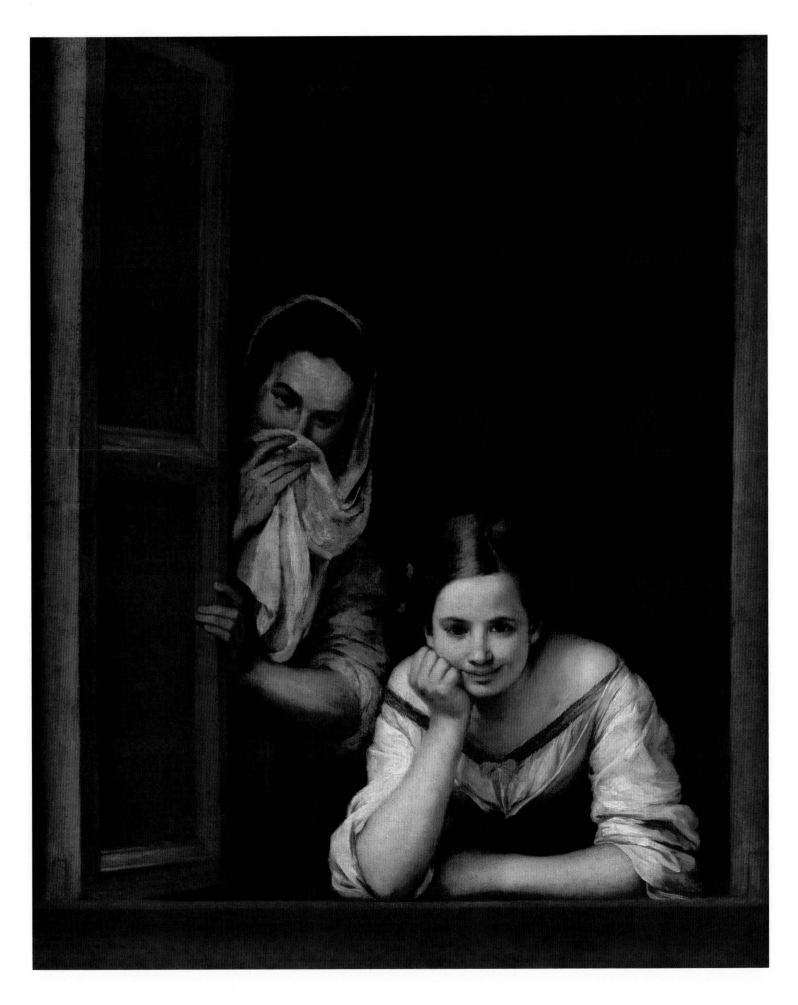

Fig. 32. Bartolomé Esteban Murillo, *Two Women at a Window*, ca. 1655–60. Oil on canvas, 49 1/4 × 41 1/8 in. (125.1 × 104.5 cm). National Gallery of Art, Washington (cat. 8)

Fig. 33. Rembrandt van Rijn, *Girl at a Window*, 1645. Oil on canvas, 32 1/4 × 26 in. (81.8 × 66.2 cm). Dulwich Picture Gallery, London

Fig. 34. Bartolomé Esteban Murillo, *A Peasant Boy Leaning on a Sill*, ca. 1675. Oil on canvas, 20 1/2 × 15 1/8 in. (52 × 38.5 cm). The National Gallery, London (cat. 9)

Fig. 35. Bartolomé Esteban Murillo, *Young Girl Lifting Her Veil*, ca. 1670–75. Oil on canvas, 20 5/8 × 15 1/2 in. (52.4 × 39.4 cm). Private collection

The protruding hand in Murillo's portraits and in the work of his followers dissolves the boundaries between art and reality, making the apparently distant sitters in the portraits closer to the viewer. It is as if Murillo in his self-portrait broke down notions of time and space, making his presence felt well beyond his death. That Murillo was interested in these frontiers—already explored by ancient painters such as Zeuxis and Parrhasius, according to many early and modern literary sources—is proven by a number of works in which he explored the possibilities of painting and representation through trompe l'oeil effects.[93]

The most important of these is *Two Women at a Window* (fig. 32), painted in the late 1650s.[94] One of the most celebrated—and mysterious—of Murillo's works, the canvas is devised as the space of a window. On the right and left are the jambs of the window and at the bottom its ledge. This lower part, about 9 centimeters, was added at a later stage, but the top portion of the ledge is part of Murillo's original concept. It is unclear if this added strip replaced something already painted by Murillo or was a new addition. The window opens onto an absolutely dark space, and at the left one of the window's shutters leads into that space. Within this neutral and timeless realm, Murillo places two female figures. The one on the left emerges from behind the wooden shutter, holding it with one hand and with the other covering (or uncovering) her face with a veil. The second woman leans on the window ledge with her elbows and leans onto her right hand, staring out at the viewer. The effect of these two emerging figures is exceptionally realistic. With almost full-size depictions, the painting places the viewer in front of an imagined window, somewhere between reality and fiction. The only factor that makes the painting less effective for a contemporary viewer is the seventeenth-century attire of the figures.

The two women have been identified in the first references to the painting as Gallegas—women from Galicia. Women from the northwest of Spain traveled to larger cities in the seventeenth century to carry out domestic chores in wealthy households. In the eighteenth and nineteenth centuries, the two women seem to have been typically identified as servants. In the literature, they are also invariably described as being of different ages, the foreground figure a young girl and the veiled woman the older one. However, it is clear that both figures are girls; the background figure is probably as young as the girl in the foreground, just more darkly painted to position her in shadow. What are these two women doing at the window? Are they servants? Early literature on this painting notes that it is charged with erotic connotations and that the two women may be prostitutes. The idea that the figure on the left would be an elder duenna is disproved

by close visual analysis of the painting. Both girls are meant to be young and pretty. Aristocratic or wealthy women in seventeenth-century Spain did not spend time at their windows, as these figures do. The way they so brazenly reveal themselves at the window and seem to interact directly with the presumably male viewer suggests that they are indeed prostitutes. A Spanish proverb from the period claims, "la mujer ventanera, uva de la calle" (a woman at the window, a grape of the street).[95]

We do not know for whom a painting such as this was destined or if it was meant to have an allegorical or moral meaning. Nor is it known how it would have been displayed in Murillo's day. But clearly the painting is designed to trick the viewer into an apparent vision of reality, one beyond the painted space. This trompe l'oeil tradition is a particularly northern one. In 1708, Roger de Piles described a painting he owned that may have been Rembrandt's *Girl at a Window* (fig. 33),[96] painted in 1645:

On one day, for example, Rembrandt amused himself by painting the portrait of his servant girl. He wanted to arrange it in front of the window, so that the passer-by should think that she herself was really to be found there. He succeeded, as the optical illusion was only discovered several days later. As one can imagine of Rembrandt, it was neither the beautiful design nor the nobility of expression that caused the effect. When I stayed in Holland, I was curious to see the portrait. The beautiful brushstrokes and strength made a great impression on me; I bought it, and at present it has an important place in my study.[97]

The concept behind the Rembrandt painting is similar to the one in the Murillo. No Spanish prototypes seem to exist for Murillo, and it is likely that the idea for his *Two Women at a Window* came from northern paintings.[98] Seville was populated by a large number of Dutch and Flemish merchants—Nicolás Omazur, for example—and paintings such as the Rembrandt could have been seen by Murillo in Seville.

Windows as devices for compositions appear again in Murillo's work later in his career, at the time of the National Gallery self-portrait and of the portraits of Omazur and Malcampo. In the mid-1670s, Murillo painted a small picture representing a single figure (fig. 34).[99] The canvas has been cut down but by how much is unclear; it was probably not much larger. A boy is shown at a window, his right arm and elbow leaning on a stone sill. He is similar to many of the street urchins depicted by Murillo in the previous decades. Dressed in ragged clothes, he leans over, and, like the girl in the *Two Women at the Window*, engages directly with the viewer. As

Fig. 36. Juan Martínez Gradilla, *King Philip IV of Spain*, 1666. Oil on canvas, 70 × 53 3/8 in. (180.5 × 135.6 cm). CSG CIC Glasgow Museums

PHILIPVS QVARTVS
HISPANIARVM
REX

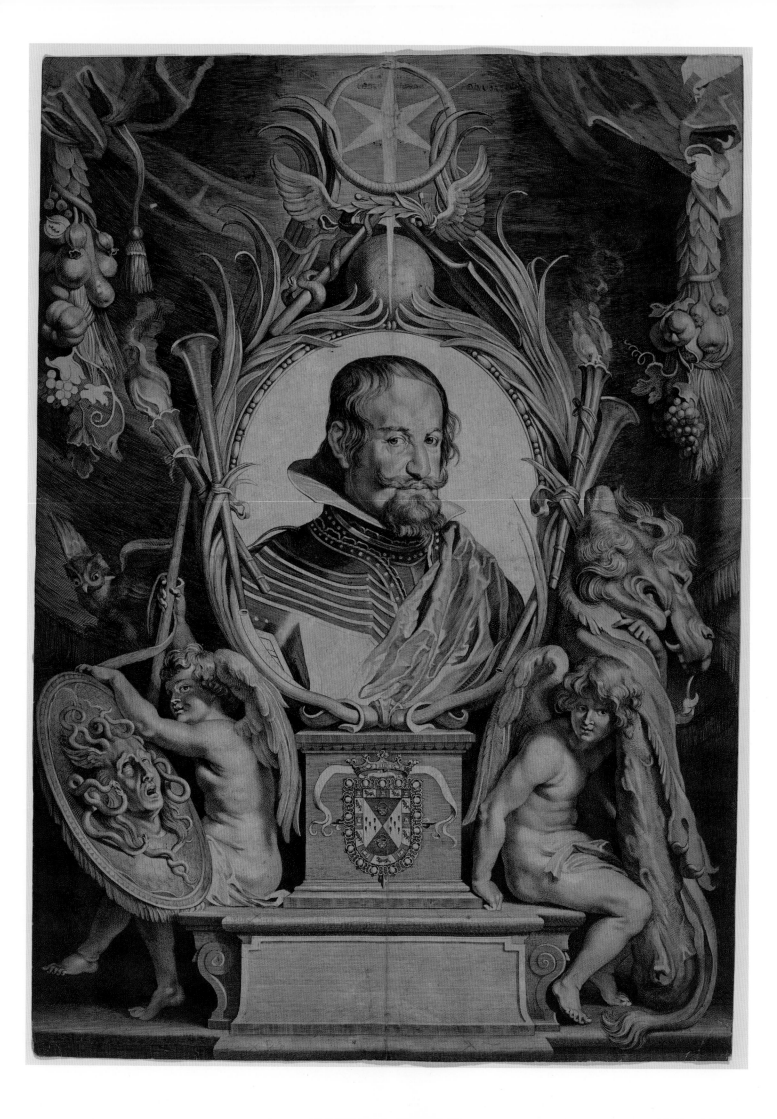

Murillo's hand in the National Gallery self-portrait implies a space beyond the surface of the painting, the boy's gaze is resolved only in relation to an object of desire outside the canvas. It has been suggested, and it is entirely possible, that this painting is the one that appeared in the sales of the collections of the Countess of Verrue in 1737 and of Randon de Boisset in 1774, where it was paired with a second canvas, also by Murillo.[100] This is the *Young Girl Lifting Her Veil* (fig. 35), which used to be in the Carras Collection in London.[101] The girl's costume is almost identical to those in *Two Girls at a Window*, and she lifts a veil akin to the one worn by the girl on the left in the other painting. She is attractive and smiles while lifting her veil. She may be a prostitute or just a peasant girl, whose eye has been drawn to the peasant boy. The boy is clearly smitten by her and beams across the boundaries of the two canvases. The two paintings are understood when seen together.

Murillo establishes a similar relationship between his other portraits and the viewer. The trompe l'oeil effects in his two self-portraits only make sense once admired by a viewer. Not only did Murillo, therefore, preserve his image for posterity twice, but he also cleverly played on the relationship between his audience—his children or an observer centuries later—and his own image. Murillo's hand in the National Gallery self-portrait does not simply project into space; it also reaches across the boundaries of time.

The Celebration of Fame

In 1666, the painter Juan Martínez Gradilla signed and dated his only known portrait (fig. 36). The canvas represents Philip IV, King of Spain, and was a gift from the painter to the Academia de Pintura in Seville.[102] The king is portrayed in an oval, within a stone frame. The stone frame is surrounded by fictive sculptures of putti holding various attributes of the art of painting and also includes dedicatory inscriptions. By the

mid-1660s, this type of frame had been used by Murillo on a number of occasions. His first known portrait, of Juan Arias de Saavedra (see fig. 10), had a similar frame. In 1981, Diego Angulo Íñiguez proposed that the portrait of Saavedra may trace its visual origins to the world of prints and book frontispieces.[103] Portraits such as Saavedra's and Martínez Gradilla's of Philip IV have clear prototypes and parallels in the print culture of the age.

Frontispieces of books in sixteenth-century Spain were mainly decorated with inscriptions inset in architectural elements. As printing techniques developed in the seventeenth century, these architectural designs started to surround portraits, and in books they were mainly images of the king.[104] Between the early 1640s and the mid-1660s, a number of frontispieces of books in Spain included portraits of Philip IV with architectural surrounds, often accompanied by inscriptions and allegorical figures. An early example is provided by a 1641 print by Juan de Noort, and between 1655 and 1665, Pedro de Villafranca y Malagón (appointed engraver of royal works in 1654) produced at least five different frontispieces for books with the royal portrait.[105] While most of these prints represented Philip IV, on occasion they could also portray aristocrats or ecclesiastical figures.[106] Martínez Gradilla's portrait of Philip IV derives from such sources, and the painter produced an enlarged and painted version of a frontispiece similar to those that were disseminated in books around Spain and Europe. Murillo's early portraits, those of Saavedra (see fig. 10) and Diego Ortiz de Zúñiga (see fig. 26) in particular, are also strictly linked to this visual world. The painters used a series of devices and architectural solutions that had been promoted through printmaking in the middle of the seventeenth century.

Many of the frontispieces and prints available to Murillo were not printed in Spain or by Spanish artists alone. Most prints that circulated in Spain in the seventeenth century were northern, and examples of portraits in this medium from 1610 to 1640 would have been available in Spain.[107] One of the most important prints portraying a Spanish subject in the first half of the seventeenth century was Paulus Pontius's allegorical portrait of the powerful minister of King Philip IV, Gaspar de Guzmán, Count-Duke of Olivares (fig. 37).[108] Produced in about 1626, the large print was based on a portrait of Olivares by Velázquez, and the surrounding frame and decorative and allegorical elements were instead designed by Rubens. The portrait of the minister is set in a complex frame, formed partly by palm branches, to which torches and trumpets are attached, to signify Olivares's fame. The print is accompanied by the sitter's coat of arms and inscriptions. Two winged genii sit at each side; the one on

Fig. 37. Paulus Pontius, after Diego Velázquez and Peter Paul Rubens, *Gaspar de Guzmán, Count-Duke of Olivares*, ca. 1626. Engraving on paper, 23 3/4 × 17 1/8 in. (60.3 × 43.6 cm). National Gallery of Art, Washington

Murillo's Self-Portraits: A Sketch

Fig. 38. Matías Arteaga y Alfaro, after Bartolomé
Esteban Murillo, *King Ferdinand III of Spain*, 1671.
Etching on paper, 17 3/8 × 9 in. (44 × 22.7 cm).
The British Museum, London

Fig. 39. Bartolomé Esteban Murillo, *Young Christ
as the Good Shepherd*, ca. 1665–70. Oil on canvas,
48 3/8 × 39 3/4 in. (123 × 101 cm). Museo Nacional
del Prado, Madrid

the left holding the spear and shield of Minerva (her owl flies above), and the one on the right supporting Hercules's lion skin and club. The objects at each side of the portrait present Olivares's wisdom and strength, attributes of Minerva and Hercules, respectively. While Pontius's print does not provide the specific example on which any of Murillo's portraits were precisely based, it must have been known to the artist. The palm branches in the portrait of Saavedra (see fig. 10) are not dissimilar to those in the Olivares engraving. The ambition of the design in Rubens and Velázquez must have appealed to Murillo. While no specific and exact print source has been found for any of Murillo's portraits, it seems that the painter drew on earlier precedents to devise his own designs for the surrounds of his paintings. Each one is different, and they all testify to Murillo's interest and engagement with frontispieces and prints.

Murillo's involvement with the print world resulted in a 1671 etching printed by Matías Arteaga y Alfaro, after Murillo's design (fig. 38).[109] This portrait of King Ferdinand III follows the model adopted by Murillo for half-length portraits. The image of the king is set within an oval, surrounded by an inscription identifying the sitter, and framed by palm branches. The portrait is encircled by putti, lifting a curtain and holding a large cartouche with an inscription. Evidently, when it came to memorializing sitters, both painting and print shared a visual language of celebration.

The Stones of Seville

Murillo's self-portraits, and many of his portraits, present the sitter as if he were, literally, "set in stone" for posterity. This is particularly evident in the stone block of the Frick self-portrait, chipped and scarred by time. When looking at Murillo's oeuvre in general, one is struck by the common presence of fragments and ruins in the backgrounds of his paintings. His *Young Christ as the Good Shepherd* (fig. 39), of about 1665–70, is set, with lamb and flock, in a broad landscape

with rolling hills and verdant pastures.[110] Christ sits on a bare rock, and behind him is a fragment of a marble entablature, with an egg-and-dart motif. Next to him, behind a ruined and overgrown wall is the fragment of an ancient column. Ruins occupy the background of many of Murillo's works. As we have seen, the Marquis of Legarda (see fig. 18) was placed, on his return from the hunt, within a landscape with fragmentary walls, an empty stone pedestal, and a large weathered and damaged stone, on which his family's coat of arms is carved. Both the young Christ and the marquis are set in a timeless world inhabited by the ravaged evidence of times past.

Murillo's street urchins are usually described as poor boys in the streets of Seville, but none are, in fact, ever represented in urban surroundings.[111] They occupy empty, barren rooms (see fig. 3) or are shown in front of rocky structures or ruined buildings (see fig. 4). They are usually set in the open countryside, with overgrown vestiges of the past behind them.[112] Timeless allegorical figures, such as the Seasons, are also depicted by Murillo in ruined landscapes. His *Summer* (fig. 40), painted for Justino de Neve in the early 1660s, portrays a handsome youth wearing a striped turban and sheaves of barley.[113] He presents the viewer with a basket containing fruit and vegetables. The basket rests on a rough stone ledge, similar to the one in the Frick self-portrait and the windowsill in *A Peasant Boy Leaning on a Sill* (see fig. 34). Behind the young man, to the right, is another ruined wall, overgrown and weather-beaten.

Murillo's interest in ruins and remnants of antiquity is not surprising. In the seventeenth century, Seville was known as a "New Rome," and its citizens were steeped in humanistic studies.[114] In Murillo's time, Seville—built on the Roman city Hispalis, which was said to have been founded by Hercules— was the main Spanish city that could boast prestigious ancient foundations. Only a few miles northwest of Seville are the ruins of Italica, one of the largest and most important cities of the Roman Empire and the birthplace of emperors Trajan and Hadrian. Even though Italica was not systematically excavated until the nineteenth and twentieth centuries, its location was known in the seventeenth century, and fragments from the city were collected in Seville. Throughout Seville, relics of its Roman past, and of Hispalis, would have been visible and known to Murillo. Most important, ancient marble columns of a destroyed Roman temple were visible in what is today's calle de Mármoles, in the parish of San Bartolomé, where Murillo lived between 1663 and 1681. Two of the six columns had been moved in the sixteenth century to the nearby Alameda de Hércules, where they still remain.

The aristocracy of Seville had been interested in archaeology and antiquity since the sixteenth century. Two of the

Fig. 40. Bartolomé Esteban Murillo, *Summer, as a Young Man with a Basket of Fruit and Vegetables*, ca. 1660–65. Oil on canvas, 40 1/8 × 32 1/8 in. (101.9 × 81.6 cm). Scottish National Gallery, Edinburgh

Fig. 41. Courtyard of the Casa de Pilatos, Seville

Fig. 42. Fragments of ancient inscriptions, Casa de Pilatos, Seville

most important private buildings in the city, the Casa de Pilatos and the Palacio de las Dueñas, were built in the first half of the sixteenth century by Fadrique Enríquez de Ribera, first Marquis of Tarifa, and by his brother Fernando, second Marquis of Villanueva del Río. These buildings, constructed with the income provided by the substantial wealth acquired by aristocratic families with the arrival of American gold, were magnificent dwellings in which the classical architectural language and Islamic style coexisted. Entering the Casa de Pilatos, the visitor encounters a large stone portal, built in 1529–33, that is adorned with inscriptions and medallions of emperors.[115] The courtyard of the house (fig. 41) is decorated with a series of ancient busts set in round niches and with full-length sculptures. Most of the archaeological collections of the Casa de Pilatos were added by a subsequent owner, Per Afán de Ribera, first Duke of Alcalá, who had been viceroy in Naples between 1559 and 1571 and who had sent to Spain one of the most impressive collections of ancient statuary of the time. These included not only sculpture but also fragments and inscriptions (fig. 42).

The busts around the courtyard of the Casa de Pilatos may have provided Murillo with the idea of setting his self-portraits and portraits within oval fictive stone frames. It seems that other buildings in Seville were decorated with similar busts in niches, such as, for example, the courtyard of the Casa de los Pinelo.[116] The idea of ancient figures set in oval niches was common in seventeenth-century Seville, and no doubt Murillo would have known many of the collections of antiquities in his hometown. The combination of half-length portraits in stone frames, with Latin inscriptions, was based not only on northern and Spanish print culture of the time but also on the antiquarian culture of Seville, a city where the past and the present shared the urban fabric more than in any other place in Spain at the time.

Many aristocrats in Seville collected ancient coins and medals in the seventeenth century, and these, with their portraits, were another type of ancient object that may have inspired Murillo.[117] One of the most interesting eyewitnesses to Murillo's interest in antiquity was the silversmith Salvador de Baeza, one of the painter's neighbors and presumably also a friend. Baeza recorded that, about 1667, Murillo happened to be at his house when Juan Ignacio de Alfaro y Aguilar,

knight of Puente de Don Gonzalo, stopped by to exchange for currency a number of gold and silver ancient Roman coins he had found. Baeza recalled, "As I was cognizant of the great affection he [Murillo] has for all things from Antiquity, I gave him some of the said Roman coins as a gift, for which he was enormously pleased."[118] This, the only evidence we have for Murillo's direct interest in antiquity, seems to suggest that the artist's love for archaeological finds was well known in Seville. Ancient sculptures, inscriptions, and coins were evidently familiar to Murillo and a source of inspiration for his art.

Both of Murillo's self-portraits are potent statements about his art. They celebrate the man and his artistic achievements and are powerful masterpieces with which to commemorate the four-hundredth anniversary of the artist's birth. Painted at different moments in his career, both were personal documents envisioned for his immediate circles and family. But they were more than simple gifts to his children. He was proud of his success and of his skills as an artist and produced the self-portraits for posterity: he painted them for us. Murillo wanted future generations to know what he looked like and who he was. His features are recorded in the paintings, and the way they are painted is a simple and effective witness to his talent. In creating these extraordinary statements, Murillo was inspired by ancient Roman art and by contemporary northern artists. He looked at flimsy prints in books that were produced to disseminate the image of the king, and he looked at the stone remnants from a very distant past. He united these and achieved a sense of reality and immediacy with his use of trompe l'oeil effects. Murillo wanted to make the invisible visible not only with his religious works but also with his portraits, and any viewer confronted with his self-portraits can feel the powerful presence of the artist in these works. By painting his self-portraits, Murillo defeated the inadequate length of his life. The stone frames may be battered and old, his clothes may be out of fashion, and the inscriptions may be in a language not as easily understood as it once was. But with his eyes and his art—and his hands—Murillo reached into the future, to us.

Notes

1 "Hizo también su retrato a intancia de sus hijos (cosa maravillosa) el cual está abierto en estampa en Flandes por Nicolás Amazurino; y el otro de golilla quedó en poder de Don Gaspar Murillo, hijo suyo"; Palomino 1986, 293, translated in Palomino 1987, 283.

2 "Itt. otro lienzo del retrato de Dn. Bartholome Murillo con su letrero abaxo y su moldura dorada toda en trescientos rs. V. 300. Itt. otro lienzo retrato de dcho. Dn. Bartholome Murillo hecho por el mismo de bara y tercia con su moldura de juguetes dorados y media caña picada en trescientos y setenta y cinco reales V. 375"; Montoto 1945, 349.

3 For Murillo's Seville, see Dominguez Ortiz 1983; Valdivieso 2010, 28–32.

4 For Murillo's life, see, in particular, Angulo Íñiguez 1981, 1: 3–97; Stratton-Pruitt 2002; Valdivieso 2010, 15–23.

5 Stratton-Pruitt 2002, 16; Valdivieso 2010, 16.

6 "Y después de haber aprendido, lo que bastaba, para mantenerse pintando de feria (lo cual entonces prevalecía mucho) hizo una partida de pinturas, para cargazón de Indias … y aunque algunos autores extranjeros (como Joaquín de Sandrart, y otro italiano) han dicho que pasó a las Indias cuando mozo, y después a Italia, estuvieron mal informados; pues con exacta diligencia he investigado este punto de sujetos muy ancianos, y de toda excepción, intimos suyos, y tal cosa no hubo … que pasó a Indias, fue su hijo Don José Murillo, sujeto de gran habilidad en la Pintura, y de mayors esperanzas, y allá murió bien mozo"; Palomino 1986, 290–91, translated in Palomino 1987, 280–81.

7 See Beatriz's will, in Montoto 1945, 330–31.

8 "Fue también nuestro Murillo tan honesto, que podemos decir que de pura honestidad se murió; pues estando subido en un andamio, para pintar un cuadro muy grande de Santa Catalina, que haciá para el Convento de Capuchinos de la ciudad de Cádiz, tropezó al subir del andamio; y con occasion de estar él relajado, se le salieron los intestinos; y por no manifestar su flaqueza ni dejarse reconocer, por su mucha honestidad, se vino a morir de tan inopinado accidente el año de 1685, a los setanta y dos, poco más, de su edad"; Palomino 1986, 294, translated in Palomino 1987, 284.

9 For the cycle, see Angulo Íñiguez 1981, 2: 3–18, cats. 1–13; Gerard Powell and Ressort 2002, 208–11; Stratton-Pruitt 2002, 16–17; Cano Rivero 2009; Odile Delenda in Bilbao / Seville 2009, 211–45; Valdivieso 2010, 49–59, 259–71, cats. 6–16.

10 For Murillo's paintings of street urchins, see, in particular, London / Munich 2001. For the two paintings, see Angulo Íñiguez 1981, 2: 301–4, cats. 387, 390; Xanthe Brooke and Peter Cherry in London / Munich 2001, 86–89, cats. 4–5; Gerard Powell and Ressort 2002, 198–202; Claudie Ressort in Bilbao / Seville 2009, 246–51, cat. 12; Benito Navarrete Prieto in Bilbao / Seville 2009, 252–57, cat. 13; Valdivieso 2010, 532–35, cats. 381, 384.

11 For the painting, see Angulo Íñiguez 1981, 2: 238–39, cat. 284; Valdivieso 2010, 115–16, 324–25, cat. 87.

12 Palomino 1986, 280.

13 For Murillo and Justino de Neve, see Madrid / Seville / London 2012–13.

14 For Murillo's lunettes for Santa María la Blanca, see Angulo Íñiguez 1981, 2: 41–45, cats. 39–42; Gerard Powell and Ressort 2002, 188–90; Valdivieso 2010, 120–26, 360–65, cats. 140–43; Gabriele Finaldi in Madrid / Seville / London 2012, 102–13, cats. 3–6.

15 For the paintings at San Agustín, see Angulo Íñiguez 1981, 2: 35–39, 53–58, cats. 33–38, 55–58; Valdivieso 2010, 127–32, 386–87, cats. 176–79. For the Capuchinos, see Angulo Íñiguez 1981, 2: 59–76, cats. 59–79; Valdivieso 2010, 133–49, 388–405, cats. 180–202.

16 For the paintings in the Hospital de la Caridad, see Angulo Íñiguez 1981, 2: 77–92, cats. 80–87; Valdivieso 2010, 147–56, 410–21, cats. 215–27.

17 Palomino 1986, 291, translated in Palomino 1987, 283.

18 For the painting, see Angulo Íñiguez 1981, 2: 151–52, cat. 152; Valdivieso 2010, 520–21, cat. 359.

19 "En retratos fue también eminente"; Palomino 1986, 293, translated in Palomino 1987, 283.

20 "No es el retrato el género donde Murillo aporta verdaderas novedades a la pintura del siglo XVII"; Angulo Íñiguez 1981, 1: 459.

21 For Murillo and portraiture, see, in particular, Angulo Íñiguez 1981, 1: 459–71; Valdivieso 2010, 241–51.

22 Valdivieso 2010, 251.

23 For the bibliography on this painting, and on Saavedra, see cat. 3 on the exhibition checklist. The portrait has been very little known and often confused with an identical, later, copy, in the palace of the Marqués de Viana, in Córdoba, now the headquarters of the Cajasur Foundation.

24 Duffy-Zeballos 2007, 149–50.

25 For the almost nonexistent bibliography on this painting, see cat. 4 on the exhibition checklist.

26 Angulo Íñiguez 1981, 1: 127.

27 For the portrait, see Curtis 1883, 300–301; Mayer 1923, 226, 293; Angulo Íñiguez 1981, 2: 331–32, cat. 422; Valdivieso 1990, 216; Valdivieso 2010, 247, 560, cat. 410.

28 It is impossible to determine the exact color of the cross. If green, it would be the order of Alcántara; if red, that of Calatrava.

29 For the portrait, see Angulo Íñiguez 1981, 2: 317–18, cat. 409; Valdivieso 1990, 216; Martínez del Valle 2010, 158; Valdivieso 2010, 247, 561, cat. 411.

30 For the portrait, see Angulo Íñiguez 1981, 2: 330–31, cat. 421; Valdivieso 1990, 223; Martínez del Valle 2010, 159; Valdivieso 2010, 561, cat. 412.

31 For the portrait and the sitter, see Mayer 1923, 234; Angulo Íñiguez 1981, 2: 332, cat. 423; Valdivieso 1990, 218; Gerard Powell and Ressort 2002, 214–16; Martínez del Valle 2010, 160; Valdivieso 2010, 246–47, 562, cat. 413.

32 For the bibliography on the drawing, see cat. 5 on the exhibition checklist.

33 For the other four drawings, see Mena Marqués 2015, 200–203, 216–17, 220–23, cats. 28, 32, 34, 35.

34 For the portrait and the sitter, see Carande 1972, 213–14; Gaya Nuño 1978, 92, cat. 68; Angulo Íñiguez 1981, 1: 459, 2: 313–14, cat. 405; Valdivieso 1990, 216; Suzanne L. Stratton-Pruitt in Fort Worth / Los Angeles 2002, 90, 92, 188–90, cat. 34; Martínez del Valle 2010, 163; Valdivieso 2010, 247, 562–63, cat. 414.

35 Stirling 1848, 2: 919.

36 For the portrait and the sitter, see Gaya Nuño 1978, 91, cat. 60; Angulo Íñiguez 1981, 1: 462–63, 2: 318, cat. 410; Valdivieso 1990, 218; Martínez del Valle 2010, 169; Valdivieso 2010, 248–50, 564–65, cat. 416.

37 "Como lo testifica el Don Faustino de Nebes, Canónigo de Sevilla, que por su muerte lo dejó en los Venerables, que es extremo de lo parecido, y bien pintado. Pero sobre todo, a una perrilla inglesa que tiene junto a sí, la suelen ledrar los perros, y ella parece, que los quiere embestir, y se extraña, que no les ladre, según parece estar viva"; Palomino 1986, 293, translated in Palomino 1987, 283.

38 For the portrait, see Mayer 1923, 229, 293; Gaya Nuño 1978, 94, cat. 86; Braham 1980; Angulo Íñiguez 1981, 1: 463–65, 2: 325–26, cat. 415; Valdivieso 1990, 219; Martínez del Valle 2010, 164; Valdivieso 2010, 248–49, 566–67, cat. 417; Gabriele Finaldi in Madrid / Seville / London 2012–13, 96–98, cat. 1.

39 "praecirca obsequium desiderio pingebat" (painted this with the intention of making a gift).

40 For the most comprehensive study on Justino de Neve and Murillo, see Madrid / Seville / London 2012–13. On the exhibition, see also Brooke 2012 and Salomon 2013.

41 For the portrait and the sitter, see Mayer 1923, 232; Angulo Íñiguez 1981, 1: 465, 2: 314–15; cat. 406; Valdivieso 1990, 219; Duffy-Zeballos 2007, 166; Martínez del Valle 2010, 166; Valdivieso 2010, 242–43, 568, cat. 419.

42 For the most up-to-date biography of Omazur, see Kinkead 1986. Most sources, even recently, confuse Nicolás Omazur with his father, also called Nicolás, and provide inaccurate biographical data. The Nicolás who was born in either 1603 or 1609, and in 1629 married Susannah Belens, was the father of the Nicolás portrayed by Murillo; see Kinkead 1986, 132.

43 Kinkead 1986, 135. Isabel is often mentioned as being Sicilian and the couple's marriage placed about 1665 in Sicily. This was repeated until recently (see, for example, Valdivieso 2010, 245) but is wrong.

44 This date is also often mistakenly given as Nicolás's death date.

45 Kinkead 1986, 135.

46 For Omazur's collection, see Kinkead 1986.

47 "19–20. Yten dos retratos el uno del dho Dn Nicolas Omazur, y el otro el de la dha Da Ysavel Malcampo su mugger ambos orijinales del dho Murillo"; Kinkead 1986, 139.

48 "39–40. Yten dos lienssos de a bara y media de alto y bara y quartta de ancho con molduras dorados embuttidas de Piedras pintados los retrattos del dho Don Nicolas Omazur y a Da Ysavel Malcampo su primera mugger originales del dho Murillo"; Kinkead 1986, 142.

49 Céan Bermúdez 1806, 105–6.

50 For the Prado portrait, see the bibliography in cat. 6 on the exhibition checklist. For the private-collection portrait, see Céan Bermúdez 1806, 105–6; Stirling 1848, 2: 899; Lefort 1892, 94; Montoto 1932, 212; Pollok House 1967, 56, cat. 115; Gaya Nuño 1978, 108, cat. 244; Angulo Íñiguez 1981, 1: 452, 465–71, 2: 319, cat. 411; Sanz 1982, 119–20; Harris 1982a, 767; Kinkead 1986, 132, 135–36, 139, 142; Valdivieso 1990, 220–22; Valdivieso 2002, 130; Valdivieso 2003, 360; Martínez del Valle 2010, 157–58; Valdivieso 2010, 243–45, 569, cat. 421. Another portrait of Omazur, dated 1667, from the circle of Murillo, was sold at Christie's, London, on July 7, 2006, lot 148. This could be a copy after a lost original by Murillo.

51 Most sources recognize the private-collection painting as a copy after Murillo. But, most recently, Valdivieso (2002, 130; and 2010, 245, 569, cat. 421) suggests that it could be an original painting by Murillo or by his workshop. The current owners of the portrait have not allowed the authors of this book to examine the work; therefore our knowledge of the painting is purely based on photographs.

52 Pollok House 1967, 56, cat. 115. Puzzlingly, the painting is not mentioned by Stirling in the edition of his *Annals* of 1848. A note in the archives of Pollok House reads as follows: "Note by Sir William Stirling Maxwell–London July 31, 1847. I bought this picture thro' Mr. Salva, the Spanish bookseller in Paris, from a widow lady whose husband had purchased it or inherited it from the collection of Don Bernardo Iriate at Madrid. Buying for £15, without seeing it, I supposed it might be the portrait of Dona Isabel Malcampo painted by Murillo which existed in that collection and is described by Cean Bemander in his CARTA, p. 105. If not the original it is probably a copy of that picture." I would like to thank Pippa Stephenson for alerting me to this text.

53 Only a thorough examination of the painting and comparison with the Prado portrait will answer these questions once and for all.

54 It would be interesting to know, from examination, if the private-collection painting was also cut down, which would suggest that it was the original companion to the Prado painting.

55 One *vara* is about 84 cm.

56 Céan Bermúdez 1806, 105–8.

57 "sobre el retrato de Omazurino y entre el adorno que le rodea se lee . . ."; Céan Bermúdez 1806, 106n. 6.

58 "debaxo del mismo retrato . . ."; Céan Bermúdez 1806, 106n. 6.

59 "Y en el zócalo, sobre que descansa el óbalo del retrato, está la inscripcion siguiente: 'Nicolai Omazurini Antuerpiensis effigiem simulque tuam futuram spectas ipsius enim mortis velatam nunc faciem circumferimus, etsi diversissima sit nostri aspectus delineatio, tamen in uno omnia omnium claunduntur osa terrae alvo. Quid ultra? si sinus universae matris ortum, et occasum pro prolis retinet; sed haec omnia in uno Bartholomei Murillij opera exprimuntur. Hispali anno Dñi. M.DC.LXXII'" (And in the socle, over which is the oval of the portrait, is the following inscription: 'You are looking at the image of Nicolás Omazur of Antwerp and at the same time at your own future image, as we uncover the hidden aspect of death itself. Even if our appearance is completely different, nevertheless the bones of all of us are sealed in the same womb of the earth. And what more? If the womb of the universal mother contains the beginning and the end of posterity; but all these concepts are expressed in one work

of Bartolomé Murillo. Seville, in the year of the Lord 1672'); Céan Bermúdez 1806, 106–7n. 6.

60 "Rus amo (ait Omasur) licet malum, dum spinis nascitur rosa. Sed hei! Brevitatis humanae vitae insignia. De altera flore, Musa sile, locuente ipsa pictura Dominam Elizabetham Malcampo hic adesse. Illus ergo divinus Apollo, non Apellis, sed Murilij tabellam laudat, quae artem lineis, virtutem labore, comnubij pacem oliva, vitam rosa, morten spina, et haec omnia in uno (quasi ictu oculi) admirari docet. Ita conjux Coningi: anno MDCLXXIV" (I love the countryside [says Omazur] even when hostile, but even a rose is born with thorns. But, hey! These are the signs of the brevity of human life. Oh Muse, keep silent on the other flower, since the painting itself reveals the presence of Lady Isabel Malcampo. Thus, the divine Apollo praises not Apelles' but Murillo's painting, which teaches how to admire art in the lines, virtue in the labor, conjugal peace in the olive branch, life in the rose, death in the thorns, and all these things almost at once. Thus, to his wife from Koninck: in the year 1674); Céan Bermúdez 1806, 107–8n. 6.

61 The text is in fact from Job, 14: 2 (not Job, 10: 4, as stated in the inscription).

62 For the portrait and the sitter, see Mayer 1923, 242; Gaya Nuño 1978, 114, cat. 315; Angulo Íñiguez 1981, 2: 319–20, cat. 412; Enrique Valdivieso in London 1983, 196, cat. 77; Valdivieso 1990, 222; Martínez del Valle 2010, 168; Valdivieso 2010, 250, 571, cat. 424; Javier Portús in Madrid 2012, 156–57, cat. 19; Fernando Checa in Dallas 2016, 96, 98, 339, cat. 44.

63 AETATIS SVAE VIGESSIMO / QVINTO AN. 1680

64 Calvert 1908, 60.

65 "Y el otro de golilla quedó en poder de Don Gaspar Murillo, hijo suyo"; Palomino 1986, 293, translated in Palomino 1987, 283. The English translation of the passage mistakes Gabriel with Gaspar.

66 "Itt. otro lienzo del retrato de Dn. Bartholome Murillo con su letrero abaxo y su moldura dorada toda en trescientos rs. V. 300"; Montoto 1945, 349.

67 "Itt. otro lienzo retrato de dcho. Dn. Bartholome Murillo hecho por el mismo de bara y tercia con su moldura de juguetes dorados y media caña picada en trescientos y setenta y cinco reales V. 375"; Montoto 1945, 349.

68 For the bibliography on the self-portrait, see cat. 1 on the exhibition checklist. Recently, Javier Portús (Madrid 2016, 155; and Seville 2016, 81) has dated the self-portrait to about 1660. I find this dating too late on a stylistic basis. The portrait should be dated to the previous decade and before the 1658 trip to Madrid.

69 See Dorothy Mahon and Silvia A. Centeno's essay in this publication (p. 116).

70 For the deterioration of the blue smalt pigment, see also Dorothy Mahon and Silvia A. Centeno's essay in this publication (p. 116).

71 The inventory is transcribed in Montoto 1945, 322–29; Angulo Íñiguez 1981, 1: 163–67.

72 "Un rettratto de Dn Bartholome murillo su padre con su moldura dorada"; Gabriele Finaldi and Peter Cherry in Madrid / Seville / London 2012–13, 100, 166.

73 "Yten dos rretratos el uno de morillo y el otro de Juan marttinez montañez yguales Con ssus molduras dorados que tiene ciette quarttas de largo cada uno"; Peter Cherry in Madrid / Seville / London 2012–13, 163.

74 "Hizo también su retrato a intancia de sus hijos (cosa maravillosa) el cual está abierto en estampa en Flandes por Nicolás Amazurino"; Palomino 1986, 293, translated in Palomino 1987, 283.

75 For the bibliography on this self-portrait, see cat. 2 on the exhibition checklist.

76 Waldmann 2007, 151–56.

77 For the bibliography on the print, see cat. 7 on the exhibition checklist.

78 Sandrart 1683, 396.

79 "Otro de mas edad y con Valona pasó á Flándes, donde grabáron por él una Buena estampa, que conservo"; Ceán Bermúdez 1800, 55; repeated with a few adjustments in Ceán Bermúdez 1806, 104–5.

80 For the portrait, see Angulo Íñiguez 1981, 2: 328, cat. 417; Valdivieso 1990, 223; Duffy-Zeballos 2007, 151–52; Martínez del Valle 2010, 156; Valdivieso 2010, 251.

81 "Un retrato de medio cuerpo de Don Diego Ortiz de Zúñiga de mano de Murillo"; Angulo Íñiguez 1981, 2: 328.

82 The inscription, identifying the sitter, is present in the Seville copy but not in the Penrhyn Castle one.

83 The first of these three portraits is in the Musée Calvet, Avignon. The other two—in private collections—came up at auction at Christie's, London, December 16, 1998, lot 157, and at Sotheby's, London, July 10, 2008, lot 195.

84 This is the painting that last appeared at auction in 2008. See note 81.

85 For the portrait and the print, see Angulo Íñiguez 1981, 2: 329–30, 577–78, cat. 419; Martínez del Valle 2010, 174–75; Valdivieso 2010, 251.

86 "Un retrato del señor D. Ambrosio Arzobispo de Sevilla de mano de Morillo"; Angulo Íñiguez 1981, 2: 329.

87 Waldmann 2007, 152; Gabriele Finaldi in Madrid / Seville / London 2012–13, 99.

88 For the link between Pedro de Villafranca's engraving and Murillo, see Javier Portús in Madrid 2016, 159–60; Javier Portús in Seville 2016, 57.

89 For examples by these two artists, see Martínez del Valle 2010, 183, 188.

90 Angulo Íñiguez (1981, 2: 566, cat. 2759) misreads the surname as "Farra" instead of "Larra." I would like to thank Véronique Gerard Powell for identifying this portrait and making me aware of it. The portrait will be published in Gerard Powell and Ressort forthcoming.

91 Waagen 1857: 151.

92 Both paintings appeared on the market recently and are in different private collections. The male portrait was sold at Alcalá Subastas, Madrid, December 17–18, 2014, lot 803. The female portrait was sold at Christie's, London, July 9, 2014, lot 164. I would like to thank José Luis Colomer for drawing my attention to these two portraits.

93 For a recent, thorough discussion of Murillo's self-portraits in these terms and for the broader Spanish context, see Javier Portús, "Apologías de la pintura en el Siglo de Oro. El rostro del arte," in Madrid 2016, 95–163.

94 For the bibliography on the painting, see cat. 8 on the exhibition checklist.

95 A connection between the proverb and the painting was first made by Xanthe Brooke and Peter Cherry in London / Munich 2001, 98.

96 For the painting, see, most recently, Xavier F. Salomon in New York 2010b, 34–37, cat. 3; Jonker and Bergvelt 2016, 165–68.

97 De Piles 1708, 3.

98 For Murillo's Netherlandish sources, see, in particular, Peter Cherry in London / Munich 2001, 19.

99 For the bibliography on the painting, see cat. 9 on the exhibition checklist.

100 For the pair, see Soria 1948.

101 For the painting, see Angulo Íñiguez 1981, 2: 306–7, cat. 396; Xanthe Brooke and Peter Cherry in London / Munich 2001, 120–21, cat. 20; Valdivieso 2010, 231–32, 547, cat. 398.

102 Martínez del Valle 2010, 178–79; Javier Portús in Madrid 2016, 100–102.

103 Angulo Íñiguez 1981, 1: 459.

104 For a survey of illustrated frontispieces in Spain, see Garcia Vega 1984. And for books and libraries in the seventeenth century in Spain, see Noble Wood, Roe, and Lawrance 2011.

105 McDonald 2012, 116. For these prints and their illustrations, see Garcia Vega 1984, 2: cats. 2214, 2466, 2480, 2487, 2489, 2495.

106 An example of a similar portrait of an ecclesiastical figure is the frontispiece with the portrait of Toribio Alfonso Mogrovejo by Pedro de Villafranca of 1653; see Garcia Vega 1984, 2: cat. 2463.

107 For foreign prints in Spain, see Blas, de Carlos Varona, and Matilla 2011. Particularly fitting examples include the print by Cornelis Boel of Henry Frederick Prince of Wales (ca. 1611); that of Juan de Vourbes of Mary Queen of Scots (1627); the ones by Juan de Courbes of Lope de Vega (1630), Bernabé Moreno de Vargas (1633), and Juan Pérez de Montalbán (1638); the one by Martin Droeshout of Juan Pérez de Montalbán (1639); the two by Herman Panneels of Philip IV (1638) and of the Count Duke of Olivares (1638); and the one by Pedro Perete of Philip IV (1636). For these prints, see Blas, de Carlos Varona, and Matilla 2011, 236–38, 357–58, 385–86, 396, 425, 461–62, 590–91, 634–35, cats. 243, 431, 483, 503, 556, 616, 829–30, 900.

108 For the print, see McDonald 2012, 118.

109 Valdivieso 2010, 479, cat. 310; McDonald 2012, 161; Javier Portús in Madrid 2016, 111.

110 For the painting, see Angulo Íñiguez 1981, 1: 437, 2: 185–87, cat. 202; Valdivieso 2010, 432–33, cat. 242.

111 For a thorough study of Murillo's genre scenes, see London / Munich 2001.

112 For examples of such paintings, see Valdivieso 2010, 536, 542–46, 550–57, cats. 385–86, 392–94, 396, 401–6.

113 For *Summer*, see, most recently, Xavier Bray in Madrid / Seville / London 2012–13, 125–29, cat. 12.

114 For Seville, and antiquity, see Seville 2008; Lleó Cañal 2012.

115 Lleó Cañal 2012, 44.

116 Ibid., 52.

117 Ibid., 55, 86.

118 "Yo sabidor de la grande afizion que tiene a todas las cosas de la Antiguedad, fizile merced de algunas de las dichas monedas romanas por lo qual tuvo gran contentamiento"; Angulo Íñiguez 1981, 1: 102–3; Ignacio Cano Rivero in Bilbao / Seville 2009, 190, 519.

Murillo's Self-Portraits: A Sketch

"An Arsenal of Passions": The Frick Self-Portrait from Seville to Manhattan

Xavier F. Salomon

In the mid-1760s, Catherine the Great commissioned the architect Yuri Velten to design a two-story building adjacent to the Winter Palace in St. Petersburg. Immediately after, in 1767–69, she had the French architect Jean-Baptiste Vallin de la Mothe build a pavilion next to it, on the river Neva. Linked together by a garden, the two buildings became known as the Small Hermitage, destined to house the empress's art collections.[1] The ceilings of the galleries were later decorated with stucco roundels that depicted the celebrated artists represented in Catherine's collection, Bartolomé Esteban

Murillo among them. The anonymous artist responsible for the design of the roundels portrayed Murillo in profile and wearing a painter's cap (fig. 43), beardless and looking like a Russian peasant; clearly, he had no idea what the painter looked like. While paintings by Murillo had reached Russia by that time and the Spanish artist was considered important enough to have his portrait included among the painters collected by Catherine the Great, apparently his image had not yet traveled as far. The knowledge of Murillo's likeness is tied to the whereabouts of the two self-portraits and the circulation of prints after them.

The two self-portraits were documented in the inventory of the possessions of Murillo's son, Gaspar, dated May 15, 1709, shortly after his death, but their location after that is unknown. The National Gallery self-portrait seems to have been in Seville for a relatively short time after Gaspar's death; by 1729, it was in London.[2] Through the Collin prints after it (see fig. 67), this image became, for a time, the canonical likeness of the painter. The whereabouts of the Frick self-portrait for most of the eighteenth century is unclear.

In his *Diccionario Histórico* of 1800, the art historian and literary figure Juan Agustín Ceán Bermúdez described the Frick self-portrait as belonging to Bernardo de Iriarte (1735–1814), in Madrid.[3] A prominent political and cultural figure in the Spanish capital at the turn of the nineteenth century, Iriarte was director of the Council of the Indies and in 1797 was named Minister of Agriculture and Commerce by King Charles IV.[4] He was also the Vice-Protector of the Academia de San Fernando and a good friend of Goya, who painted his portrait in 1797 (fig. 44). With his brother Tomás, a well-known poet, Iriarte maintained an impressive library and collected works of art, owning not only the Frick self-portrait but also two other portraits by Murillo, those of Nicolás Omazur and Isabel Malcampo (see figs. 21 and 22). Where Iriarte acquired these paintings, whether in Madrid or in Seville, is not known. The Frick self-portrait was engraved, presumably for the first time, in 1790, by the printmaker Manuel Alegre (1768–1815) (fig. 45).[5] In the inscription below the print, Alegre states that he had been awarded a prize by the Academia de San Fernando, in 1790, for the print. He also asserts that the self-portrait was at the time in the collection of Bernardo de Iriarte. Iriarte had lent the portrait to the Academia so that young engravers could copy it.[6] An unpublished drawing, possibly by Alegre, relating to the print (fig. 46) is also conserved in Seville, at the Fundación Fondo de Cultura de Sevilla (Focus), but whether this is a drawing after the print or a preparatory work is uncertain. Below the drawing, which is the same size as the print and executed in black chalk, the part of the print with

the inscription identifying Murillo has been attached. The inscription, however, lacks Alegre's signature or the text locating the self-portrait in Iriarte's collection. It could therefore have been a proof Alegre made to see how the image and text worked together before he printed the full image with the additional texts. Instead of the trompe l'oeil stone frame around Murillo's self-portrait, Alegre reproduced his portrait in an oval.

When Iriarte's possessions were sold in 1806, the self-portrait was acquired in Madrid by Francisco de la Barrera Enguídanos. When the collector died, in 1832, the canvas was purchased for 1,000 pounds by Julian Williams, the English vice-consul in Seville, and it returned briefly to the Andalusian city before it was purchased for King Louis-Philippe of Orléans, who ruled France from 1830 to 1848. From a young age, the king had a taste for Spain and for Spanish art, and he commissioned an agent, the half-English, half-Belgian Isidore-Justin-Séverin Taylor (fig. 47)—who in 1825 had been made Baron Taylor—to acquire a large number of Spanish paintings for the Louvre.[7] Baron Taylor traveled to Spain between October 1835 and April 1837. About four hundred forty paintings, the result of his travels to Castille and Andalusia, were displayed in the Galeries de la Colonnade at the Louvre, which opened to the public on January 7, 1838, and became known as the Galerie Espagnole.[8] For a short period between the Napoleonic plunder from Seville in the 1810s, when many of Murillo's masterpieces left their original locations and reached the rest of Europe, and Baron Taylor's purchases in the 1830s, Paris was one of the most important European centers for the collection of Spanish paintings. Five of the canvases acquired by Baron Taylor for King Louis-Philippe came from the collection of Julian Williams in Seville, and among them was Murillo's self-portrait, which was purchased in 1836 for 2,500 *duros*.[10] King Louis-Philippe's and Baron Taylor's interest in Murillo is further testified to by Taylor's plan in the 1830s and 1840s, presumably on the king's orders, to erect a monument to the painter in the Cathedral of Seville.[11]

During the ten years the self-portrait was displayed in the Galerie Espagnole, it was among the most well-known works by Murillo in France, its fame demonstrated by references to it in art and literature. In 1837–41, Paul Delaroche painted a large mural in the hemicycle of the École des Beaux-Arts of Paris that depicted celebrated artists from antiquity to the modern age.[12] In it, squeezed among Paolo Veronese, Antonello da Messina, Jan van Eyck, and Titian, is Murillo (fig. 48), whose image is clearly based on the self-portrait then in the Galerie Espagnole. Murillo, together with Velázquez, was one of only two Spanish artists included in

Fig. 43. Anonymous, *Murillo*, after 1770. Stucco. Hermitage Museum, St. Petersburg

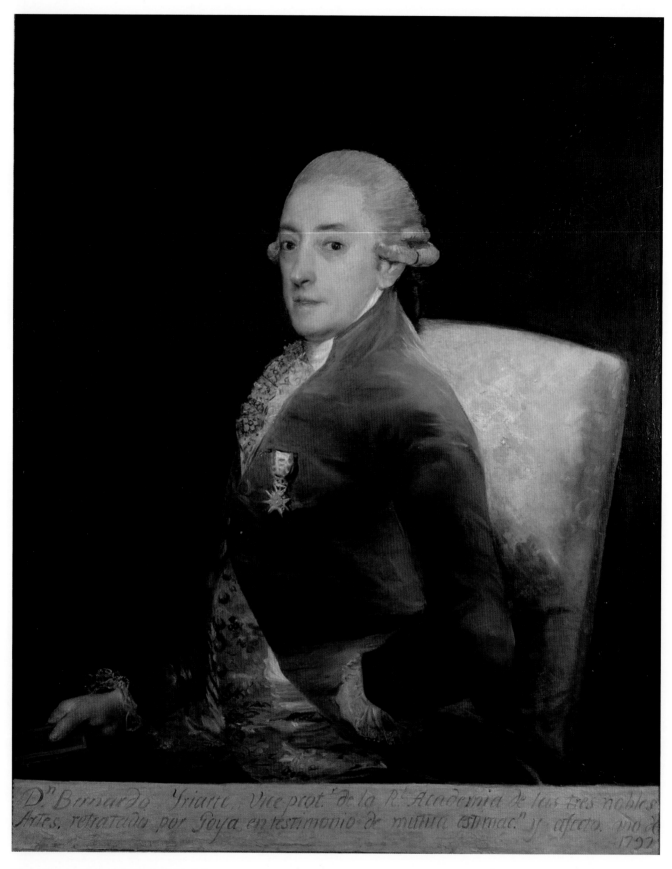

Fig. 44. Francisco de Goya y Lucientes, *Bernardo de Iriarte*, 1797. Oil on canvas, 42 1/2 × 33 1/8 in. (108 × 84 cm). Musée des Beaux-Arts, Strasbourg

the painting. At the beginning of August 1843, a year after Delaroche had completed his mural, the twenty-five-year-old art historian Jacob Burckhardt penned these impressions of the self-portrait after visiting the Galerie Espagnole:

> Murillo is still one of the greatest who ever lived. Here hangs his portrait (by his own hand). It is the key to all his works. Compare it with all the beautiful cavalieros from the court of Don Philip IV, which, by no means badly painted by Velázquez, shine forth here from every wall, and you will comprehend what it was that elevated Murillo above his own time—it is the physical and intellectual power still wielded by this force of nature, while around him his magnificent fatherland and its noble people sank lower and lower. Look at these splendid, slightly pouting lips! Do they not reveal the man of action! These slightly retracted nostrils, these flashing eyes under the splendid, wrathfully arching eyebrows, this whole face, is it not an arsenal of passions? Yet above it there reigns supreme an imperious forehead, which ennobles, controls, spiritualizes everything: and by its sides, the most beautiful jet-black locks flow down. Happy the woman who has been loved by this man! His mouth has kissed a lot, I believe.[13]

Burckhardt's description, which no doubt seems melodramatic to a modern audience, demonstrates the remarkable popularity of Murillo's portrait and of the artist's work in general in the mid-nineteenth century.

In the 1840s, there were two Murillo self-portraits displayed at the Louvre. In addition to the canvas acquired in Seville by Baron Taylor and on view in the Galerie Espagnole was a painting that had been given to the king by Frank Hall Standish in 1840 (fig. 49), together with his collection of more than two hundred paintings.[14] These were displayed in the Louvre's so-called Musée Standish. The canvas was supposedly acquired by Hall Standish from the Count of Maule in Cádiz. In this portrait, Murillo's image (the same as the Frick self-portrait) is also encircled in a stone frame. At some point, it was painted over in black (not uncovered until 1947). The bottom left corner is heavily repainted and suggests that originally the painting was a faithful copy of the New York self-portrait, including the full stone block, which was subsequently cut down. The copy is of very high quality, but not by Murillo and probably a later painting from the eighteenth century. After it left the Louvre, together with the paintings from the Galerie Espagnole in 1849, it was sold at auction in London to William Marshall, who hung it in his house at 85, Eaton Square in London, where Gustav Friedrich Waagen saw it in 1857.[15] Three years later, Théophile Toré described it as a feeble copy of the Frick self-portrait.[16] A number of copies of the self-portrait were clearly painted and engraved in the eighteenth and nineteenth centuries.

About 1842, soon after the original self-portrait entered the Galerie Espagnole, a second, large print was produced after it, by Auguste Blanchard *fils âiné* (1792–1849) (fig. 50). In 1848, William Stirling published his *Annals of the Artists of Spain*, where, in his discussion of Murillo, he describes

both self-portraits, referring to the Frick picture as being in the Galerie Espagnole. The account of the painting is accompanied by an engraved illustration of it by Henry Adlard (active 1828–69), and according to Stirling, it "has been engraved, for the third time, for the present work" (fig. 51).[18] Stirling describes how "according to a whimsical fashion of the time, it affects to be painted on a stone slab, carelessly placed upon a block, along the edge of which a later hand has inscribed the name of the painter, and dates of his birth and death." He further comments that "although wanting in the beauty of feature and the highbred air which distinguished Velasquez, the countenance of Murillo is not unworthy of his genius; the lips betoken firmness, and above the keen intelligent eyes, there rises a broad intellectual brow." According to Stirling, Sir David Wilkie had also painted a copy of the self-portrait, and in 1848, in the *Annals*, he lists it as being in the collection of the Earl of Leven at Melville House in Fifeshire.

With the traumatic events of the 1848 revolution in France, King Louis-Philippe abdicated and went into exile in England. On January 1, 1849, the Galerie Espagnole closed to the public, never to re-open. With the establishment of the Second Republic under Louis-Napoleon (the future Emperor Napoleon III) and the death of Louis-Philippe in England in 1850, the French government decreed that the Spanish paintings assembled in the Galerie Espagnole were the private property of the deceased king, and they were returned to the Orléans family in July 1851, and subsequently sent to England. The dispersal of the Spanish works in the Galerie Espagnole was swift, with the auction of May 27–28, 1853, breaking up what had been the most important group of Spanish paintings ever assembled at that time outside of Spain. The brief period of Spanish art collecting in France came to an abrupt end.

The Frick self-portrait remained in London briefly. At the Louis-Philippe auction, it was acquired for 420 pounds by John Nieuwenhuys of Wimbledon. At this time, it was copied once again by an English artist, John Richard Coke Smyth (1808–1882) (fig. 52). The Coke Smyth canvas is a faithful copy, including the trompe l'oeil stone frame and the inscription in red letters. Below it, however, a second inscription in French was added, in white letters, with Coke Smyth's name and the date of the copy.[19] By 1866, the copy belonged to Antoine d'Orléans (1824–1890), Duke of Montpensier, the youngest son of King Louis-Philippe. In 1846, he had married the Infanta Luisa Fernanda of Spain, younger sister of Queen Isabel II, and the couple displayed their art collection at the Palacio de San Telmo in Seville.[20] The copy was likely either commissioned by the Duke of Montpensier himself or by someone else as a gift for him, considering that Murillo's original had belonged to his father.[21]

In the late nineteenth century, as the discipline of art history became better codified, books on Spanish art, and specifically on Murillo, began to be published. At least three of these included prints to illustrate the Frick self-portrait, which led to it becoming the standard image of the painter. Charles Blanc's *Histoire des peintres de toutes les Ecoles*, published in Paris by Jules Renouard in 1869, included a print after

Grabado por Manuel Alegre, à quien concedió el Premio la Real Academia de S.ⁿ Fernando, año de 1790.

BARTHOLOME MURILLO,

Pintór Sevillano; murió de 72. años en el de 1682. está sepultado en
la Ayuda de Parroquia de Santa Cruz de Sevilla.

Pintado por el mismo, cuyo Quadro conserva en su colec.ⁿ el S.^{or} D.^r Bernardo de Iriarte.

Fig. 45. Manuel Alegre, after Bartolomé Esteban
Murillo, *Bartolomé Esteban Murillo*, 1790. Engraving
and etching on paper, 12 5/8 × 8 5/8 in. (32 × 22 cm).
Fundación Fondo de Cultura de Sevilla (Focus), Seville

Fig. 46. Manuel Alegre, after Bartolomé Esteban
Murillo, *Bartolomé Esteban Murillo*, 1790. Black chalk
on paper, 9 7/8 × 7 3/8 in. (25 × 18.8 cm). Fundación
Fondo de Cultura de Sevilla (Focus), Seville

BARTHOLOME MURILLO,

*Pintór Sevillano; murió de 72 años en el de 1682. está sepultado en
la ayuda de Parroquia de Santa Cruz de Sevilla.*

Fig. 47. Federico de Madrazo, *Isidore-Justin-
Séverin Taylor*, 1833. Oil on canvas, 24 × 19 3/4 in.
(61 × 50 cm). Châteaux de Versailles et de Trianon

Fig. 48. Paul Delaroche, *Hemicycle* (detail), 1837–41.
Mural painting, 153 1/2 × 972 1/2 in. overall
(390 × 2,470 cm). École des Beaux-Arts, Paris

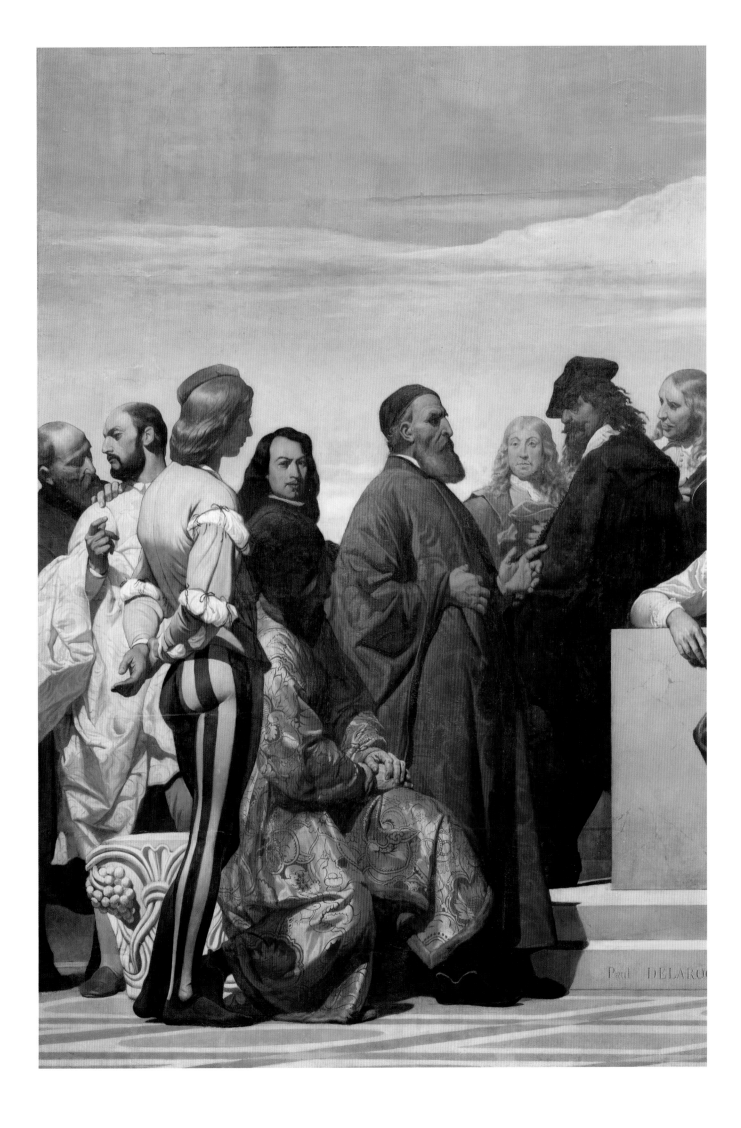

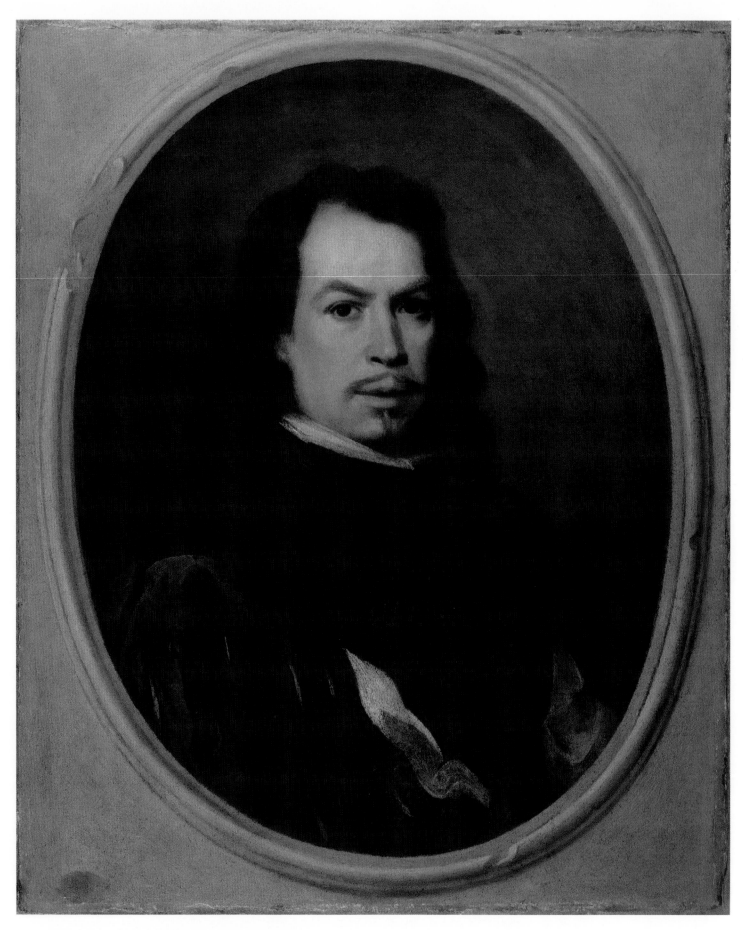

Fig. 49. After Bartolomé Esteban Murillo, *Bartolomé Esteban Murillo*, possibly 18th century. Oil on canvas, 30 × 25 in. (76.2 × 63.5 cm.). The John Paul II Collection of European Paintings. The Zbigniew and Janina Carroll-Porczynski Foundation, Warsaw

Fig. 50. Auguste Blanchard *fils âiné*, after Bartolomé Esteban
Murillo, *Bartolomé Esteban Murillo*, ca. 1842. Etching and
engraving on paper, 15 × 11 in. (38 × 28 cm). The Metropolitan
Museum of Art, New York

Fig. 51. Henry Adlard, after Bartolomé Esteban Murillo, *Bartolomé
Esteban Murillo*. From William Stirling-Maxwell, *Annals of the Artists
of Spain* (London, 1848). Steel engraving on paper, 5 7/8 × 4 1/4 in
(14.8 × 10.7 cm). The National Gallery, London

Fig. 52. John Richard Coke Smyth, after Bartolomé
Esteban Murillo, *Bartolomé Esteban Murillo*, 1853. Oil on
canvas, 41 3/4 × 29 7/8 in. (106 × 76 cm). Town Hall, Seville

Fig. 53. Jean-Baptiste-Charles Carbonneau, after Bartolomé
Esteban Murillo, *Bartolomé Esteban Murillo*. From Charles Blanc,
Histoire des peintres de toutes les Ecoles (Paris, 1869). Engraving on
paper, 5 1/8 × 4 3/8 in (13 × 11 cm) Private collection, New York

Murillo's self-portrait by Jean-Baptiste-Charles Carbonneau (1815–71) (fig. 53). The frontispieces of two small popular monographs on Murillo—by Ellen Minor (1882) (fig. 54) and Albert F. Calvert (1907) (fig. 55), respectively—also bore printed images after the New York self-portrait.

By 1883, Murillo's self-portrait was back in Paris, where it belonged to Frédéric, Baron Seillière (1839–1899). His daughter, Anne-Alexandrine-Jeanne-Marguerite (1839–1905), who had become Princess of Sagan after her marriage to Boson de Talleyrand-Périgord, inherited the painting upon her father's death and sold it, in 1904, to the dealers Lawrie and Co. of 159 New Bond Street, London. That same year, the canvas was purchased by the American coke and steel industrialist and art collector Henry Clay Frick (1849–1919).

By the late nineteenth and early twentieth centuries, American collectors had become fascinated by Murillo, and many works by the painter had already crossed the Atlantic.[22] Frick was particularly interested in Spanish paintings, especially after a brief trip to Spain in 1893.[23] Following the traumatic events in his life in 1892—an assassination attempt, following the crushing of the Homestead Strike, and the deaths of two of his four children, Martha and Henry Clay Jr.—he embarked on a European Grand Tour with his wife Adelaide Childs and their surviving children, Childs and Helen. Traveling with a larger group—Adelaide Frick's sister, a nurse, Childs Frick's tutor Clyde Augustus Duniway, and family friends Mr. and Mrs. Philander Knox and their teenage daughter, Rebeka—they left New York on March 13,

Fig. 54. *Murillo's Self-Portrait.* From Ellen Minor, *Murillo* (London, 1882). Engraving on paper, 5 1/8 × 4 1/8 in. (12.9 × 10.4 cm). Private collection, New York

BARTOLOMÉ ESTÉBAN MURILLO. By Himself.
Formerly in the Collection of King Louis Philippe.
Now in the possession of the family of the late Baron Selliere.

" *The whole world without Art would be one great wilderness.* "

MURILLO

By ELLEN E. MINOR

LONDON
SAMPSON LOW, MARSTON, SEARLE, & RIVINGTON
CROWN BUILDINGS, FLEET STREET
1882

1893, on the Cunard steamship *Etruria*. Their two-month trip included a two-week sojourn in Spain, with visits to Granada, Seville, Cordóba, and Madrid.

By the early 1900s, Frick was collecting significant works by Old Masters. On October 4, 1904, he purchased Murillo's self-portrait for $22,000 (fig. 56). The painting was sold to him by Lawrie & Co., together with two other canvases by George Romney, a portrait and a sketch. The acquisition was chronologically positioned between the first trip to Spain in 1893 and a second one in 1909. In 1904, Frick was still based in Pittsburgh but was planning his move to New York. These were the crucial years in which his collecting taste was transformed and his interest in the Old Masters shaped. The Murillo was the first Spanish canvas to be purchased by Frick,

a year before he acquired his first El Greco, the *St. Jerome*. It is not surprising that his first Spanish painting was a Murillo. By the early twentieth century, Murillo was highly celebrated and collected in the United States, more than Velázquez, El Greco, or Goya.

In 1905, Frick moved from Pittsburgh to New York, where he signed a ten-year lease for the Vanderbilt family house at 640 Fifth Avenue. Between 1913 and 1914, he built a residence at 1 East 70th Street that was destined to become The Frick Collection. In 1909, Frick traveled for the second and last time to Spain. On this occasion, the travel itinerary of the Frick family is documented in photographs and in two diaries of Frick's daughter Helen.[24] Young Helen, with her mother and brother, left New York for Liverpool, aboard the *Celtic*,

Fig. 55. *Murillo's Self-Portrait*. From Albert F. Calvert, *Murillo: A Biography and Appreciation* (London, 1907). Engraving on paper, 4 1/2 × 3 1/4 in. (11.3 × 8.1 cm). Private collection, New York

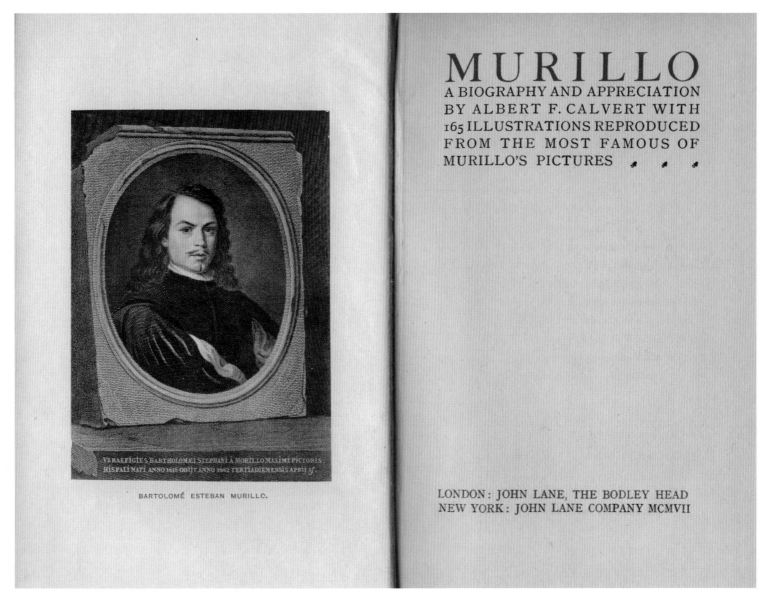

BARTOLOMÉ ESTEBAN MURILLO.

MURILLO
A BIOGRAPHY AND APPRECIATION
BY ALBERT F. CALVERT WITH
165 ILLUSTRATIONS REPRODUCED
FROM THE MOST FAMOUS OF
MURILLO'S PICTURES

LONDON: JOHN LANE, THE BODLEY HEAD
NEW YORK: JOHN LANE COMPANY MCMVII

on January 16, 1909. On January 29, while in London, they visited the National Gallery; among the many masterpieces there, Helen records, in particular, the "Murilos, Grecos, etc." At the Wallace Collection, she singled out a *Holy Family* by Murillo as one of her favorite works of art. They subsequently traveled south to France, where they were joined by Mr. Frick in Paris in February.

The Frick family arrived in Madrid on Monday, March 8. They visited most of the principal sites in the city, including the Palacio Real, the Academia de San Fernando, and the Museo del Prado. Here Helen describes in her diary a series of paintings, starting with Velázquez's *Las Meninas* and continuing with "some of the Murillos are so entrancingly lovely, that I was hardly able to leave them. My favorites were these: the Ecce Homo, Mary Magdalene, the little Jesus giving St. John the Baptist a cup of water, the Baptist with his lamb, Holy Family of the Bird, 2 Assumptions, Dreams of St. Idelfonsus [sic] + of St. Bernardinus." On Saturday March 13, back at the Prado, Helen writes: "the Prado again! I have decided that the 'Little St. John' and the 'Dream of St. Bernard' (Murillo),

'Las Meninas' and 'Don Olivares' (Velazquez) are my favorites here." The Frick family traveled to other cities in Spain for brief visits. On March 9, they were in "dear old, oriental Toledo," and on March 15 they arrived in Seville (fig. 57). Throughout their stay in the Andalusian city, Helen focused on her love for Murillo. In the cathedral, "while looking at Murillo's strong, uplifting S. Antony, we listened to the organ! The other most important pictures seen here, were: Murillo's well known Conception (in Chapter House), surrounded by panel portraits, also by him." At the Museo de Bellas Artes, the focus was once again on Murillo:

Here, there are quite a number of Zurbarans and Pachecos etc. which I do not care for, but the Murillos are lovely! My favorites of his here, are the following: St. Felix Cantalicia with Infant in his arms, S. Antonio de Padua, S. Joseph and Child, & the Adoration. Perhaps the finest of all, for it was Murillo's favorite, is St. Thomas Villanueva. Another well known picture by him, is the Madonna of the Serviette, but the colors are quite faded.

Fig. 56. Receipt for Henry Clay Frick's acquisition of Murillo's self-portrait, 1904. The Frick Collection/ Frick Art Reference Library Archives, New York

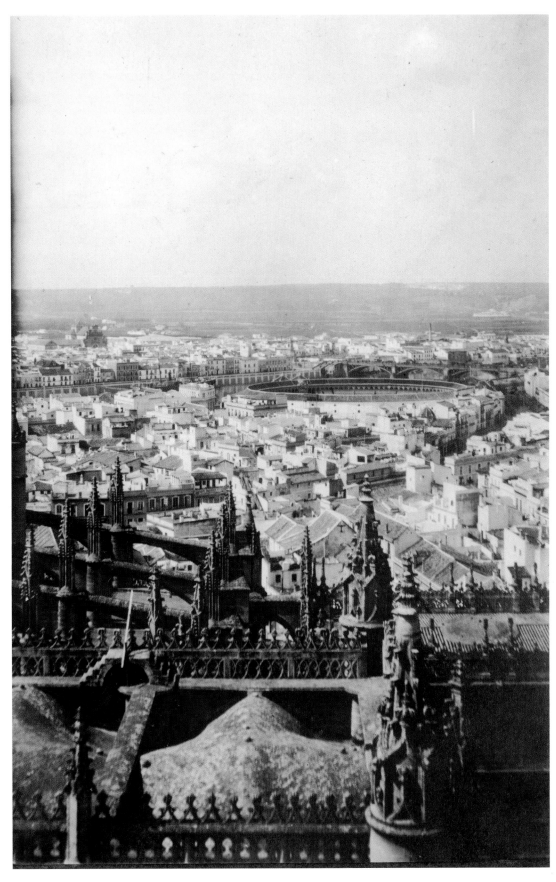

Fig. 57. View of Seville from La Giralda, taken by a member of the Frick family, 1909. The Frick Collection/Frick Art Reference Library Archives, New York

Fig. 58. Murillo's self-portrait in the Morning Room
at Eagle Rock, ca. 1938. The Frick Collection/Frick
Art Reference Library Archives, New York

Sightseeing in Seville included a visit to Murillo's house, to the Casa de Pilatos, to the Hospital de la Caridad, and even to the building believed to be the shop of Figaro, the fictional barber celebrated by Pierre Beaumarchais and later immortalized in Mozart's *Marriage of Figaro* and Rossini's *Barber of Seville*. When the family was back in Madrid, on March 29, Helen went to the Prado for one last visit: "I had to say good bye to my old friends, and how I hated to have to do it, especially to the little St. John by Murillo." After twenty days in Spain, Helen Frick had clearly developed a passion for Murillo's work. We do not know if Frick's admiration for Murillo was at the level of his daughter's. Helen's taste may have followed her father's or may have developed after he bought the self-portrait. The brief Spanish portion of the trip concluded in Barcelona; from there, at the end of March, Frick and his family went to France, and by April they had traveled south to Italy.

The self-portrait has remained in the Frick family for more than a century. Henry Clay Frick displayed the canvas at Eagle Rock, the Frick family summer retreat at Pride's Crossing on Boston's North Shore. Built in 1902–5 by Arthur Little and Herbert Browne, the mansion was designed following the model of cottages in Newport, Rhode Island. The family moved there in 1906, two years after Frick had acquired the Murillo and a year after his move to New York. The sole image showing the Murillo at Eagle Rock is a photograph from 1931, recording the painting in the Morning Room (fig. 58). The painting's subsequent history is directly linked with Eagle Rock and Helen Clay Frick. When The Frick Collection opened in the mid-1930s, the Murillo was sent, presumably for the first time, to be displayed at 1 East 70th Street. Between September 1935 and April 1936, the canvas was on loan to the Frick in New York; in 1938, after a period back at Eagle Rock—with the downsizing of the

house and the demolition of part of it—the picture was sent on long-term loan to the Fogg Museum in Cambridge, Massachusetts. In 1952, Helen Clay Frick gave the painting to her nephew Henry Clay Frick II. In October 1961, a press release by The Frick Collection announced John D. Rockefeller Jr.'s gift to the museum of three important works of art: the *Crucifixion* by Piero della Francesca and two Renaissance marble busts, one by Laurana and another by Verrocchio. These were displayed at the time in the Enamels Room and in the North Hall. To coincide with the gift, Henry Clay Frick II lent three of the paintings that his grandfather had bought and that belonged to him: the Murillo and two full-length portraits by Francis Cotes. The English portraits were shown in the Oval Room, together with two other portraits by Van Dyck, while the Murillo was displayed in the South Hall.

Even though Murillo's self-portrait was never shown at 1 East 70th Street during Henry Clay Frick's lifetime, this masterpiece of Spanish painting belongs in the house conceived by Frick for his collection, which remains his most enduring legacy. The provenance of Murillo's self-portrait demonstrates that prominent collectors owned and treasured this masterpiece. Most seem to have kept the painting for an average of ten to twenty years; in its history, the ten years this canvas was in the Galerie Espagnole at the Louvre are probably the most significant. Yet, except for the sixty or seventy years the painting spent in Murillo's own house and family collection, the Frick family has owned the work longest, having lived with Murillo's self-portrait for more than a hundred years. It is therefore thanks to three generations of the Frick family that this exceptional masterpiece has found its permanent home in New York.

Notes

1 For a recent history of the Hermitage Museum, see Piotrovsky 2015.

2 See p. 101 in this publication.

3 Ceán Bermúdez 1800, 2: 55.

4 For Iriarte, see, most recently, Xavier Bray in London 2015, 84–85, 235.

5 Carrete Parrondo, Vega, and Solache 1996, 51, cat. 46.

6 Angulo Íñiguez 1981, 2: 321.

7 For Baron Taylor, see, most recently, Luxenberg 2013.

8 For the Galerie Espagnole, see Baticle and Marinas 1981; Baticle 2003.

9 For this period in Seville, see, in particular, Lleó Cañal 1997, 12–35; Cano Rivero 2003.

10 *Notice des tableaux* 1838, 48, cat. 183.

11 Luxenberg 2013, 166–67.

12 Haskell 1976, 9–11.

13 Schiff 1988, 111–12.

14 For the painting, see Waagen 1857, 183; Bürger 1860, 130; Angulo Íñiguez 1981, 2: 321; Baticle and Marinas 1981, 134; Christie's, London, July 9, 1982, lot 20; Kwiatkowski 1991, 194, cat. 73; Suzanne L. Stratton-Pruitt in Fort Worth / Los Angeles 2002, 186; Ignacio Cano Rivero in Bilbao / Seville 2009, 188–93, 519–20.

15 Waagen 1857, 183. The painting was subsequently bought by Sir Henry Hope Edwardes of Wootton Hall in Derbyshire and sold at Christie's, London, April 27, 1901, lot 45. Bought by Loeffler and then belonging to Sir John Musker and his daughter, Mrs. Brian Gething of Newbury, Crossway, Berkshire. Sold at Christie's, London, July 9, 1982, lot 20, it was acquired by Zbigniew and Janina Carroll-Porczynski in Warsaw.

16 "and which is considered as a very low-quality copy of the first [the Frick self-portrait]" (et que l'on considérait comme une sorte de copie assez faible du premier); Bürger 1860, 130.

17 Stirling 1848, 897–99. For more on William Stirling, later known as Sir William Stirling-Maxwell, see p. 94 in this publication.

18 Stirling seemed not to know of the existence of the Alegre 1790 print. He mentions prints made in Paris by Blanchard and by Schling. For Adlard, see Macartney and Matilla 2016, 48–49.

19 "Coke Smyth, after the original painting belonging to Mr. Nieuwenhuys. 1853" (Coke Smyth, d'apres le tableau original dans la possession de Mr. Nieuwenhuys. 1853). For the painting, see Angulo Íñiguez 1981, 2: 322.

20 For the Dukes of Montpensier in Seville, see Lleó Cañal 1997.

21 Together with other paintings, the copy of Murillo's self-portrait was left to the city of Seville in 1989 and is currently displayed in the Salón Montpensier of the Town Hall.

22 For Murillo in America, see Suzanne L. Stratton-Pruitt in Fort Worth / Los Angeles 2002, 91–109.

23 For Frick and Spanish art, see Galassi 2012 and Salomon forthcoming.

24 The photographs from the trip, Miss Frick's diary (which covers January to April 1909) and her notes from the trip (which cover January to June 1909) are all preserved at The Frick Collection/Frick Art Reference Library Archives, Helen Clay Frick Papers, Series: Calendars and Diaries.

The Frick Self-Portrait

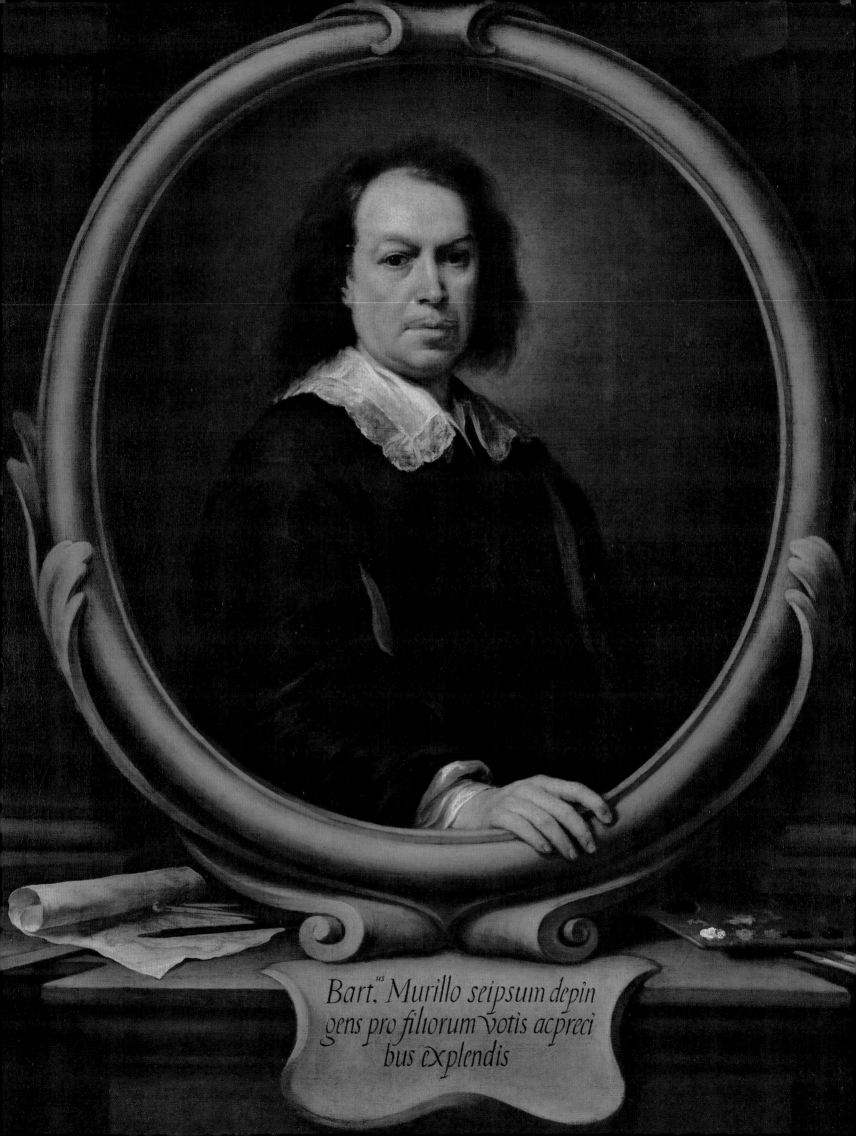

Bart.us Murillo seipsum depin
gens pro filiorum votis acpreci
bus explendis

Murillo and Britain: The National Gallery Self-Portrait

Letizia Treves

"Run my dear fellow to Seville and for the first time in your life know what a great artist is—Murillo, Murillo, Murillo!" Thus wrote the British writer and politician Benjamin Disraeli (1804–1881) in a letter from Spain to a friend in 1830.[1] His entreaty conveys the high esteem in which Murillo was held at the time. This admiration, felt since the first paintings entered Britain in the eighteenth century, reached its peak during the first half of the nineteenth century, before slowly giving way to an ever-increasing regard for Diego Velázquez and a renewed interest in El Greco at the dawn of the twentieth century. Murillo's universal popularity in the eighteenth and nineteenth centuries may have been partly to blame for the decline in his critical fortunes: the widespread copying, mass reproduction, and popularization of his images not only diluted the power and refinement of his originals but also damaged his reputation in more distinguished artistic

circles. Murillo's paintings were increasingly regarded as sentimental, particularly in comparison to the works of the more "modern" painters Velázquez, Goya, and El Greco. Although Murillo had featured prominently in exhibitions focusing exclusively on Spanish art in the late nineteenth and early twentieth centuries—notably, the *Exhibition of Spanish Art* at the New Gallery, London (1895–96), the *Exhibition of Spanish Old Masters* at the Grafton Galleries, London (1913–14), and the *Exhibition of Spanish Paintings* at the Royal Academy of Arts, London (1920–21)—the first comprehensive monographic exhibition on Murillo would not take place until 1983.[2] This renewed appreciation for Murillo in the 1980s coincided with a growing interest in the history of collecting Spanish art in Britain, and further exhibitions on Murillo have been staged more recently, most memorable among them one focusing on the artist's scenes of childhood (2001) and another dedicated to Murillo's close friendship with Justino de Neve (2013).[3]

Murillo never left Spain. In fact, with the exception of a single documented stay in Madrid in 1658, he rarely left his native Seville. In order to appreciate Murillo's work in context, nineteenth-century art enthusiasts had to make their way to Spain, specifically to Seville; yet the artist's international reputation was established well before this date, in large part due to those of his works that had already made their way abroad. In 1672, ten years before Murillo's death, the Sevillian poet and priest Fernando de la Torre Farfán (1609–1677) wrote of "our Bartolomé Murillo, who cannot be praised highly enough, and whose name is better known in Europe than in his own homeland."[4] Murillo was especially admired for his paintings of street children, the genre for which he was perhaps best known, at least in eighteenth-century England. The first such work is recorded in England as early as 1693: the traveler and art enthusiast John Evelyn records two paintings of "boyes of Morella, the Spaniard" being bought for a high price ("80 ginnies, deare enough") by Sidney, first Earl of Godolphin, at a London auction in June of that year.[5] In 1797, the Reverend Matthew Pilkington wrote of Murillo that "his favourite subjects were beggar-boys, as large as life, in different actions and amusements… His original pictures of those subjects have true merit, and are much esteemed, many of them being admitted into the most capital collections of the English Nobility."[6] The first work by Murillo—indeed by any Spanish artist—to enter the National Gallery, London, was a picture painted in this vein. *A Peasant Boy Leaning on a Sill* (see fig. 34) was presented to the National Gallery in 1826, just two years after the museum's foundation; thanks to its dissemination through William Ward's mezzotint of the previous year, it

soon became one of Murillo's most famous works.[7] Similarly, the admiration for Murillo's *Infant St. John with the Lamb* (fig. 59), which entered the gallery's collection in 1840, is borne out by the numerous engravings based upon it. The proliferation of prints after Murillo's works testifies to the artist's rising fame and popularity in nineteenth-century Britain.[8]

As well as having popular appeal, Murillo's genre paintings were admired by eighteenth-century British painters, particularly Thomas Gainsborough (1727–1788) and Joshua Reynolds (1723–1792), whose portraits of innocent children in rustic settings owe a great deal to Murillo, though they sentimentalize his prototypes considerably. Gainsborough admired Murillo for his painting technique, especially the delicate colors and vaporous brushwork of his later works, and is known to have both copied and possessed works by Murillo. He once owned the National Gallery's *St. John the Baptist in the Wilderness* (fig. 60)—a work long thought to be by Murillo—which he had acquired from the French-born picture dealer and collector Noel Desenfans in 1787, just two years after painting *The Cottage Girl* (fig. 61), one of Gainsborough's most celebrated "fancy pictures."[9] Reynolds also held Murillo's paintings of children in high regard, and particularly admired the self-portrait now in the National Gallery. In a letter of December 14, 1785, he strongly recommended the painting as a purchase to the Duke of Rutland: "The portrait of Morilio [*sic*] which I have seen is very finely painted, and there is not the least doubt about its being an original of his hand; it will be a very considerable acquisition to your Grace's collection."[10]

It was not just artists, however, who came to appreciate and admire Murillo. A growing interest in Spain—and in Spanish art and culture generally—among connoisseurs and travelers coincided with an increasing number of publications on the subject. Antonio Palomino's biography of Murillo, published in his *Parnaso español* (1724), the third volume of *El Museo pictórico* (1715–24), appeared in an English abridged version in 1739, translated from the original Spanish text for the very first time. Palomino wrote that "at this very Time, out of Spain, a Picture of Murillo's is more esteem'd than one of Titian's or Vandyke's so powerful is the Blandishment of Colouring, to attract the popular Breath and Applause of the many."[11] The translation of Palomino's text into English is itself evidence of the British interest in Spanish art, but his words also confirm the claim that Murillo's works were widely admired outside of Spain at an early date. In the 1850s, the German art historian Gustav Friedrich Waagen noted the presence of fifty-two paintings by or attributed to Murillo (five of which he considered doubtful) in private collections across Great Britain, and in the 1857 Manchester *Art Treasures Exhibition* more paintings

Fig. 59. Bartolomé Esteban Murillo, *The Infant St. John with the Lamb*, 1660–70. Oil on canvas, 65 × 41 3/4 in. (165 × 106 cm). The National Gallery, London

Fig. 60. Probably by Bartolomé Esteban Murillo,
St. John the Baptist in the Wilderness, ca. 1660–70.
Oil on canvas, 47 1/4 × 41 1/2 in. (120 × 105.5 cm).
The National Gallery, London

Fig. 61. Thomas Gainsborough, *The Cottage Girl*,
1785. Oil on canvas, 68 1/2 × 49 in. (174 × 124.5 cm).
National Gallery of Ireland, Dublin

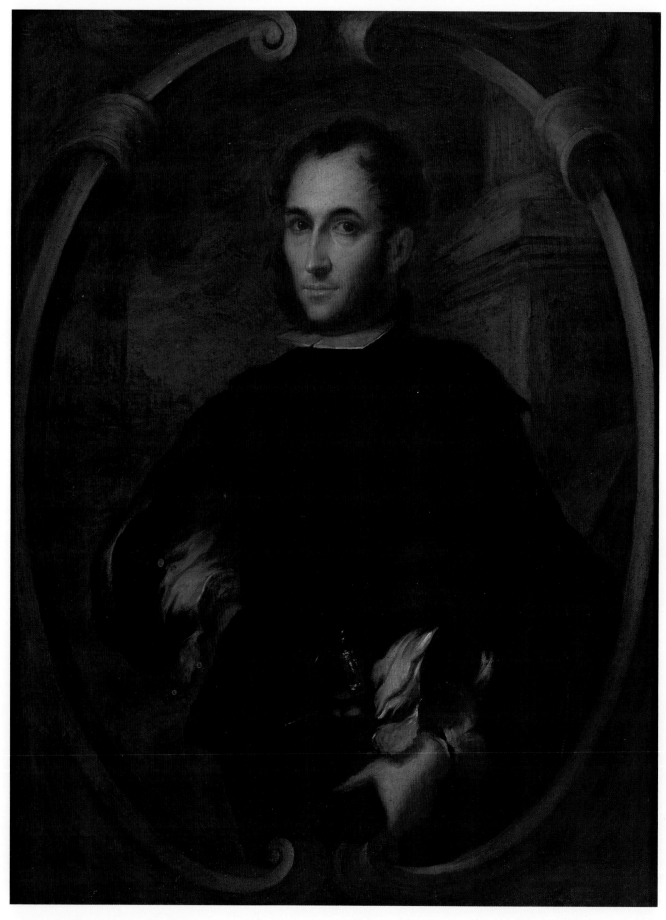

Fig. 62. José Gutierrez de la Vega, *Richard Ford*
(1796–1858), 1831. Oil on panel, 13 1/4 × 10 3/8 in.
(33.5 × 26.5 cm). Francis Ford Collection, London

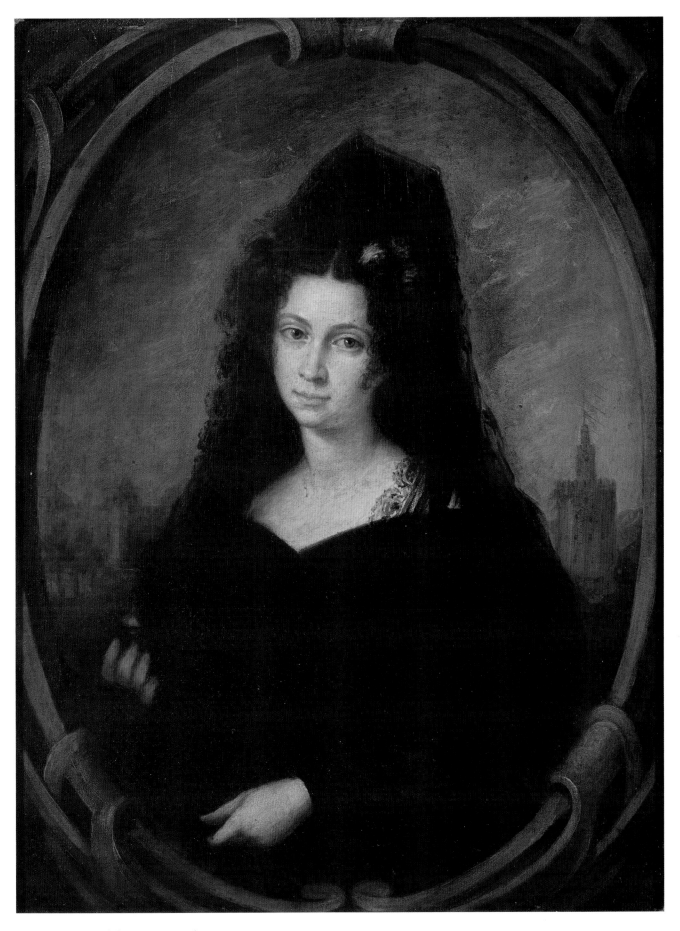

Fig. 63. José Gutierrez de la Vega, *Harriet Ford*
(1806–1837), 1831. Oil on panel, 13 1/2 × 9 7/8 in.
(34.2 × 25 cm). Francis Ford Collection, London

by Murillo were included than by any other Spanish artist.[12] By the time the American author Charles Curtis published his catalogue of the works of Murillo a hundred and fifty years later (1883), more paintings by the artist were recorded in British collections than in the whole of Spain.

The first predominantly English-language monograph on Murillo—written by Edward Davies, an ex-military man—was published in 1819 and drew upon the texts of previous authors such as Palomino, Céan Bermúdez, Richard Cumberland, and Antonio Ponz. In it, Davies includes a royal edict of 1779, in which Charles III prohibited the export of paintings by deceased Spanish artists, with Murillo specifically mentioned.[13] Elsewhere in his book, Davies describes the artist as "the tender and natural Murillo, a painter better known in England than any of the Spanish School, except Ribera."[14] Some twenty years earlier, Reverend Pilkington had also admired Murillo for his naturalism, drawing particular attention to the "striking character of truth and nature in all his paintings."[15] And yet up to this point, observations on Murillo's art were drawn primarily from the works available in Britain; Spain did not form part of the Grand Tour itinerary, and travelers did not begin to venture there until the late eighteenth and early nineteenth centuries. By that time, a number of guidebooks facilitated travel to the region, the most famous of which was Richard Ford's *Hand-book for Travellers in Spain* (1845), which was unprecedented in its range and detail regarding the country's art and architecture.[16] Ford (1796–1858) had gone to southern Spain in 1830 and, after spending three winters in Seville, had come to know the city, its customs, and its art extremely well. While in Seville, Ford sat for José Gutierrez de la Vega (1791–1685), who had previously painted a portrait of the collector Frank Hall Standish (fig. 62). Gutierrez de la Vega was known for his copies after Murillo, and Ford himself considered him to be "the best copier of Murillo in Seville."[17] Ford is depicted as a *hidalgo*, with the Giralda (the bell tower of the Cathedral of Seville) in the background, within an oval trompe l'oeil stone frame not unlike those used by Murillo in a number of his portraits. Ford's portrait was paired with that of his wife Harriet, in which she wears a *maja* costume made especially for the occasion and stands before another Sevillian landmark, the Torre del Oro, a military watchtower (fig. 63).[18]

Although Ford wrote his *Hand-book* well after his return to England, his impressions of Seville remained vivid. He admired Murillo enormously for his "perfect mastery over materials," reserving particular praise for his sense of color and "delicate tones." Lacking a wide knowledge of Spanish art, however, some writers—and, more specifically, their readers—were unable to appreciate Murillo's art except by way of comparison with Italian painters about whom they knew considerably more. Ford compared Murillo's brushwork to that of Correggio—an artist considerably more familiar to the British public—referring to his "Correggiesque morbidezza."[19] In the previous century, Murillo's style had been associated with artists as diverse as Guercino and Paolo Veronese.[20] Murillo's popularity in eighteenth-century Britain may also derive from his being viewed as a Spanish equivalent to the Roman painter Carlo Maratta, whose works were avidly collected by Grand Tourists. This was particularly true of Murillo's religious paintings. At Houghton Hall in Norfolk, for example, the prime minister, Sir Robert Walpole (1676–1745), had a room dedicated to Carlo Maratta ("The Carlo Maratta Room"), where religious paintings by Murillo also hung, including his *Flight into Egypt* and *Crucifixion*, now in the State Hermitage Museum, St. Petersburg.[21]

This situation changed toward the middle of the nineteenth century. The first detailed account of the history of Spanish art—William Stirling's *Annals of the Artists in Spain* (1848)—was published, and a number of Spanish paintings appeared on the London art market in the aftermath of the Peninsular War. The most significant were those from the collections of Louis-Philippe d'Orléans and Frank Hall Standish, sold at Christie's in 1853.[22] William Stirling (1818–1878), known as Sir William Stirling-Maxwell after 1863, wrote his pioneering study of Spanish art when he was just thirty years old (fig. 64). The three volumes cover a period running from the early Middle Ages to the time of Goya, with large sections dedicated to Velázquez and Murillo, whose works are discussed for the first time in a broader social, historical, and artistic context. Stirling's *Annals* was widely read, and the details he wrote concerning the artists' lives provided particular inspiration to Victorian painters of the period.[23] The Scottish painter John Phillip (1817–1867)—who visited Spain on three occasions (1851, 1856–57, and 1860–61) and was known as "Spanish" Phillip due to his predilection for Spanish subjects—took Palomino's biography and, more specifically, Stirling's picturesque account of Murillo's beginnings literally in his *Early Career of Murillo, 1634* (fig. 65).[24] The work shows the young Murillo peddling his modest paintings at the weekly Thursday market in the calle de la Feria in Seville. When Phillip's painting was exhibited at the Royal Academy in 1865—to great critical acclaim—a passage from Stirling's *Annals* was quoted in the accompanying catalogue: "he was reduced to earn his daily bread by painting coarse and hasty pictures for the Feria… the unknown youth stood there amongst gipsies, mulateers, and mendicant friars, selling for a few reals those productions of his early pencil for which royal contenders are now ready to contend."[25] Phillip's portrayal of the youthful Murillo is based on the Frick self-portrait rather than on the National Gallery picture: not only was the former a more appropriate model, showing the artist in his younger years, but it was also the image reproduced in engraved form in Stirling's *Annals*, thus ensuring that Murillo was instantly recognizable to connoisseurs.[26]

The Frick self-portrait was widely admired in the nineteenth century, having been on public display in the Galerie Espagnole (the Spanish gallery in the Louvre) for ten years (1838–48) and subsequently appearing at auction in London. The Scottish artist David Wilkie (1785–1841) is said to have copied it earlier in the century, while residing in Seville.[27] Wilkie was an admirer of Murillo, and his acute observations on the respective artistic merits of Murillo and Velázquez, written in his journal and letters during a visit to Spain in 1827–28 and published posthumously in 1843, continued to

Fig. 64. Thomas Annan, *Sir William Stirling-Maxwell*,
1870s. Albumen carte-de-visite, 3 3/4 × 2 3/8 in.
(9.4 × 6 cm). National Portrait Gallery, London

provide a source of inspiration for artists and writers in the ensuing decades. In his *Annals*, Stirling quoted Wilkie's comparison of the two artists' styles: "Murillo being all softness, while Velazquez is all sparkle and vivacity."[28] These words went some way in shaping the public perception of these two painters, and the Manchester *Art Treasures Exhibition* in 1857 gave the British public an opportunity to study and compare works by—or attributed to—both artists for the first time, with twenty-seven paintings by Murillo (including the self-portrait now in the National Gallery) and twenty-six by Velázquez on display. Although on that occasion the self-portrait was greatly admired for its lifelike quality—"a most speaking picture, the head actually standing out from the canvas beaming with life"—it was a likeness closer to the Frick *Self-Portrait* that was chosen to illustrate the artist in the *Art Treasures Examiner*, the publication accompanying the exhibition.[29] Shortly after this landmark exhibition, the young Murillo took his place alongside Velázquez among the world's most famous artists in Henry Hugh Armstead's Podium of the Painters on the Albert Memorial, a monument commissioned by Queen Victoria to commemorate the Prince Consort, after his death from typhoid in 1861 (fig. 66). The queen herself had been an admirer of Murillo, writing in her private journal in 1836 that she considered his paintings "beautiful" and "exquisite."[30]

This is the background in which the history of the National Gallery's self-portrait (see fig. 25) should be considered, for

it is one of the earliest paintings by Murillo—albeit not the first—to have made its way to Britain. Painted to fulfill the wishes and prayers of his children, according to the Latin inscription on the plaque, the portrait probably remained in the possession of Murillo's family and, more specifically, of his son Gaspar (in whose 1709 inventory it likely appears).[31] Its fame outside of Seville was secured by Richard Collin's engraving, which was made in Brussels in 1682, shortly after Murillo's death, at the behest of the painter's friend and patron Nicolás Omazur (fig. 67). Collin's print is the model upon which subsequent engravings of the artist are based, including the head-and-shoulders portrait of Murillo (also by Collin) in Joachim von Sandrart's *Academia Nobilissimae Artis Pictoriae* of the following year (1683) and the frontispiece in Antoine-Joseph Dezallier d'Argenville's *Abrégé de la vie des plus fameux peintres* (1762), both of which show Murillo facing right (in the same direction as the painting).[32]

The National Gallery painting was therefore considered the accepted likeness of the artist in the late seventeenth century and was the better known of the two self-portraits at an early date. Only in the ensuing centuries was this widely recognizable image supplanted by that of the more youthful Frick self-portrait, in large part due to the latter's fame and greater accessibility in the Galerie Espagnole in Paris and, subsequently, in London, when it came up for sale. The human side of Murillo—so vividly portrayed by

The National Gallery Self-Portrait

Fig. 65. John Phillip, *The Early Career of Murillo, 1634*, 1865. Oil on canvas, 71 1/2 × 98 3/8 in. (181.5 × 250 cm). Collection Pérez Simón, Mexico

Fig. 66. Henry Hugh Armstead, *Podium of the Painters*, Albert Memorial (detail), Kensington Gardens, London

MURILLO.

CLAUDE. DAVID.

ASQUEZ POUSS

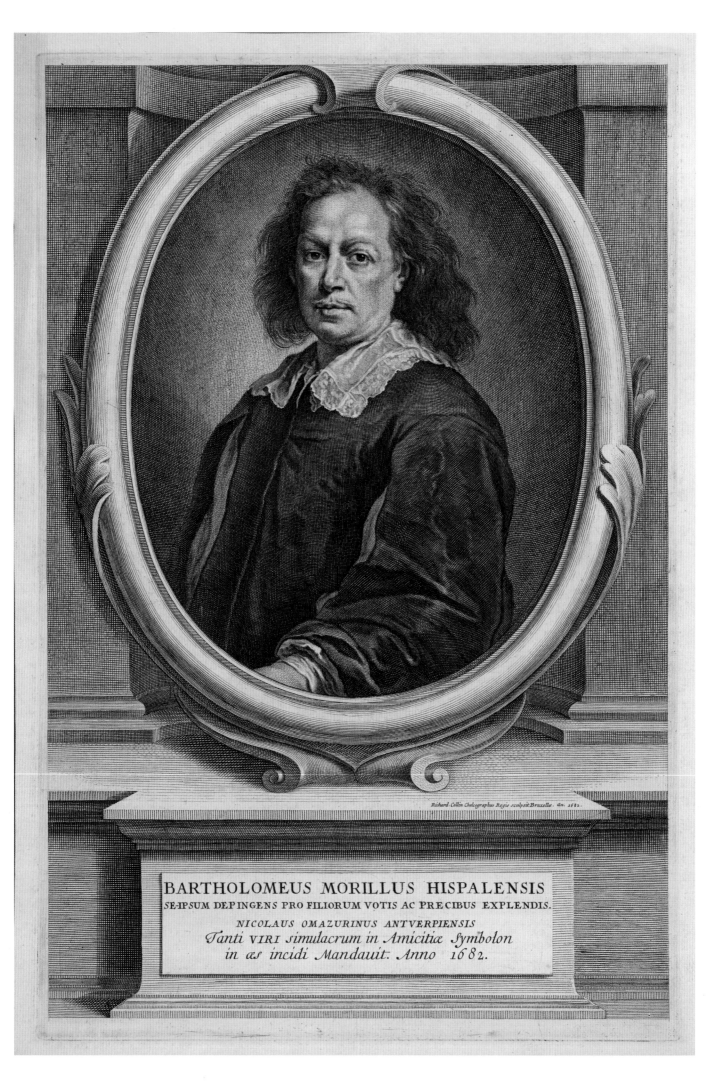

BARTHOLOMEUS MORILLUS HISPALENSIS
SE-IPSUM DEPINGENS PRO FILIORUM VOTIS AC PRECIBUS EXPLENDIS.
NICOLAUS OMAZURINUS ANTVERPIENSIS
Tanti VIRI *simulacrum in Amicitiæ Symbolon*
in æs incidi Mandauit. Anno 1682.

Palomino—finds more resonance in the National Gallery self-portrait, which, after all, was intended as a private image for his children. Murillo's representation of his mature self in an informal but lifelike manner, dressed simply and surrounded by the tools of his trade, accorded well with the eighteenth-century British perception of Murillo as a "truthful" artist.[34] Indeed, the fame of the portrait in England is demonstrated by the existence of a number of copies in British collections, some of which appear to date from the eighteenth century.[35]

It was through Daniel Arthur, an Irish merchant and banker, that the National Gallery self-portrait probably made its way to England. There is considerable confusion over Daniel Arthur's identity, however. As many authors had done before him (including Ellis Waterhouse and Neil MacLaren), Nigel Glendinning identified the Daniel Arthur who owned the self-portrait as Sir Daniel Arthur (?1620–1705), a Jacobite Irish banker knighted by James II in 1690.[36] Arthur was said to have brought to England the Murillos that once belonged to Francis Arthur (named as "Francisco Artier" in Spanish legal documents of the time), who Glendinning assumed was a brother or cousin. Sir Daniel Arthur died in Paris in 1705, however, and since Murillo's self-portrait was likely still in Seville at that time, it may have been Sir Daniel's son by his second marriage, Daniel "Mannock" Arthur, who came into possession of the painting and brought it to England. Daniel "Mannock" Arthur had remained in Paris until 1713, but, following a dispute over his father's inheritance that was resolved in favor of his brother Daniel "Smith" Arthur, he seems to have left the family business and traveled to Spain. The precise date of Daniel Arthur's ownership is unknown, but it can be safely assumed that Murillo's self-portrait was still in Seville in the first decade of the eighteenth century, both because it is probably one of the two self-portraits listed in Gaspar Murillo's inventory of 1709 and because it clearly served as a model for Alonso Miguel de Tovar's *Gentleman of the Mendoza y de la Vega Family* of 1711 (fig. 68). This is further strengthened by the existence of a simplified copy after Murillo's self-portrait by Tovar, today in the Museo Nacional del Prado, Madrid (fig. 69).

Murillo's self-portrait is first mentioned in England in 1729, when Viscount Percival, first Duke of Egmont, saw "several pieces by Monglio [sic] a famous painter in Spain little known here, together with his own picture" in the house of "Mr Bagnall."[37] Mr. Bagnall is to be identified with George Bagnall of 26 King Square (later called Soho Square), the second husband of Lady Arthur (Daniel Arthur's widow), who seems to have inherited the paintings from her late husband. The self-portrait was also seen in Bagnall's collection by George Vertue, who noted its sale to Frederick, Prince of Wales (1707–1751), sometime before 1740: "Mr. Bagnals Soho Square … a head—Moriglios own portrait—Moriglio 'sold to the prince.'"[38] The painting thus entered the possession of one of the most avid art collectors and enthusiasts the British monarchy had ever seen. After Prince Frederick's death, Vertue wrote that "no Prince since King Charles the First took so much pleasure nor observations on works of art or artists—and in all probability if he had lived, been an ornament to this Country." Horace Walpole also praised Prince Frederick's artistic tastes, stating that "the late prince of Wales, who had begun to assemble a fine collection, proposed to acquire as many as possible of King Charles I's pictures."[39] Prince Frederick was particularly interested in portraiture: in addition to commissioning portraits from the most fashionable artists of his day—including Philip Mercier and Antoine Pesne—he amassed an important collection of Old Master paintings.[40] Along with Murillo's self-portrait, the prince also bought from Bagnall works by Peter Paul Rubens, David Teniers, Jan Brueghel, and Jusepe de Ribera.[41] The self-portrait remained in Prince Frederick's collection until at least 1750—and probably right up to his sudden death the following year—and was restored and relined while in his possession.[42]

It seems likely that Murillo's self-portrait became known to William Hogarth (1697–1764) while it was in the collection of Prince Frederick, for Hogarth's own self-portrait of about this date—*The Painter and His Pug* (fig. 70)—recalls certain trompe l'oeil motifs adopted by Murillo. Hogarth represents himself within a feigned oval, as if painted on an unframed canvas that sits atop a stack of books by the authors he most admired—Shakespeare, Swift, and Milton. He is dressed informally, wearing an artist's garb and cap, with his painter's palette propped up nearby.[43] The portrait is signed and dated 1745 but seems to have evolved over the course of several years. X-radiographs reveal that Hogarth initially portrayed himself in a much more conventional manner, wearing the full wig of a gentleman, a white cravat, and a coat and waistcoat with gold buttons. A miniature by Jean-André Rouquet (1701–1758) in the National Portrait Gallery, London, may reflect the portrait's appearance at an earlier stage in its development.[44] This representation was then replaced by a more informal portrayal, and it has often been suggested that Hogarth may have radically changed his own portrait after seeing Murillo's self-portrait. Whether this is true or not, the two self-portraits were clearly seen as related as early as 1855, when they were referred to in the same breath: "[Murillo's] portrait of himself is, as to the head, admirably painted, but he presents himself in an oval

Fig. 67. Richard Collin, after Bartolomé Esteban Murillo, *Bartolomé Esteban Murillo*, 1682. Engraving on paper, 14 1/4 × 9 5/8 in. (36.2 × 24.4 cm). The British Museum, London (cat. 7)

The National Gallery Self-Portrait

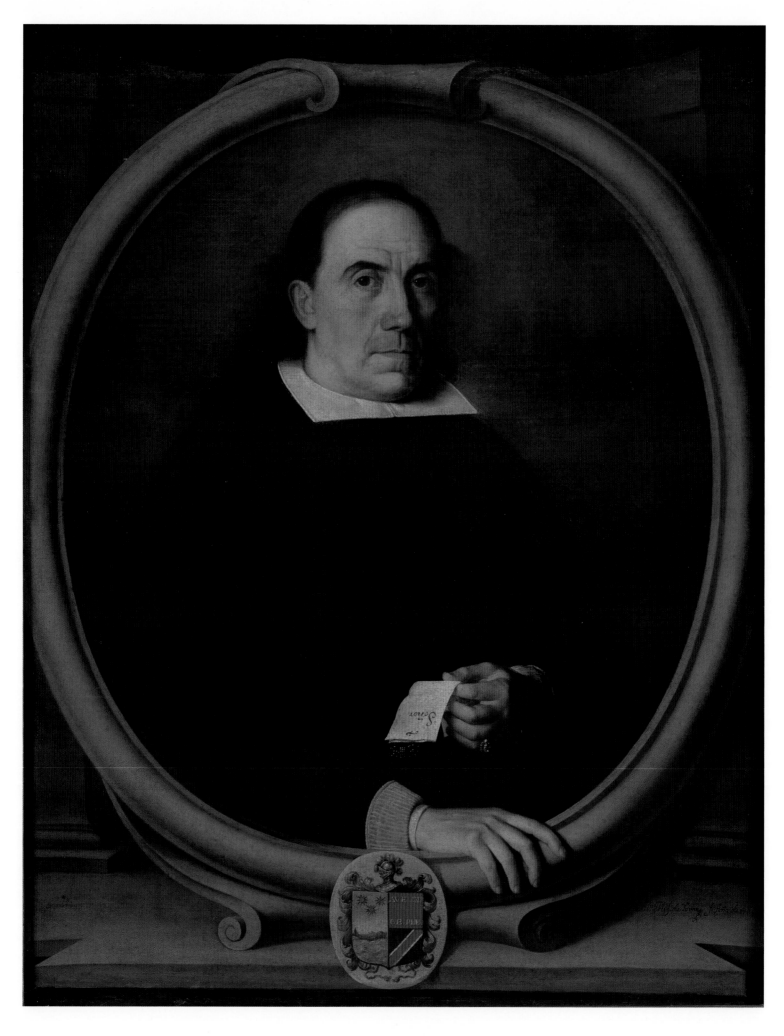

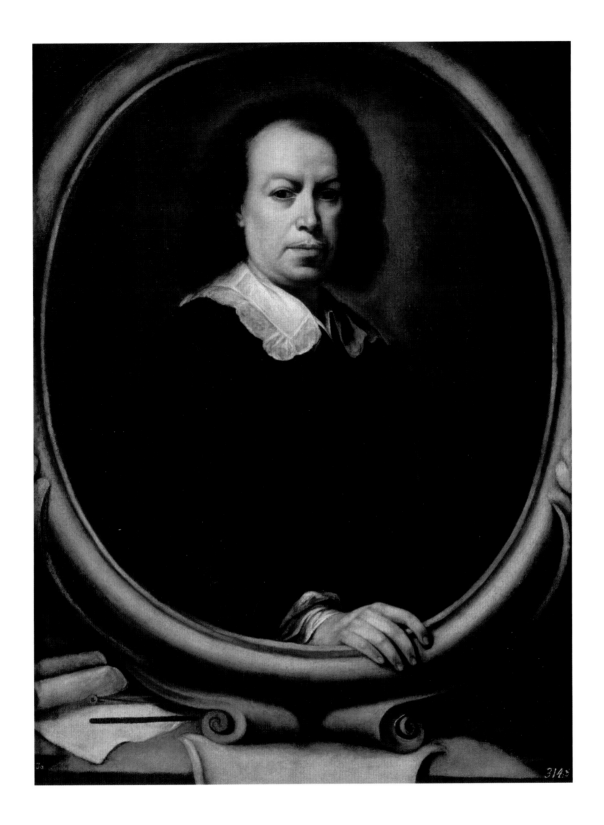

Fig. 68. Alonso Miguel de Tovar, *Gentleman of the
Mendoza y de la Vega Family*, 1711. Oil on canvas,
41 3/4 × 31 7/8 in. (106.1 × 81 cm). Museum of Art,
Rhode Island School of Design, Providence

Fig. 69. Alonso Miguel de Tovar, after Bartolomé
Esteban Murillo, *Bartolomé Esteban Murillo*, n.d.
Oil on canvas, 39 3/4 × 29 7/8 in. (101 × 76 cm).
Museo Nacional del Prado, Madrid

Fig. 70. William Hogarth, *The Painter and His Pug*, 1745. Oil on canvas, 35 3/8 × 27 1/2 in. (90 × 69.9 cm). Tate Gallery, London

Fig. 71. William Hogarth, *The Painter and His Pug*, 1749. Etching and engraving on paper, 14 1/2 × 10 5/8 in. (36.8 × 27 cm). The British Museum, London

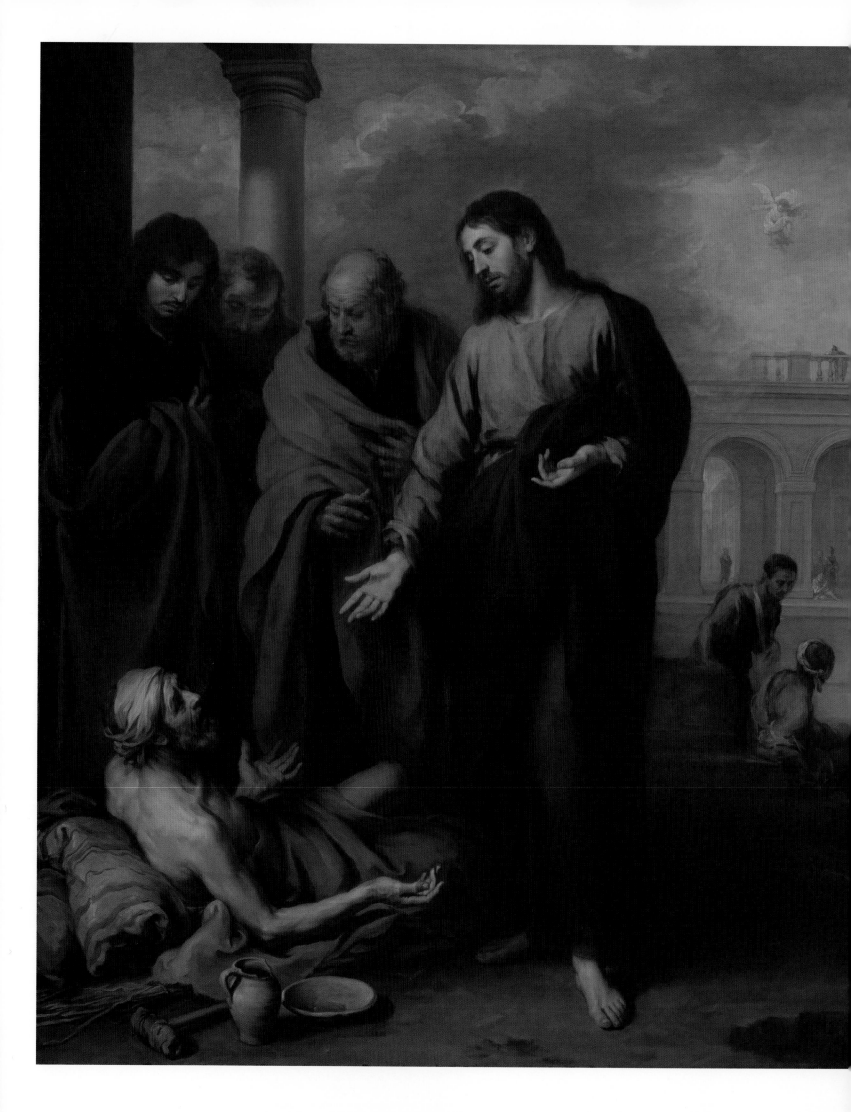

compartment somewhat whimsically—like Hogarth."[45] Although Murillo's self-portrait was engraved shortly after the artist's death, it was always conceived as a painting: not only does the inscription suggest this, but so does the life-like and subtly modeled figure of Murillo himself, emerging from within the monochromatic trompe l'oeil stone frame. Hogarth, on the other hand, seems to have painted his own self-portrait with engraving in mind (fig. 71). His 1749 engraving shows two significant differences: Hogarth represents himself as a graphic artist, with a graving tool in the foreground (this was originally in the painting also but was painted out); and the painter's palette has blobs of paint, neatly arranged from light to dark (as in Murillo's self-portrait), of which however there is no trace in Hogarth's painting. The greater informality of Hogarth's final painted image seems more closely aligned with Murillo's representation of himself as an aging artist, surrounded by the attributes of his profession. Both artists successfully combine a certain intimacy with dignity in their respective images of themselves; interestingly, Hogarth's self-portrait, like Murillo's, seems to have remained in the possession of the painter's family for a considerable length of time, underlining the very personal nature of its representation.[46]

The next recorded owner of Murillo's self-portrait was Sir Lawrence Dundas (ca. 1710–1781), who probably acquired the painting shortly after Prince Frederick's death. The picture was sold posthumously in 1794 and described in the sale catalogue as "a Pure and Perfect Picture, painted with Great Force and Delicacy." At this time, when appreciation for Murillo was growing, the portrait was evidently admired not only for its subtle and delicate handling of paint but also for its powerful imagery. After all, Reynolds had recommended the painting to the Duke of Rutland in 1785, emphasizing the autograph quality of the work (suggesting that by this date pictures wrongly attributed to Murillo appeared frequently on the market). Lord Ashburnham, who acquired the self-portrait at the 1794 Dundas sale, displayed the painting in his house in Dover Street, where it was seen by J. E. Breen ten years later.[47]

By the time Murillo's self-portrait next appeared on the art market, at the fourth Earl of Ashburnham sale in 1850,[48] the artist's fame had grown considerably. The painting was one of the highlights of the sale, fetching the fourth highest price, and its purchase was seriously considered by the National Gallery.[49] The gallery's interest may have been enhanced by the fact that Hogarth's self-portrait was already in its collection: it was among the thirty-eight paintings belonging to the banker and philanthropist John Julius Angerstein (1732–1823) that formed the nucleus of the

Fig. 72. Bartolomé Esteban Murillo, *Christ Healing the Paralytic at the Pool of Bethesda*, ca. 1667–70. Oil on canvas, 93 1/4 × 102 3/4 in. (237 × 261 cm). The National Gallery, London

The National Gallery Self-Portrait

Fig. 73. *The Masterpieces of Murillo* (cover). Gowans's
Art Books, No. 10 (London and Glasgow, 1906).
Paper, 5 3/4 x 4 in. (14.7 x 10 cm). The National
Gallery, London

National Gallery's collection when it was founded in 1824.[50]
At a board meeting held on July 17, 1850, just three days
before the Ashburnham sale, the trustees resolved to write
to the treasury recommending the purchase of three paint-
ings "at a price not exceeding six thousand pounds": Murillo's
self-portrait, Teniers's *Village Feast*, and Rembrandt's *Portrait
of Anslo and His Wife*.[51] Such was the success of the sale that
the gallery's keeper, Thomas Uwins, had to report back to
the board that they had been unsuccessful in acquiring any
pictures from the Ashburnham collection. This may also have
been due to the treasury only granting the gallery "a sum not
exceeding three thousand pounds," that is, half of what the
gallery had previously petitioned for.[52]

Richard Ford had also wished to acquire Murillo's
self-portrait at the Ashburnham sale—almost certainly
for William Stirling, who had considerably more dispos-
able income than he—but, as with the National Gallery,
his attempts were futile, such was the interest in Murillo
among collectors of the time. After viewing the sale on July
19, 1850, the day before the auction, Ford wrote to Stirling
saying, "I am afraid there is no chance of you getting the
Murillo. I dare say it will fetch £500. The room was full of
millionaries [*sic*] and aficionados... I was told in the room
that the pictures were largely protected. I left a commis-
sion for 150 guineas and if we get it and you don't like the
lot, I shall be charmed to see it at 123 if not 128."[53] Having

attended the sale the following day, Ford relayed to Stirling that Murillo's self-portrait had fetched the vast sum of 790 guineas (equivalent to £829 10s), making it one of the most significant Spanish paintings sold at auction in London in the nineteenth century. The painting was acquired by Earl Spencer and displayed at Althorp House in Northumberland almost immediately—appearing in the *Catalogue of Pictures at Althorp House* published a year later—and remained hanging there for more than a century.[54]

After the National Gallery's failed first attempt to acquire Murillo's self-portrait, another opportunity to purchase the painting did not arise until 1953. Just a few years after an exhibition of paintings from Althorp House was held at Agnew's in 1947, the picture was offered to the National Gallery for £16,000. After considerable negotiation attempts on the part of the gallery, the sale finally went through in June 1953, and the painting entered the national collection definitively.[55] It joined eight other paintings by—or attributed to—Murillo, including the almost contemporaneous masterpiece *Christ Healing the Paralytic at the Pool of Bethesda* (one of eleven canvases for the Hospital de la Caridad in Seville), which had been presented to the gallery by the executors of W. Graham Robertson three years earlier (fig. 72). The self-portrait was the first painting by Murillo that the National Gallery had actively acquired since 1837, when it had purchased *Heavenly and Earthly Trinities* shortly after its foundation.

By the twentieth century, the National Gallery self-portrait had supplanted the Frick painting as the most widely recognizable image of Murillo. This was in part due to the latter having been in a private collection in Paris in the late nineteenth century and subsequently having gone to America in 1904. And so it is that the National Gallery self-portrait, in which an aging Murillo presents himself as an experienced artist—albeit in a very personal manner—was chosen as the frontispiece for both the popular Gowans's Art Books (fig. 73) and *Klassiker der Kunst* series (1913), being universally considered the most familiar and enduring image of the painter.[56] Its arresting appearance and highly inventive representation still distinguish it as one of the most significant self-portraits of the Spanish Golden Age.

Notes

1 Flavelle Monypenny 1910, 145.

2 Murillo's self-portrait in the National Gallery, London, featured in all these exhibitions: London 1895–96, cat. 103; London 1913, cat. 99; London 1920–21, cat. 83; London 1983, cat. 61.

3 Both were held at Dulwich Picture Gallery in London (see London / Munich 2001 and London 2013). On the subject of the taste of Spanish painting in Britain, see the exhibitions in London and Edinburgh (London 1981 and Edinburgh 2009) and the collection of essays edited by Glendinning and Macartney (2010).

4 F. Torre Farfán, *Fiestas de la Sta. Iglesia de Sevilla*…, Seville 1672, 191, quoted by E. Harris (translated by N. Glendinning) in Glendinning and Macartney 2010, 228.

5 *Diary of John Evelyn* 1955, 325. These paintings, *Three Boys* and *Invitation to a Game of Argolla*, are now at Dulwich Picture Gallery, London; see London / Munich 2001, 125–27, cats. 22 and 23, and Bray 2013, 22.

6 Pilkington 1797, 432.

7 Harris 1987, pl. 36c.

8 Harris 1987.

9 For Gainsborough and Murillo, see Bray 2013, 12 and 30. *St. John the Baptist in the Wilderness* was exhibited for sale with the rest of Gainsborough's collection in 1789, two years after the artist's death. It was ascribed to Murillo until Neil MacLaren cast doubts on its attribution in his Spanish paintings catalogue (1970, 80).

10 Letter XCV (Hilles 1929, 145).

11 Palomino 1739, 121.

12 In Manchester, twenty-seven paintings by Murillo were exhibited, compared to twenty-six by Diego Velázquez, six by Francisco de Zurbarán, four by Francisco de Goya, three by Alonso Cano, two by El Greco, and two each by Francisco Ribalta and Jusepe de Ribera.

13 Davies 1819, 127.

14 Ibid., xi.

15 Pilkington 1797, 433.

16 For a discussion of eighteenth-century guidebooks and their respective merits, see Braham in London 1981, 13–15.

17 Ford 1998a, 33.

18 Both are in the Francis Ford Collection, London. See Ford 1998b, 381–82, nos. FP12 and FP21; and Sarah Symmons in Glendinning and Macartney 2010, 23–25.

19 Ford 1847, 52.

20 Richard Twiss (1772–73) considered Murillo's style to be "in the manner of Paul Veronese, whom he sometimes nearly equalled," and Henry Swinburne (1772–73) wrote that Murillo's "manner puts me much in mind of Guercino"; see London 1981, 19.

21 A. Moore, "Sir Robert Walpole, Prime Minister and Collector," in Norfolk 2013, 55. The hang was recreated at Houghton Hall in 2013 and is reproduced in color in the catalogue accompanying the exhibition.

22 Christie's, London, May 27–28, 1853. A number of important Spanish paintings were acquired at the sale by the National Gallery, London (such as Francisco de Zurbarán's *St. Francis in Meditation*), and it also included the Frick self-portrait by Murillo.

23 Previously, John Frederick Lewis had made the watercolor *Murillo Painting the Virgin in the Franciscan Convent at Seville* (1838; Minneapolis Institute of Art), following a visit to Spain in 1832.

The National Gallery Self-Portrait

24 On Phillip's painting, see H. Macartney, "The British 'Discovery' of Spanish Golden Age Art," in Edinburgh 2009, 82–83.

25 Stirling 1848, 2: 829. Stirling stated that "this venerable market presents every Thursday an aspect which has changed little since the days of Murillo," and Richard Ford had also vividly described it a couple of years earlier (Ford 1847, 56).

26 Stirling 1848, 2, reproduced facing p. 826.

27 Stirling listed Wilkie's copy in the collection of the Earl of Leven, Melville House, Fifeshire (Stirling 1848, 2: 898).

28 Stirling-Maxwell 1891, 3: 1098.

29 *Art Treasures Examiner* 1857, 179; the engraved likeness of Murillo reproduced on p. 178.

30 Princess Victoria's Journal, August 3, 1836; quoted by Brooke in Liverpool 1990–91, 25.

31 For a fuller discussion, see "Murillo's Self-Portraits: A Sketch" in this publication, especially pp. 40–43.

32 Sandrart 1683, reproduced facing p. 392; Dezallier d'Argenville 1762, 2, reproduced facing p. 254. In his text, Dezallier d'Argenville conflates the two self-portraits, stating that Murillo painted himself at the insistence of his children, portraying himself wearing a *golilla*: "Murillo n'a pas moins bien réussi dans le portrait & dans le paysage; il céda à l'empressement de ses enfans, en se poignant lui-même en golille" (p. 257).

33 In the original text, though not in the abridged translation of 1739, Palomino wrote of "his natural endowments; he had a good figure and an amiable disposition and was humble and modest, so much so that he did not disdain to accept correction from anyone" (1987, 283).

34 The Rev. Pilkington referred to "the striking character of truth and nature in all his paintings" (see note 11 above), though this was a consideration more often applied to Murillo's paintings of street children.

35 A high-quality copy after the National Gallery self-portrait, identical in every respect except for the arrangement of letters within the inscription, is at Petworth (Courtauld Institute, neg. B.58/282); another, of much smaller dimensions (14 × 11 in.) and omitting the objects and inscription in the foreground, is in the Wellington collection at Stratfield Saye (Courtauld Institute, neg. B.76/1094; Wellington 1901, 1: 162, no. 106 [as Murillo]); a bust-length version (16 × 21 in.) is in the Duke of Bedford's collection at Woburn Abbey and was seen there by Gustav Friedrich Waagen in 1857 (Waagen 1857, 336; Scharf 1877, 102–3, no. 161); and a head-only variant (16 × 16 in.), formerly in the Standish collection and sold at Christie's in 1853,

has more recently appeared on the market as an autograph replica (sale, Tajan, Paris, June 20, 2007, lot 47).

36 Waterhouse 1947, 78; MacLaren 1970, 71–74, no. 6153; N. Glendinning in Glendinning and Macartney 2010, 44–45.

37 Entry for February 3, 1729, Diary of the first Earl of Egmont, Historical Manuscripts Commission, 1923, 3: 344 (transcribed by Waterhouse 1947, 78).

38 Vertue 1937–38, 126–27. Other Murillos listed by Vertue in Bagnall's possession include a large picture of flying angels, another of two beggar boys playing dice, one of the Infant St. John with a lamb, and a companion picture of a sleeping child with a skull.

39 Rorschach 1989–90, 20.

40 For an account of Prince Frederick as a collector and patron of the arts, see Rorschach 1989–90, 1–76 (Murillo's self-portrait on pp. 63–64, no. 60).

41 Vertue 1937–38, 126–27. As well as *A Philosopher* by Ribera, Prince Frederick also owned a *Flight into Egypt* by Murillo and *Portrait of the Marquis of Aytona* by Velázquez (both untraced).

42 In the household accounts of Prince Frederick and his wife, preserved in the Duchy of Cornwall Office, is an invoice submitted by John Anderson for work on the prince's pictures. Not settled until September 1749, the account for 1747 includes "Lineing & Cleaning Morellas Head 1: 1: 0" (extract from a letter, January 10, 1957, from Oliver Millar to Neil MacLaren in the National Gallery Archives). In the same letter, Millar refers to an unpublished volume of Vertue's notes (B.M., MS 19027, f. 20v), in which a list of the Prince's pictures in 1750 includes "Morriglio [sic] the painter by himself."

43 For a detailed discussion of the painting and the various props within it, see Einberg and Egerton 1988, 110–14, cat. 103.

44 See Einberg and Egerton 1988, 112–13, figs. 36 and 37. Hogarth originally included some long paintbrushes poking through the thumbhole of the palette, though these were subsequently painted out.

45 *Art-Journal* 1855, 213.

46 After his death in 1764, Hogarth's *Portrait of the Painter and His Pug* was left to his widow and subsequently passed to her cousin Mary Lewis, who eventually sold it at Greenwood's, April 24, 1790, lot 47, where it fetched £47 5s (less than half the sum realized by Murillo's self-portrait at the same auction house four years later).

47 A copy of the Dundas sale catalogue in the National Gallery Archives is annotated by J. E. Breen, who visited Lord Ashburnham's house on Dover Street on May 13, 1804. Murillo's self-portrait is listed in *A Catalogue of the Pictures of John, 2nd Earl of Ashburnham*, a typescript copy of which is in the National Gallery Library, dated 1793], 9, no. 96: "[Murillio] his Portrait by himself £105 . . . The above five Pictures bought at Sir Thos. Dundas's sale of Pictures." (The date of 1793 must be erroneous, for the Dundas sale did not take place until the following year).

48 Earl of Ashburnham sale, Christie's, London, July 20, 1850, lot 50.

49 The price obtained for Murillo's self-portrait was inferior only to that of a landscape by Salvator Rosa (lot 45, sold for £1735) and two paintings by Nicolas Poussin, *The Triumph of Bacchus* (lot 63, for £1218; now in the Nelson-Atkins Museum of Art, Kansas City) and its pendant *The Triumph of Pan* (lot 64, for £1239; in the National Gallery, London, purchased in 1928).

50 Angerstein was an admirer of William Hogarth. In addition to *The Painter and His Pug*, he owned his *Marriage à la Mode* series (National Gallery, London). Hogarth's self-portrait was among the British paintings moved to the newly founded National Gallery of British Art at Millbank in 1897 and transferred definitively to the Tate Gallery in 1951.

51 July 17, 1850; National Gallery Archives, Minutes of the National Gallery Board Meeting, NG1/2, pp. 99–100. The self-portrait is listed as "No. 1. Murillo, Portrait of the Painter" (p. 100).

52 August 12, 1850; National Gallery Archives, Minutes of the National Gallery Board Meeting, NG1/2, p. 103.

53 Ford is referring to his own house (123 Park Street) and Stirling-Maxwell's (128 Park Street). Ford's letter is transcribed in full by Howarth (1999, 42).

54 Althorp catalogue 1851, 65, no. 272.

55 On April 9, 1953, the board considered Agnew's offer of the painting at £16,000 and resolved to counter-offer £14,000. This was refused on May 14, 1953, and, after further negotiations, it was resolved to purchase the picture for £16,000 (with the board authorizing payment on June 11, 1953).

56 The volume titled *The Masterpieces of Murillo* (fig. 73) was the tenth in the popular and affordable Gowans's Art Books series "intended to give the lover of art a general idea of the style and characteristics of the most famous painters in the world." The image was also reproduced—as a head-and-shoulders detail—on the front cover. The National Gallery self-portrait also appeared as the frontispiece in Mayer 1913.

Checklist
of the Exhibition

Bartolomé Esteban Murillo
Self-Portrait, ca. 1650–55
Oil on canvas, 42 1/8 × 30 1/2 in. (107 × 77.5 cm)
Inscribed: VERA EFIGIES BARTHOLOMAEI STEPHANI A
MORILLO MAXIMI PICTORIS, / HISPALI NATI ANNO 1618
OBIJT ANNO 1682 TERTIA DIE MENSIS APRILIS. (The true
image of Bartolomé Esteban Murillo, famous painter, born
in Seville in the year 1618 and died on the third day of the
month of April in the year 1682.)
The Frick Collection, New York; Gift of Dr. and Mrs. Henry
Clay Frick II, 2014 (2014.1.01)
Figure 24

Provenance: Property of the painter's son, Gaspar Murillo
(1661–1709), Seville, until 1709; Bernardo de Iriarte (1735–
1814), Madrid, from 1790; acquired by Francisco de la Barrera
Enguídanos, Madrid, upon sale of Iriarte's possessions, 1806;
upon his death, acquired for £1,000 by the English vice-
consul Julian Williams, Seville, 1832; acquired through the
intervention of Isidore-Justin-Séverin, Baron Taylor (1789–
1879), for 2500 *duros*, for King Louis Philippe d'Orléans
(1773–1850), Paris, 1836; Louis Philippe's Galerie Espagnole,
Musée du Louvre, Paris, 1838–49; Louis Philippe d'Orléans
sale, Christie's, London, May 27–28, 1853, lot 329; acquired
for £420 by John Nieuwenhuys, Wimbledon, 1853; Frédéric,
Baron Seillière (1839–1899), Paris, by 1883; inherited
by his daughter Anne-Alexandrine-Jeanne-Marguerite
(1839–1905), Princess of Sagan, Paris; sold at Lawrie and Co.,
London, 1904; acquired for $22,000 by Henry Clay Frick
(1849–1919), New York, October 4, 1904; by descent through
his family, New Jersey and New York; Gift of Dr. and Mrs.
Henry Clay Frick II, 2014, The Frick Collection, New York.

Bibliography: Ceán Bermúdez 1800, 2: 55; Ceán Bermúdez
1806, 103–4; *Notice des tableaux* 1838, 48, cat. 183; Stirling 1848,
897–99; *The Athenaeum—Journal of Literature, Science, and the
Fine Arts*, May 14, 1853, 628; Bürger 1860, 130; Curtis 1883,
295, cat. 465; Alfonso 1886, 235–36; Lefort 1892, 94, cat. 407;
Calvert 1907, 185; Mayer 1912, XX, XXIII; Boston 1912, 18, cat.
67; *Pictures in the Collection of Henry Clay Frick* 1925, 146–47;
Montoto 1932, 213; MacLaren 1970, 73; Bédat 1973, 144;
Angulo Íñiguez 1981, 1: 461–62, 2: 320–22, cat. 413; Baticle
and Marinas 1981, 133–34; Allan Braham in London 1981,
85; Harris 1982a, 767; Princeton 1982, 169; Manuela Mena
Marqués and Enrique Valdivieso in London 1983, 188; Harris
1987, 159; Palomino 1987, 283; Schiff 1988, 111–12; Valdivieso
1990, 216; Karge 1991, 167; Waldmann 1995, 167; Barry 2002,
80; Suzanne L. Stratton-Pruitt, in Fort Worth / Los Angeles
2002, 186–87, cat. 33; Baticle 2003, 180, 185; María de los
Santos García Felguera in New York 2003, 432–33, cat. 49;
Valdivieso 2003, 358; Ignacio Cano Rivero in Bilbao / Seville
2009, 188–93, 519–20, cat. 1; Martínez del Valle 2010, 155–56;
Valdivieso 2010, 242, 245, 559, cat. 409; Gabriele Finaldi in
Madrid / Seville / London 2012–13, 100; Galassi 2012, 128–29;
Galassi 2016, 114, 116; Javier Portús in Madrid 2016, 155–57;
Javier Portús in Seville 2016, 80–81, cat. 2.

Bartolomé Esteban Murillo
Self-Portrait, ca. 1670
Oil on canvas, 48 × 42 1/8 in. (122 × 107 cm)
Inscribed: BART.US MURILLO SEIPSUM DEPIN/GENS PRO
FILIORUM VOTIS ACPRECI/BUS EXPLENDIS (Bartolomé

Murillo portraying himself to fulfill the wishes and prayers
of his children)
The National Gallery, London; Bought, 1953 (NG 6153)
Figure 25

Provenance: Painted for the artist's children; possibly property of the painter's son, Gaspar Murillo (1661–1709), Seville, until 1709; acquired, probably in Seville, by Daniel Arthur, an Irish merchant and banker; George Bagnall, who had married Arthur's widow, 26 King Square (later called Soho Square), London, by 1729; Frederick, Prince of Wales (1707–51), London, from at least 1740; probably acquired after his death by Sir Lawrence Dundas (ca. 1710–1781); Sir Lawrence Dundas's Sale, Greenwood's, London, May 31, 1794, lot 25; purchased for £105 by John Ashburnham, 2nd Earl of Ashburnham (1724–1812); by descent; Bertram Ashburnham, 4th Earl of Ashburnham (1797–1878) sale, Christie's, London, July 20, 1850, lot 50; purchased by Frederick Spencer (1798–1857), 4th Earl Spencer, Althorp House for £829 10s; by descent at Althorp House until sold by John Spencer (1924–1992), 8th Earl Spencer, through Agnew's to the National Gallery, June 1953.

Bibliography: Ceán Bermúdez 1806, 103–4; Stirling 1848, 898–99; Scharf 1877, 103; Curtis 1883, 293–94, cat. 462; Alfonso 1886, 203; Lefort 1892, 95; Justi 1904, 88–89; Calvert 1907, 148, cat. 164; London 1913–14, 99–101, cat. 99; Waterhouse 1947, 78; Edinburgh 1951, 23, cat. 28; Harris 1951, 314; Kubler and Soria 1959, 277; Carter 1963, 9–10; *Acquisitions* 1963, 65–67, cat. 6153; MacLaren 1970, 71–74, cat. 6153; Gaya Nuño 1978, 111, cat. 281; Angulo Íñiguez 1981, 1: 462, 2: 322–26, cat. 414; Allan Braham in London 1981, 85–86, cat. 43; Caamaño Martinez 1982; Luna 1982, 160; Manuela Mena Marqués and Enrique Valdivieso in London 1983, 188, cat. 61; Palomino 1987, 283; MacLaren and Braham 1988, 71–74, cat. 6153; Rorschach 1989–90, 63–64, cat. 60; Xanthe Brooke in Liverpool 1990–91, 30, cat. 1; Valdivieso 1990, 217, 220; Brown 1991, 276–77; Karge 1991, 10–11; Howarth 1999, 42; Xanthe Brooke in London / Munich 2001, 24, 116–17, cat. 18; Valdivieso 2003, 358–59; Waldmann 2007, 151–56; Martínez del Valle 2010, 156–57; Pergam 2010, 275; Valdivieso 2010, 245–46, 572–73, cat. 425; Gabriele Finaldi in Madrid / Seville / London 2012–13, 99–101, cat. 2; Javier Portús in Madrid 2016, 16, 128, 153, 155–60, 276, cat. 83; Javier Portús in Seville 2016, 55–59.

CAT. 3

Bartolomé Esteban Murillo
Juan Arias de Saavedra, 1650
Oil on canvas, 53 1/8 × 38 5/8 in. (135 × 98 cm)
Inscribed at bottom: VIRO SVPRA OMNEM LAVDEM POSITO, REGALI PROAVORVM SANGINE CLARISSIMO, NATVRAE / DOTIBVS VSQVE AD INVIDIAM ORNATO, PVRPVREO D. IACOBI STEMMATE INSIGNITO, PRO / ARCENDIS COERCENDIS QVE, INFIDVM CRIMINOSIS SACRAE HISPALENSIS INQVISITIONIS / MAIORI MINISTRO, INGENVARVM ARTIVM, PICTORIA PRAESERTIM PHILOSOPHO, D.D. / IOANI DE SAAVEDRA, HANC SVI CORPORIS VMBRAM ET ANIMI IDEAM. SD QVID. NI / ALIVD NISI SE SIBI SVVS BARTOLOMEVS AMVRILLO AVIDIS POTIVS, QVAM VIVI / DIS PENECILIS AFECTVS ET GRATITVDINIS ERGO DELINEABAT. (To the man who is above all praise, most illustrious for the royal blood of his ancestors, adorned with all virtues to the point of being envied, honored with the purple cross of Santiago, lenient to those who need to be corrected, hard with the criminals, high minister of the Holy Inquisition of Seville, profound connoisseur of the liberal arts, and of painting in particular, Don Juan de Saavedra. This shade of his body and this idea of his soul, his Bartolomeo Murillo painted, nothing else if not for himself, with brushes eager, more than vivacious, with devotion and gratitude); in tablet held by putto at top left, AETAT / XXVIIII (at the age of twenty nine); in the tablet held by putto at top right, ANNO / MDCL (in the year 1650).
Collection Duchess of Cardona
Figure 10

Provenance: Collection of the Dukes of Medinaceli, Madrid, by 1920; by descent to the Duchess of Cardona.

Bibliography: Dusmet y Alonso 1920, 50–51; Angulo Íñiguez 1981, 1: 459–61, 2: 329, cat. 454; Valdivieso 1990, 215–16; Duffy-Zeballos 2007, 148–50; Martínez del Valle 2010, 154; Valdivieso 2010, 242, 558, cat. 408.

CAT. 4

Bartolomé Esteban Murillo
Young Man, ca. 1650–55
Oil on canvas, 25 3/8 × 17 3/4 in. (64.4 × 45.2 cm)
Private collection
Figure 11

Provenance: Private collection, France; sale, Tajan, Hôtel Drouot, Paris, October 21, 2009, lot 26 (as Spanish School); with Andrew Blackman; purchased by present owner, 2012.

Bibliography: Sale catalogue, Tajan, Hôtel Drouot, Paris, October 21, 2009, lot 26. Otherwise unpublished.

CAT. 5

Bartolomé Esteban Murillo
Standing Male Figure: Study for a Portrait, ca. 1660
Pen and brown ink over traces of black chalk underdrawing
on off-white paper, 5 5/8 × 4 in. (14.3 × 10.2 cm)
Inscribed at lower center in black ink: Bartolome Muril…
The Metropolitan Museum of Art; Rogers Fund, 1965
(65.66.12)
NEW YORK ONLY
Figure 16

Provenance: Professor John Isaacs, London; Isaacs sale,
Sotheby & Co., London, January 28, 1965, lot 181; N. Betts,
London, 1965; Colnaghi & Co., London, 1965; purchased by
The Metropolitan Museum of Art, New York, 1965.

Bibliography: Angulo Íñiguez 1974, 107; Gridley McKim
Smith in Lawrence 1974, 51–52, cat. 27; Manuela Mena
Marqués in London 1983, 220, cat. D23; Bambach 1999,
415n. 16; Jonathan Brown in New York 2010a, 78–79, cat. 22;
Martínez del Valle 2010, 40–41; Brown 2012, 208–9, cat. 83;
Santander 2012, 44, cat. 22; Mena Marqués 2015, 226–27,
cat. 36.

CAT. 6

Bartolomé Esteban Murillo
Nicolás Omazur, 1672
Oil on canvas, 32 5/8 × 28 3/4 in. (83 × 73 cm)
Museo Nacional del Prado, Madrid (P03060)
Figure 21

Provenance: Painted for Nicolás Omazur in Seville, 1672; in
the inventory of his collection of January 15, 1690 (cat. 19);
his son, Nicolás Omazur, in the inventory compiled after his
father's death, between June 26 and July 8, 1698 (cat. 39);
Bernardo de Iriarte (1735–1814), Madrid, by 1806; acquired
by Dubois in Paris, 1842; Roberth S. Holford, London, 1883,
who had acquired it through Buchanan; Sir George Lindsay
Holford, Dorchester House, London, 1928; purchased by the

Museo Nacional del Prado, Madrid, from Madame Adler in
Paris, 1964.

Bibliography: Céan Bermúdez 1806, 105–6; Stirling 1848,
2: 899; Curtis 1883, 298, cat. 471; Alfonso 1886, 187; Lefort
1892, 94; Mayer 1923, 232; Montoto 1932, 212; Gaya Nuño
1978, 107–8, cat. 243; Angulo Íñiguez 1981, 1: 452, 465–71,
2: 326–28, cat. 416; Luna 1982, 160; Nina A. Mallory in
Princeton 1982, 90; Manuela Mena Marqués and Enrique
Valdivieso in London 1983, 189–90, cat. 63; Kinkead 1986,
132, 135–36, 139, 142; Valdivieso 1990, 220–22; Valdivieso
2002, 130; Valdivieso 2003, 360; Duffy-Zeballos 2007, 168;
Martínez del Valle 2010, 157–58; Valdivieso 2010, 243–45,
569, cat. 420; Javier Portús in Madrid 2016, 156, 275, cat. 56.

CAT. 7

Richard Collin, after Bartolomé Esteban Murillo
Bartolomé Esteban Murillo, 1682
Engraving on paper
Inscribed below the portrait on the right: RICHARD. COLLIN
CHALCOGRAPHUS REGIS SCULPSIT BRUXELLAE. AN.
1682.; in a tablet at bottom, BARTHOLOMEUS MORILLUS
HISPALENSIS / SE-IPSUM DEPINGENS PRO FILIORUM
VOTIS AC PRECIBUS EXPLENDIS. / NICOLAUS OMAZURINUS
ANTVERPIENSIS / TANTI VIRI SIMULACRUM IN AMICITIAE
SYMBOLON / IN AES INCIDI MANDAVIT. ANNO 1682.
(Bartolomé Murillo of Seville painted himself to fulfill
the wishes and prayers of his children. Nicolás Omazur of
Antwerp ordered that I engraved the portrait of such a man
on a copper plate, as a symbol of friendship. In the year 1682.)

Private collection, New York; 13 3/4 × 9 1/4 in. (35 × 23.5 cm)
NEW YORK ONLY
Frontispiece

The British Museum, London (1874, 0808.2375);
14 1/4 × 9 5/8 in. (36.2 × 24.4 cm)
LONDON ONLY
Figure 67

Bibliography: Ceán Bermúdez 1800, 55; Ceán Bermúdez
1806, 104–5; Stirling 1848, 898–99; Stirling-Maxwell 1873,
124; Lefort 1892, 94; Viñaza 1894, 139; Montoto 1932, 213;
MacLaren 1970, 71–72; Manuela Mena Marqués and Enrique
Valdivieso in London 1983, 188; Carrete Parrondo 1982,
138–39; Martínez del Valle 2010, 134; Murillo 2010, 35–36;
Gabriele Finaldi in Madrid / Seville / London 2012–13, 100.

Bartolomé Esteban Murillo
Two Women at a Window, ca. 1655–60
Oil on canvas, 49 1/4 × 41 1/8 in. (125.1 × 104.5 cm)
National Gallery of Art, Washingon; Widener Collection
(1942.9.46)
Figure 32

Provenance: Pedro Francisco Luján Góngora, duque de
Almodóvar del Rio, Madrid; his heirs; sold to William
A'Court (1779–1860), later 1st Baron Heytesbury,
Heytesbury, Wiltshire, 1823; by descent to his elder son,
William Henry Ashe (1809–1891), 2nd Baron Heytesbury;
by descent to his grandson, William Frederick Ashe
(1862–1903), 3rd Baron Heytesbury; sold to Stephen T.
Gooden, London, 1894; purchased by Peter A.B. Widener
(1834–1915), Elkins Park, Pennsylvania, December 3, 1894;
by descent to his son, Joseph E. Widener (1860–1943); given
to the National Gallery of Art, 1942.

Bibliography: Stirling 1848, 2: 920–21; Waagen 1857, 388–89;
Curtis 1883, 288, cat. 444; Alfonso 1886, 205; Justi 1904,
22; Mayer 1913, 287; Mayer 1915, 315; Valentiner 1931, 34;
Widener Collection 1942, 6, cat. 642; Gaya Nuño 1961, 58–59;
Gaya Nuño 1978, 103–4, cat. 197; Angulo Íñiguez 1979;
Angulo Íñiguez 1981, 1: 452–55, 2: 307–8, cat. 399; Kinkead
1981, 348; Brown 1982, 40–42; Brown and Mann 1990, 105–9;
Stoichita 1990, 118–23; Valdivieso 1990, 230; Fernández-
Galiano 1990, 331–33; Karge 1991, 172–74; Kopper 1991, 199;
Xanthe Brooke and Peter Cherry in London / Munich 2001,
15, 36, 98–100, cat. 10; Peter Cherry in Washington 2002,
270–71, cat. 70; Suzanne L. Stratton-Pruitt in Fort Worth /
Los Angeles 2002, 184–85, cat. 32; Rosenberg 2006, 108–9,
233; Valdivieso 2010, 229, 536–37, cat. 387; N. Glendinning
in Glendinning and Macartney 2010, 54–55; Stoichita 2011.

Bartolomé Esteban Murillo
A Peasant Boy Leaning on a Sill, ca. 1675
Oil on canvas, 20 1/2 × 15 1/8 in. (52 × 38.5 cm)
The National Gallery, London; Presented by M. M. Zachary,
1826 (NG 74)
Figure 34

Provenance: In the collection of Jeanne-Baptiste d'Albert
de Luynes, Countess of Verrue (1670–1736), Paris; her sale,
Paris, April 29, 1737, lot 66; bought for 2,999 *livres* 19 *sols*
(with its pendant *A Young Girl Lifting Her Veil*) by Pierre-
Louis-Paul Randon de Boisset (1708–1776), Paris; his sale,
Remy/Julliot, Paris, March 7, 1777, lot 19; bought for 2999
livres 19 *sols* (with its pendant *A Young Girl Lifting Her Veil*)
by Alexandre-Joseph Paillet (1743–1814); William Petty
(1737–1805), 2nd Earl of Shelburne and 1st Marquess of
Lansdowne, London; his posthumous sale, Coxe, London,

March 20, 1806, lot 50 (its pendant of *A Young Girl Lifting
Her Veil* sold separately, lot 51); bought for £115 10s by Sir
Francis Baring (1740–1810); M. Zachary, by 1821; presented
by M. Zachary to the National Gallery, London, 1826.

Bibliography: Curtis 1883, 276, cat. 412; Alfonso 1886, 175;
Lefort 1892, 96, cat. 433; Calvert 1907, 139; Mayer 1913, 287;
Muñoz 1942, XXVII, cat. 18; Soria 1948; MacLaren 1970,
64–65; Scott 1973, 23–24; Gaya Nuño 1978, 112, cat. 299;
Angulo Íñiguez 1981, 1: 451, 455, 2: 297–98, cat. 380; Harris
1982b, 8, 11; Luna 1982, 160; Manuela Mena Marqués and
Enrique Valdivieso in London 1983, 193, cat. 71; MacLaren
and Braham 1988, 64–65; Valdivieso 1990, 236; Xanthe
Brooke and Peter Cherry in London / Munich 2001, 26, 34,
118–19, cat. 19; Suzanne L. Stratton-Pruitt in Fort Worth /
Los Angeles 2002, 180; Gabriele Finaldi in Madrid 2004,
342, cat. 28; Valdivieso 2010, 230–31, 547, cat. 397.

Technical Studies

In conjunction with this project, four of Murillo's paintings—the two self-portraits (cats. 1, 2), *Juan Arias de Saavedra* (cat. 3), and the *Young Man* (cat. 4)—have undergone extensive technical analysis by a team of restorers and scientists in New York, London, and Madrid; and three of them (cats. 1, 3, and 4) were fully restored. Of these, two (cats. 3, 4) are shown to the public for the first time, having been virtually unpublished before now.

The essays in this section examine each of the four paintings in detail. Murillo's technique has been the subject of enlightening articles and essays, published between 1980 and 2011, and the new research adds to the growing knowledge of how Murillo painted. Through technical examination—with the use of infrared reflectography, X-radiography, and macroscopic XRF and the analysis of paint samples—we have been able to ascertain how the four paintings were created and to what degree they have changed over the centuries. From the canvases to the grounds and pigments, these works of art have been thoroughly scrutinized; the information provided here relates to the materials Murillo used and the transformations they underwent over time. It is essential and fascinating to understand these masterpieces as objects, to fully appreciate the art of Murillo and what we can see today.

Murillo's Self-Portrait of ca. 1650–55

Dorothy Mahon and Silvia A. Centeno

The technical investigation carried out in connection with the recent conservation treatment of the Frick self-portrait confirms that Murillo's initial conception of this uniquely creative depiction was rather conventional.[1] The artist began by preparing a fabric support proportioned for a bust size portrait with dimensions of about 84 by 81 cm. The support is a plain weave, handwoven fabric. The weave was counted by hand from the X-radiograph as consisting of 10 horizontal threads and 15 vertical threads per square centimeter. Radiography reveals the evidence of this original format, including the marks of the strainer and central cross bar created during the application of the priming, as well as steep cusping that resulted from the stretching of the fabric support along the top and bottom (fig. 74). Then, in order to make room for the stone surround, the support was increased in height by stitching on a piece of fabric 22 cm wide along the bottom. Microscopic analysis of samples taken above and below the canvas join indicate that the structure of the dark brown ground preparation and materials of the paint layers above and below the seam are consistent, confirming that the compositional extension was carried out by the artist.[2] Based on measurements taken from the original strainer bar marks that appear in the radiograph, it is possible to suggest that the composition was originally wider and has been subsequently reduced on the right side by 3 cm and on the left by 2.5 cm.[3] The reduction must have taken place sometime between the early 1840s and early 1880s as confirmed by engravings discussed in this publication (see figs. 50, 54). This alteration may have occurred when the painting was relined, a procedure that was probably necessitated more than once because of quite common recurring planar distortions that develop

along canvas joins. There is no record that the painting has been relined since it was acquired by Henry Clay Frick in 1904 and the existing lining, of plain-weave linen fabric attached with an aqueous glue adhesive and stretched on a traditional wooden keyable stretcher, is consistent in appearance with other relining of this type that dates to the late nineteenth or early twentieth century. Pressure during relining has, to a degree, diminished the original surface texture, and resulted in abrasion to the paint layer along the cracks, as well as to the thinly applied deep tones in the sitter's black coat. Despite these conditions, the painting is overall very well preserved. The inscription, which consists of a mixture of vermillion and lead white,[4] was probably added soon after the artist's death as the pigments, as well as the crack pattern, are consistent with the original. The dark reddish brown horizontal stroke of paint applied just above the inscription is contemporary with the inscription.[5]

Murillo began his portrait on the brown ground, sketching with a brush and black paint. Infrared reflectography reveals paint strokes defining the hair and facial features, as well as the preliminary modeling of the face (fig. 75).[6] Brushstrokes outlining the interior contour of the stone confirm that, prior to extending the composition, the artist conceived the portrait as an oval. After establishing the head and torso, the gradations in tone, which set the head apart from the background and establish a sense of light and space behind the figure within the stone frame, were achieved by scumbling with translucent mixtures containing lead white. Final, slight adjustments were then made to the contours of the hair and torso by painting over the background. Much of the paint is thinly applied, and, with age, increasing transparency of the

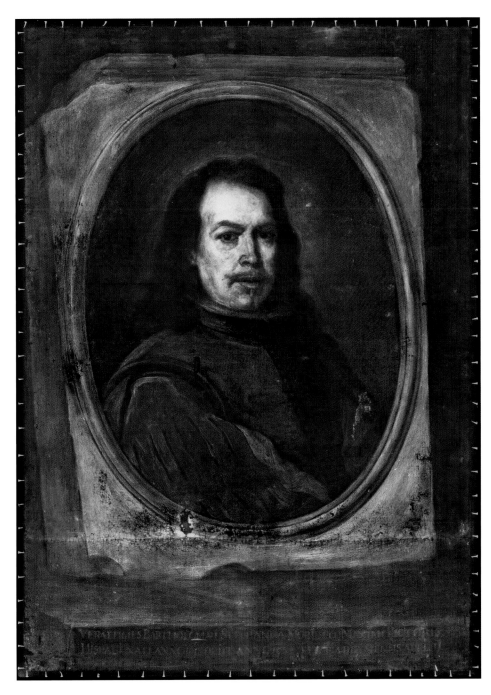

Fig. 74. X-radiograph of Murillo's self-portrait (fig. 24)

lead white has resulted in a diminishment of form in the modeling of the hair, the costume, and in details such as the buttons. The lead map obtained by macroscopic X-ray fluorescence (MA-XRF) imaging, which shows the distribution of lead white, reveals something closer to the original strength of the artist's modeling in these passages (fig. 76). By contrast, the modeling of the face, the white passages of drapery, and the modeling of the stone are painted with thicker, more

robust applications. These variations in paint applications contribute to the luminous atmosphere and tactile sensitivity that are characteristic of this artist.

Perhaps more remarkable is the significant change detected during this technical investigation in the deep brownish background in the upper right. When this area was examined with a stereomicroscope prior to embarking on the cleaning of the painting, it was apparent that the upper paint

Technical Studies

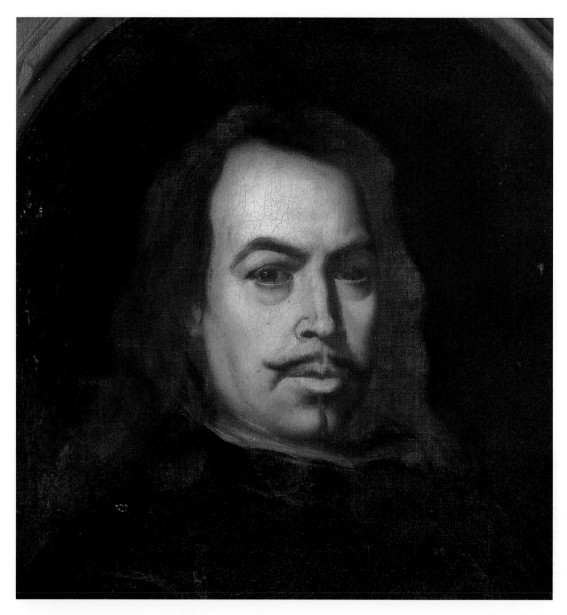

Fig. 75. Infrared reflectogram of Murillo's self-portrait (fig. 24), detail of head

layer contained bright blue pigment particles. The use in oil painting of mixtures containing the blue pigment smalt is notorious for resulting in a degradation that turns blue paint layers an ashy grey or brownish hue. Murillo was known to use smalt, and it has been shown that this pigment has resulted in deterioration in many other of his works.[7] The map for cobalt, the primary component of smalt, obtained by macroscopic XRF (MA-XRF) imaging, provides information on the distribution of this pigment.[8] When the XRF map for cobalt is overlaid with the map for lead that indicates the distribution of lead white, it is apparent that Murillo's intention was to depict the fictive stone block outside in a landscape, leaning against an earthen bluff, with a portion of distant blue sky visible in the background upper right (fig. 77). Even though there are some blue pigment particles remaining in the paint layer, the net effect of the deterioration of this pigment has resulted in an irreversible color change that must be accepted. A tiny sample of paint mounted in cross section confirms the abundance of smalt in the top layer of the background upper right (fig. 78). Only a few strokes of the paint mixtures containing lead white, which was combined with smalt to make the blue sky, remain apparent on close examination with the unaided eye. However, despite the revelation of this unfortunate change, by applying some imagination, this knowledge can bring the viewer closer to the artist's original conception and assist in a greater visual understanding of this rare and unique portrait.

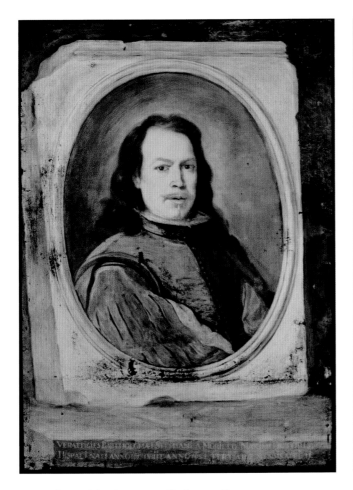

Fig. 76. Elemental distribution map of lead acquired by macroscopic X-ray fluorescence (MA-XRF). This map reveals the lead white used to model the forms and create details that have been visually diminished due to chemical deterioration.

Fig. 77. Here, the distribution map for cobalt, the primary component of the blue pigment smalt, is highlighted in blue and overlaid on the distribution map of lead. These maps were acquired by macroscopic X-ray fluorescence (MA-XRF).

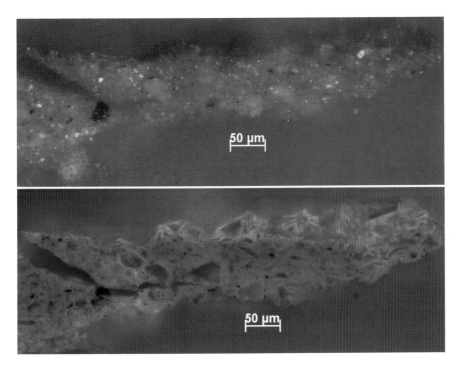

Fig. 78. Photomicrographs of a sample removed from the upper right background of Murillo's self-portrait (fig. 24), taken with visible (top) and ultraviolet (bottom) illuminations. Original magnification 200x.

Technical Studies

Notes

1 The technical investigation was directed by Dorothy Mahon, Conservator, The Metropolitan Museum of Art (MMA), who also carried out the cleaning and restoration of the painting. Pigment analysis and macroscopic X-ray fluorescence (MA-XRF) mapping were undertaken by Silvia A. Centeno, Research Scientist, MMA. The authors are grateful to Evan Read, Manager of Technical Documentation, MMA, for digitizing and assembling the radiograph films, digitally capturing and assembling the IRR images, and digitally assembling the XRF images.

2 From the examination of the cross sections by polarized light microscopy, the ground preparation appears to be a mixture of earth pigments combined with black and white pigments.

3 The estimation of original dimensions was made by measuring from the marks of the original stretcher, which are visible in the radiograph, assuming that the width of the original wood strainer was 5 cm. This is a typical width for seventeenth-century wooden strainers. In addition, the central cross bar visible in the radiograph is 5 cm wide.

4 Macroscopic X-ray fluorescence (MA-XRF) imaging measurements were carried out using a Bruker M6 Jetstream instrument. The painting was scanned with a spot size of 500 microns, at 100 msec/pixel, and with an 800 micron step size. The spectra were processed by employing the Bruker M6 Jetstream software.

5 The conservation treatment of the painting included removal of a thick, discolored varnish and restoration in the shadow side of the coat, the hair that extended onto the shoulders, the background, and the fictive stone frame. Cleaning of old overpainting revealed that the paint surface, while generally abraded, is less damaged than was initially anticipated, except along the canvas join where there is a concentration of loss and significant abrasion.

The portrait head is remarkably well preserved despite diminishment of the surface texture from excessive pressure applied during relining. After cleaning, the painting was varnished with mastic resin, a 7% solution in turpentine, and retouched with dry pigments mixed with a synthetic resin PVA/AYAB. Several thin applications of a 7% solution of mastic resin were applied to fully saturate the surface.

6 Infrared reflectography was completed with an OSIRIS InGaAs near-infrared camera with a 6-element, 150 mm focal length, f/5.6 – f/45 lens; 900-1700nm spectral response.

7 For Murillo's use of smalt, see Von Sonnenburg 1980; Von Sonnenburg 1982; Barry 2002.

8 In addition to the identification of cobalt by MA-XRF, the presence of smalt was confirmed by polarized light microscopy analysis of samples mounted in cross section.

Murillo's Self-Portrait of ca. 1670

Larry Keith

The painting was acquired by the National Gallery, London, in 1953; records suggest it was cleaned and restored not long before its purchase. It has not been treated since, apart from superficial adjustments to the varnish undertaken in 1982 and 2016.[1]

It is painted on a plain-weave canvas; remains of turnover edges are present at the top, right, and bottom edges of the painting, while cusping of the canvas weave is clearly evident at top, bottom, and left edges. The canvas was lined with a glue-paste adhesive and placed on a stretcher sometime before acquisition. The X-radiograph (fig. 79) shows remnants of an old and disrupted coating on the reverse of the original, now covered by the lining canvas, presumably intended as a protective coating as it is only present within the boundaries of what would have been the canvas's original, more slender strainer. Such coatings were often made with red lead pigment, the use of which might explain the radiographic opacity. This coating has been partially removed, though it remains intact over most of the area, resulting in a confused and disrupted radiographic image. The disposition of the coating, combined with the surface crack pattern resulting from the original strainer, strongly suggests that the painting's format remains as intended. This format is also reflected, if not faithfully reproduced, in the engraving based on the portrait made by Richard Collin in 1682 (see fig. 67).[2]

While no samples have been taken, close visual inspection shows that the composition has been developed over a brown ground that is consistent in appearance with other works by Murillo that have been examined by the National Gallery's Scientific Department.[3] The ground is visible in a few places within the composition, such as along the contours between the oval frame and background or other architectural features such as along the edge of the cartouche, but its tonality is not exploited in any systematic way within the modeling of the figure itself.

There are no changes or pentimenti; the composition must have been carefully described onto the canvas before painting, perhaps using a material such as white or red chalk (the latter is depicted among the drawing materials at the lower left), which would not be visible with IRR or radiography.[4]

IRR (fig. 80) shows broad and vigorous brushwork executed in dark paint of what appears to be the first laying-in of the tonal values, the so-called *bosquexo*. The brushwork is particularly evident in the transition between light and dark within the background of the oval and in the outer regions of the architectural elements.

That first sketching-in was then developed with denser layers of local color, smoothing the modeling transitions within the background.[5] Palomino also describes a particular mixture for the initial sketched development of areas of flesh paint; the so-called *tinta de perfilar*, made of a mixture of red lake and earth pigments. However, Murillo's painting of flesh is thickly applied throughout, and little trace of any initial work remains visible apart from within the eyes and the shadowed parts of the eye sockets, particularly the proper left eye. The flesh paint is skillfully modeled with extensive use of wet-in-wet blending between the various tones. Not all the modeling is blended within what appears to be a single layer; both IRR and radiograph images indicate that much of the darker flesh tones are achieved with warm reddish brown glazes laid over a lighter flesh color. This glaze layer has suffered pinpoint losses where it has been applied under the throat, mouth, and along the face's shadowed contour, revealing the lighter color of the underlayer.

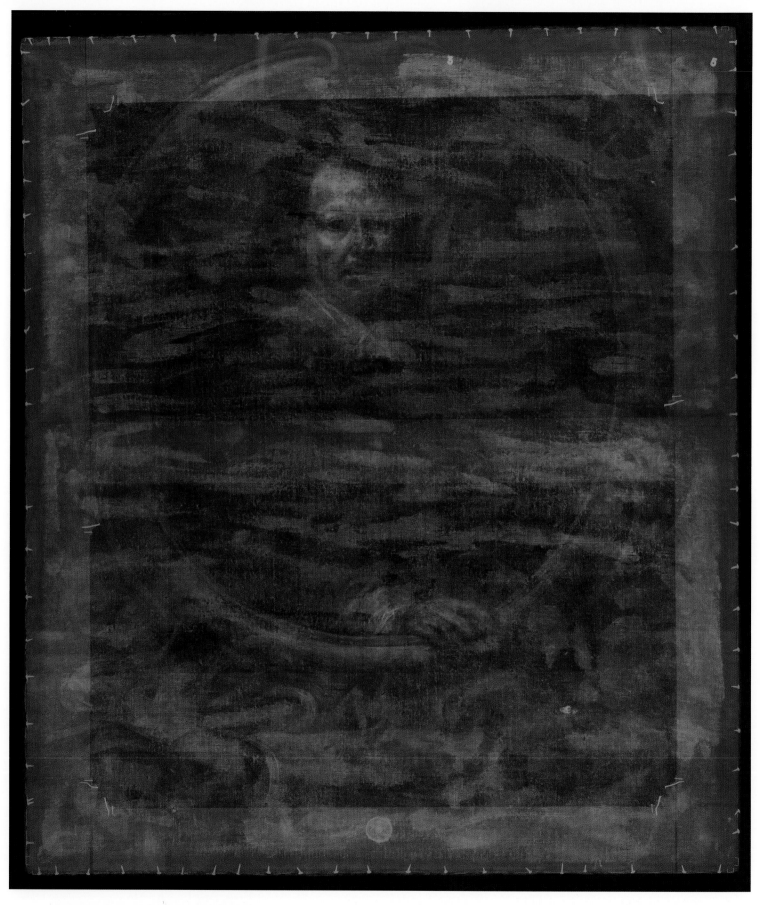

Fig. 79. X-radiograph of Murillo's self-portrait (fig. 25)

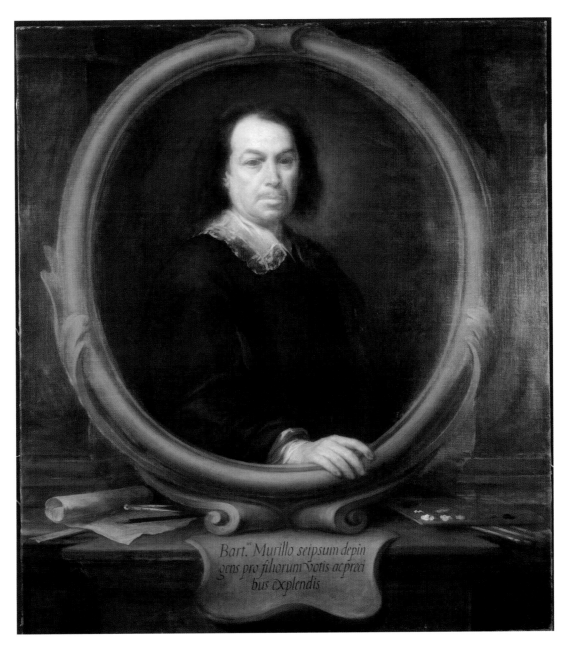

Fig. 80. Infrared reflectogram of Murillo's
self-portrait (fig. 25)

Notes

1 MacLaren and Braham 1988, 71. It may have
been cleaned in 1951, prior to its acquisition.

2 In the engraving, the composition is
reversed, the hand is behind the stone frame,
the dedicatory plaque is larger and different,
the details of the oval frame decoration are
different, and the engraving omits the attributes
of painting and drawing found at the base of the

painting. See discussion of the Collin print on
pp. 42–43, 95 of this publication.

3 For example, the brown ground of the
National Gallery's *Christ Healing the Paralytic at
the Pool of Bethesda* (NG 5931), which has been
identified as containing lead white, an earth
pigment (which is quite likely to be "Seville
earth"), and black-colored ilmenite particles;
see Ackroyd 2011. See also Barry 2002 and Gayo
and Jover de Celis 2010 (translated into English

online at museodelprado.es/en/learn/research/
studies-and-restorations).

4 Both Pacheco and Palomino refer to use of
white and red chalk. See Veliz 1986 and Barry
2002.

5 The binding medium for NG 5931 was found
to be heat-bodied linseed oil throughout a range
of samples. See Ackroyd 2011, 176 and note 19.

Technical Studies

Murillo's
Juan Arias de Saavedra

María Álvarez-Garcillán and Jaime García-Máiquez

The portrait of Juan Arias de Saavedra (see fig. 10), dated 1650 in the cartouche on the right, is in the collection of the Duchess of Cardona.[1] The impressive painting technique, as well as the putti, the Saavedra family escutcheon (with the nine-point crown of the Lordship of Piscina), and the long Latin inscription emphasize the elevated class of the sitter. Arias de Saavedra is dressed in black, wearing a cape emblazoned with a red cross and a chain that identify him as a knight of the Order of St. James. His haughty, aristocratic demeanor, completely lacking in naturalness or warmth, owes much to the phlegm that was interpreted as a sign of elegance and distinction in the Court of Philip IV.

The restoration undertaken in the workshops of the Prado Museum in 2017 had a twofold objective: (1) recovering the original work painted by Murillo to the extent possible, and (2) using this opportunity to better understand Murillo's working methodology based on technical analysis. The painting's state of conservation was far from good: the overall quality and natural reading of the work were severely hampered by a large amount of accumulated dust, oxidized varnishes and old repainted sections, peeling and disintegration of the paint surface, and damage to the fabric support (fig. 81). Cleaning and pictorial retouching have brought to light an image that is in many respects unique.[2]

The oil painting was executed on a low-density taffeta-weave canvas, a common support in mid-seventeenth-century Seville. Its current dimensions are very close to the original. The canvas was relined with another denser taffeta support. Based on the type of fabric and stretcher, this was probably carried out when the work was seized and taken to France by Napoleon's troops, since there is documentary evidence that it was returned to Spain in 1814 in the convoy that brought back artworks recovered from the Musée Napoléon in Paris.[3]

The preparation has a reddish hue, which coincides with that in early works by Murillo. It plays a relevant role in the overall look of the work, remaining visible due to the greater transparency of the top layers of pigment or to mark contours and bring greater volume to figures and forms.

The infrared reflectography (fig. 82) does not reveal a clear underdrawing, as is customary for Murillo.[4] In specific details of the face, such as the eyes or nose, and in the fingers of the putti, it is possible to make out some fine lines, which we have interpreted as drawing. The artist would have subsequently applied successive layers of pigment, respecting the original lines from the beginning. The technical documentation supports this: the figures' contours are dark both in infrared (where the drawing is comparatively darker than its surroundings) and in X-radiographs.

The X-radiograph image (fig. 83) reveals extensive generalized deterioration. At one point the work must have sustained major damage, possibly while it was being transported to France. This is evidenced in numerous losses across the entire surface.[5] It also announced the extraordinary quality of the painting from the very outset, uncovering what had been hidden beneath layers of varnish and repainting. Various small rectifications have come to light in the overall contours (the right side of the putto on the left), along with a far greater pictorial richness of the subject himself. The sitter's hair was originally given a sense of modulation and volume that became dark and flat. His left eye was slightly shifted. His attire was divided into four sections of luminosity, which are perfectly structured in the corresponding X-radiograph

imagery: The shoulder and chest are well illuminated; a band of light crosses his torso (invisible today); the shirt is simpler and, finally, the cape draped over his left shoulder is revealed by the X-radiographs to have had an intense degree of workmanship that is not apparent to the naked eye.

Throughout the cleaning process, previous interventions—oxidized varnishes and other retouching—were gradually eliminated, attaining a balance can be achieved between the damage sustained by the painting and the possibility of overall recovery. By removing the layers of repainting and discreetly retouching the missing pigment, it has been possible to recover the legibility of the composition, the different planes and treatment of space, and the use of light, and, above all, the qualities of Murillo's technical splendor.

Fig. 81. *Juan Arias de Saavedra* prior to restoration

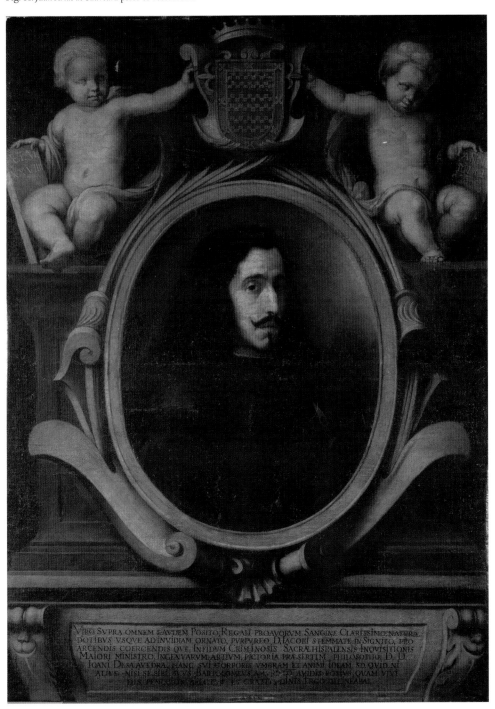

Technical Studies

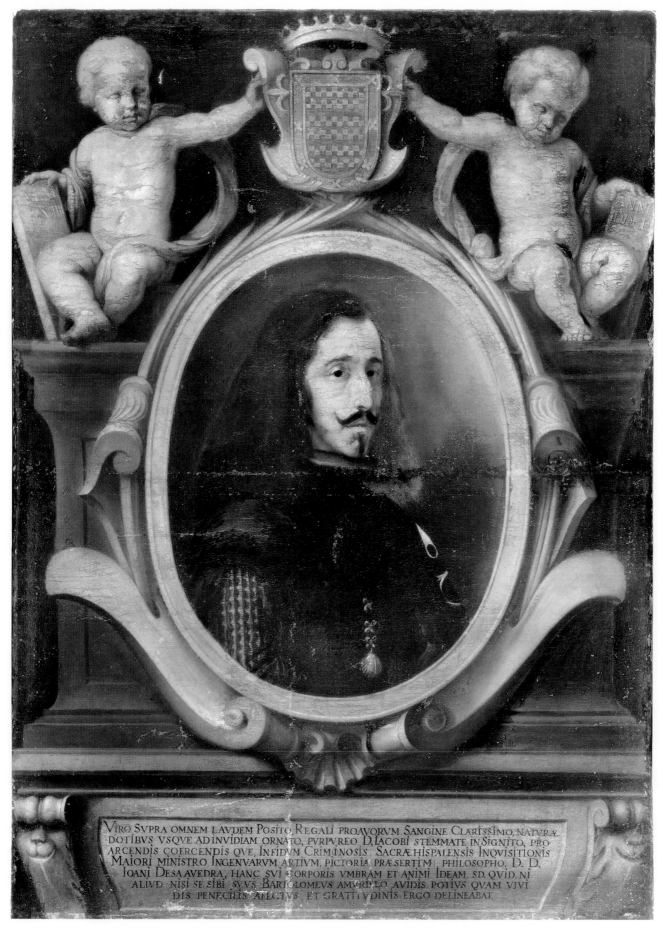

Fig. 82. Infrared reflectogram of *Juan Arias de Saavedra* (fig. 10)

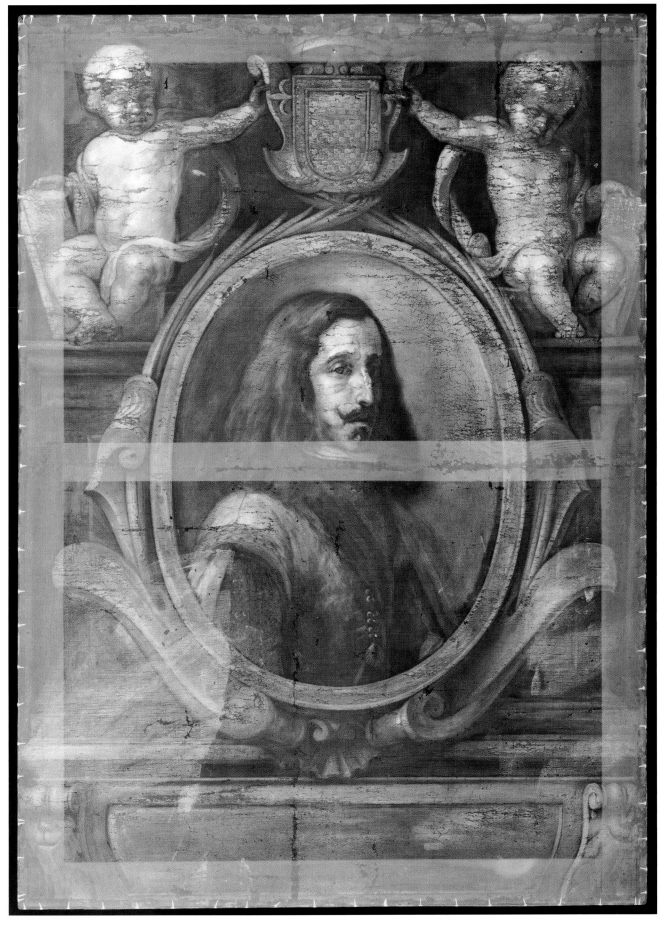

Fig. 83. X-radiograph of *Juan Arias de Saavedra* (fig. 10)

Notes

1 An old erratum reproduced by Angulo Íñiguez (1981, 329) and Valdivieso (2010, 242, 558), among others, confuses the original with a modern copy that is preserved at the Palacio de Viana (Col. Fundación Cajasur, Córdoba) instead of the work preserved in the collection of the Duchess of Cardona; two of the labels on the back indicate the provenance as the Duke of Medinaceli.

2 As described, the painted surface was badly damaged. It was necessary to consolidate the entire surface in order to recover the cohesion of the various substrata and avoid further flaking. The old losses had been covered over and hidden beneath a layer of oil repaint, which also obscured much of the original painting. Furthermore, successive layers of varnish had oxidized, imparting a brownish-yellow hue to the work. Ultimately, the artist's aesthetic and stylistic techniques had become distorted and concealed.

3 Angulo Íñiguez 1981, 329. On this same subject, see Navarrete and Martínez 2015.

4 M.V. Muñoz and F. de la Paz Calatrava in Bilbao / Seville 2009, 167–68.

5 The horizontal disposition of many of these losses may have been due to folds in the fabric or to the lack of a stretcher, or because of insufficient canvas tension. The upper section of the canvas is seriously damaged, with much resulting loss to the painted surface. A strip of plaster and repaint about three centimeters long covers this entire area.

Murillo's *Young Man*

Nicole Ryder

The recent conservation treatment of this small painting by Murillo strengthened its structure by relining and, through cleaning and restoration, revealed a finely nuanced and confidently painted portrait of a Spanish youth. The treatment provided an ideal opportunity for a full technical examination.[1]

The portrait is painted on a single piece of plain, tabby canvas with an open weave, numerous slubs, and an irregular texture.[2] Originally, this would have been stretched onto a modest, fixed strainer. Judging by the stretcher-bar cracking lines and the staining on the back of the canvas, the width of the original stretcher bars was 3–4 cm. The size of the painting has changed; formerly, it was larger by approximately 3 cm on the left side and 1 cm on the right. Remnants of the composition are still present on the tattered left-hand tacking edge; but the continuity of the oval is now broken because the damaged edge is folded around the side of a smaller stretcher.

The X-radiograph (fig. 84) and infrared reflectogram (IRR) image (fig. 85) provide useful information about the condition of the painting before treatment. The radiography shows substantial losses around the edges, a large loss running through the sitter's lips, and abrasion in the hair, face, and background.[3] The IRR image displays considerably more detail in the darkest areas of the painting than is visible to the naked eye, notably in the boy's hair and jacket. The radiograph and the IRR images also reveal energetic, multi-directional brushwork employing a variety of bold strokes, which are not all visible in the final piece. This diversity of brushwork is characteristic of Murillo's technique: his self-portrait in the National Gallery, London (see fig. 25) shows the artist with the tools of his trade, including at least six brushes of different sizes and types of bristle.

The materials found through analysis of paint and ground samples are consistent with a seventeenth-century palette and with other works by Murillo. The ground is composed of a brown clay-like material with a little black, applied in one or possibly two coats of similar composition.[5] The shared characteristics of many seventeenth-century Sevillian grounds has led to the suggestion that artists used the local river clay from the Guadalquivir that runs through Seville, praised by the Spanish painter Francisco Pacheco (1564–1654): "the best and smoothest priming is the clay used here in Seville."[6]

The half-dozen samples analyzed confirm the presence of vermilion, red and yellow ochres, red lake, umbers, lead white, and two types of black—a carbon black and a deeper and richer coal black.

Underdrawing did not show up in infrared examination, which is not to say the artist did not employ any in this picture. For example, if red chalk were used to capture the likeness, it would not be visible in IRR imaging. Following the practice of the day, it is likely that the artist started painting after drawing the contours and features of the face.[7] An absence of pentimenti supports this. Cross sections do not show an underpainting, but visual examination suggests the painting has a brown transparent *bosquexo* (or underpainting) beneath the face.[8] Having laid down the face, the artist seems to have worked rapidly and concurrently on the hair, costume, and space behind the figure with the corners and oval painted last.

The application of paint is confident and assured. The subtlety of the facial modeling survives, despite the mechanical damage and some loss to the soft transitions between the features and the surrounding flesh paint. These thinly painted

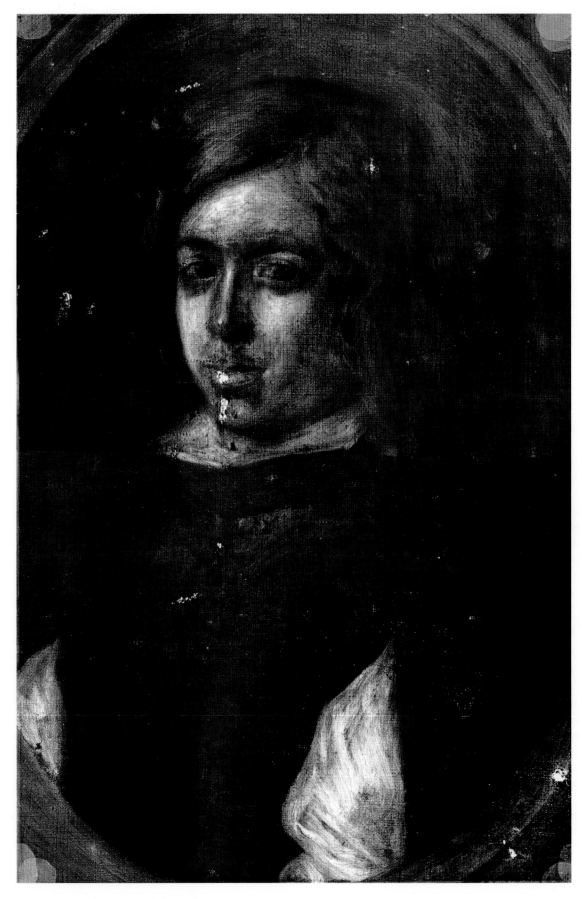

Fig. 84. X-radiograph of Murillo's *Young Man* (fig. 11)

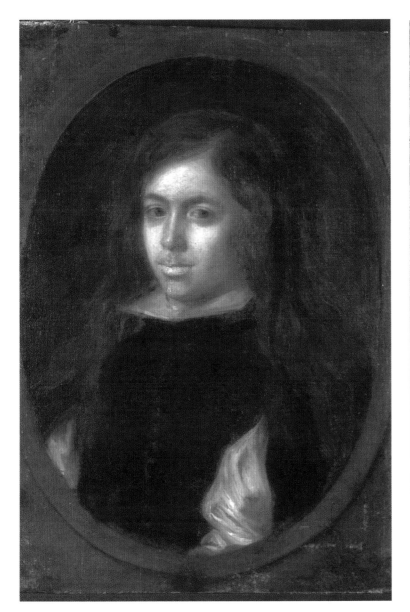

Fig. 85. Infrared reflectogram of Murillo's
Young Man (fig. 11)

Fig. 86. 8 mm splinter of wood from Murillo's
Young Man (fig. 11)

shadows and halftones are vulnerable to abrasion, and, with the natural loss of opacity due to aging of the paint, the dark underlayers show through more than originally intended. The eyes and eyebrows remain remarkably well preserved with very little loss and minimal abrasion.

The present restoration and relining improved the stability and appearance of the painting.[9] Retouching was carried out to filled losses, distracting cracks, and abrasions where they created discontinuity or interrupted visible brushstrokes. The thin remnants of an old and insoluble varnish still exist on the surface; in dark areas it is less obvious, but in the face and shirt it is apparent at close viewing. Despite this, the cleaning revealed cooler flesh tones,

greater detail in the hair, and more saturation to the darkly painted areas.

An interesting observation was made during treatment—the presence of numerous slivers of wood breaking through the surface of the paint (fig. 86).[10] At least a dozen of these large splinters, measuring between 5 and 10 mm, were found across the painting. The observation of random contaminants in the surface of paintings is not uncommon, but the quantity observed here and previously seen in other works by Murillo is noteworthy.[11] These splinters do not have any aesthetic function and so, at the present time, we can only infer that they result from accidental contamination from the artist's studio environment or from the materials and equipment he used.

Technical Studies

Notes

1 Before treatment, infrared reflectography, X-radiography, and cross-section examination using light microscopy were carried out by Aviva Burnstock at the Department of Conservation & Technology, Courtauld Institute of Art, London; unpublished report CIA2430. During treatment, further paint and ground samples were analyzed by Joanna Russell and Marika Spring in the Scientific Department at the National Gallery, London; unpublished report R98. Five paint and ground samples were examined with scanning electron microscopy coupled with energy dispersive X-ray analysis (SEM-EDX); a sample containing part of a wood splinter was examined with attenuated total reflectance Fourier transform infrared (ATR-FTIR) microspectroscopic imaging carried out on a cross section.

2 The weave count was measured from the left-hand tacking edge as 12 by 10 threads per square cm; it was not possible to distinguish between the warp and weft directions.

3 The radiograph was taken with only two plates and does not cover the edges of the painting. The central horizontal line is the radiograph plate line.

4 For accounts by artist theoreticians of brushes needed by the artist, see Veliz 1986.

5 The canvas was prepared with a brown ground containing a clay-like brown earth composed of quartz, alumino-silicates (including potassium feldspars), pyrite, gypsum and yellow iron oxides, with calcium carbonate and dolomite (either part of the earth pigment or added separately), as well as a few particles of carbon-based black. Little or no lead white was found in the ground of this painting (see Joanna Russell, National Gallery Scientific Department unpublished report R98). A similar ground containing little or no lead white was observed on *Three Boys* by Murillo, Dulwich Picture Gallery, London (DPG.222); see National Gallery Scientific Department unpublished report M1416.

6 Veliz 1986, 68. For further discussion on grounds in Murillo and seventeenth-century Spain in general, see Barry 2002, 79, and Gayo and Jover 2010.

7 For translation of Pacheco, see Veliz 1986, 103.

8 A *bosquexo* is "an underpainting in oil, carried to a more or less finished state, with colors or with monochromatic tones"; Veliz 1986, xvii.

9 Discolored varnish and considerable restoration were removed with organic solvent mixtures. The painting was relined with Beva 371 onto linen canvas. A new stretcher was made to the existing dimensions. Filled losses were textured with silicone molds taken from the painting. Retouching was carried out in Gamblin retouching colors with MS2A glazes. The varnish used was dammar.

10 One of the paint samples had part of a wood splinter attached to it; ATR-FTIR imaging and SEM imaging confirmed this was wood; see Joanna Russell, National Gallery Scientific Department unpublished report R98.

11 Barry 2002, 85. Also in *Three Boys* by Murillo, Dulwich Picture Gallery, London; see unpublished conservation report.

Bibliography

Ackroyd 2011
Ackroyd, Paul, et al. "Murillo's *Christ Healing the Paralytic at the Pool of Bethesda*; An Introduction to the Artist's Late Painting Technique." In *Studying Old Master Paintings: Technology and Practice. The National Gallery Technical Bulletin 30th Anniversary Conference (London, 16–18 September 2009)*, edited by Marika Spring, 173–79. London, 2011.

Acquisitions 1963
National Gallery Catalogues. Acquisitions 1953–62. London, 1963.

Alfonso 1886
Alfonso, Luís. *Murillo: El Hombre—El Artista—Las Obras.* Barcelona, 1886.

Althorp catalogue 1851
Catalogue of Pictures at Althorp House. 1851.

Angulo Íñiguez 1974
Angulo Íñiguez, Diego. "Algunos dibujos de Murillo." *Archivo Español de Arte* 186 (1974): 97–108.

Angulo Íñiguez 1979
Angulo Íñiguez, Diego. "Murillo y Goya." *Goya* 148–50 (1979): 210–13.

Angulo Íñiguez 1981
Angulo Íñiguez, Diego. *Murillo.* 3 vols. Madrid, 1981.

Angulo Íñiguez 1983
Angulo Íñiguez, Diego. "Murillo: His Life and Work." In *Bartolomé Esteban Murillo 1617–1682*, by Diego Angulo Íñiguez et al., 11–27. Exh. cat. London (Royal Academy of Arts), 1983.

Art-Journal 1855
The Art-Journal, new ser., I (1855).

Art Treasures Examiner 1857
The Art Treasures Examiner: A Pictorial, Critical, and Historical Record of the Art Treasures Exhibition, at Manchester, in 1857. Manchester, 1857.

Bambach 1999
Bambach, Carmen C. "Recently Acquired Spanish Baroque Drawings at The Metropolitan Museum of Art." *Master Drawings* 37 (1999): 407–15.

Barry 2002
Barry, Claire. "Looking at Murillo's Technique," 75–89. In Fort Worth / Los Angeles 2002.

Baticle 2003
Baticle, Jeannine. "The Galerie Espagnole of Louis-Philippe." In *Manet/Velázquez: The French Taste for Spanish Paintings*, edited by Gary Tinterow and Geneviéve Lacambre, 175–89. Exh. cat. New York (The Metropolitan Museum of Art), 2003.

Baticle and Marinas 1981
Baticle, Jeannine, and Cristina Marinas, eds. *La Galerie espagnole de Louis-Philippe au Louvre 1838–1848.* Paris, 1981.

Bédat 1973
Bédat, Claude. *L'Académie des Beaux-Arts de Madrid 1744–1808.* Toulouse, 1973.

Bilbao / Seville 2009
Benito Navarrete Prieto and Alfonso E. Pérez Sánchez, eds. *El Joven Murillo.* Exh. cat. Bilbao (Museo de Bellas Artes) and Seville (Museo de Bellas Artes), 2009.

Blas, de Carlos Varona, and Matilla 2011
Blas, Javier, María Cruz de Carlos Varona, and José Manuel Matilla. *Grabadores extranjeros en la Corte española del Barroco.* Madrid, 2011.

Boston 1912
Exhibition of the Paintings of the Spanish School. Exh. cat. Boston (Copley Society), 1912.

Braham 1980
Braham, Allan. "Murillo's Portrait of Don Justino de Neve." *Burlington Magazine* 122 (1980): 192–94.

Bray 2013
Bray, Xavier. *Murillo at Dulwich Picture Gallery.* London, 2013.

Brooke 2012
Brooke, Xanthe. "Review of 'Murillo and Justino de Neve.'" *Burlington Magazine* 154 (2012): 732–34.

Brown 1982
Brown, Jonathan. "Murillo, pintor de temas eroticos: Una faceta inadvertida de su obra." *Goya* 169–71 (1982): 35–43.

Brown 1991
Brown, Jonathan. *The Golden Age of Painting in Spain.* New Haven and London, 1991.

Brown 2012
Brown, Jonathan. *Murillo: Virtuoso Draftsman.* New Haven and London, 2012.

Brown and Mann 1990
Brown, Jonathan, and Richard G. Mann. *The Collections of the National Gallery of Art. Systematic Catalogue. Spanish Paintings of the Fifteenth through Nineteenth Centuries.* Washington, D.C., 1990.

Bürger 1860
Bürger, W. (Théophile Toré). *Trésors d'Art en Angleterre.* Brussels and Ostend, 1860.

Caamaño Martinez 1982
Caamaño Martinez, Jesus Maria. "Reflexiones en torno a un autorretrato." *Goya* 169–71 (1982): 33–34.

Calvert 1907
Calvert, Albert F. *Murillo: A Biography and Appreciation.* London, 1907.

Calvert 1908
Calvert, Albert F. *Murillo.* New York, 1908.

Cano Rivero 2003
Cano Rivero, Ignacio. "Seville's Artistic Heritage during the French Occupation." In *Manet/Velázquez: The French Taste for Spanish Paintings,* edited by Gary Tinterow and Geneviève Lacambre, 93–113. Exh. cat. New York (The Metropolitan Museum of Art), 2003.

Cano Rivero 2009
Cano Rivero, Ignacio. "Conjuntos desaparecidos y dispersos de Murillo: la serie para el Claustro Chico del convent de San Francisco de Sevilla," 69–93. In Bilbao / Seville 2009.

Carande 1972
Carande, Ramón. *Bartolomé Estéban Murillo.* Madrid, 1972.

Carrete Parrondo 1982
Carrete Parrondo, Juan. "El grabado de reproduccion: Murillo en las estampas españolas." *Goya* 169–71 (1982): 138–50.

Carrete Parrondo, Vega, and Solache 1996
Carrete Parrondo, Juan, Jesusa Vega, and Gloria Solache. *Catálogo de la collección de estampas de la Fundación Focus.* Seville, 1996.

Carter 1963
Carter, David Giles. "A Portrait of a Gentleman by Tovar." *Bulletin of Rhode Island School of Design* (1963): 9–11.

Ceán Bermúdez 1800
Ceán Bermúdez, Juan Agustín. *Diccionario Historico de los mas Illustres Profesores de las Bellas Artes in España (1800).* Madrid, 1965.

Ceán Bermúdez 1806
Ceán Bermúdez, Juan Agustín. *Carta de D. Juan Agustín Ceán Bermúdez a un amigo suyo, sobre el estilo y gusto en la pintura de la escuela sevillana y sobre el grado de perfeccion a que la elevó Bartolomé Estevan Murillo.* 6 vols. Cadiz, 1806.

Curtis 1883
Curtis, Charles Boyd. *Velázquez and Murillo: A Descriptive and Historical Catalogue of the Works of Don Diego de Silva Velazquez and Bartolome Estéban Murillo.* London and New York, 1883.

Cunningham 1843
Cunningham, Allan. *The Life of Sir David Wilkie.* London, 1843.

Dallas 2016
Fernando Checa, ed. *Treasures from the House of Alba: 500 Years of Art and Collecting.* Exh. cat. Dallas (Meadows Museum), 2016.

Davies 1819
Davies, Edward. *The Life of Bartolomé E. Murillo, Compiled from the Writings of Various Authors.* London, 1819.

De Piles 1708
De Piles, Roger. *Cours de peintre par principes.* Paris, 1708.

Dezallier d'Argenville 1762
Dezallier d'Argenville, Antoine-Joseph. *Abrégé de la vie des plus fameux peintres.* 4 vols. Paris, 1762.

Diary of John Evelyn 1955
The Diary of John Evelyn. Edited by Esmond Samuel De Beer. Vol. 5. Oxford, 1955.

Dominguez Ortiz 1983
Dominguez Ortiz, Antonio. "Murillo's Seville." In *Bartolomé Esteban Murillo 1617–1682,* edited by Diego Angulo Iñiguez et al., 29–39. Exh. cat. London (Royal Academy of Arts), 1983.

Duffy-Zeballos 2007
Duffy-Zeballos, Lisa. *Murillo's Devotional Paintings and the Late Baroque Culture of Prayer in Seville.* Ph.D. thesis, Institute of Fine Arts, New York University, 2007.

Dusmet y Alonso 1920
Dusmet y Alonso, José Maria. "Visita de la Sociedad Española de Excursiones al Palacio de los Duques de Medinaceli." *Boletin de la Sociedad Española de Excursiones* 28 (1920): 49–56.

Edinburgh 1951
Catalogue of an Exhibition of Spanish Paintings from El Greco to Goya. Exh. cat. Edinburgh (National Gallery of Scotland), 1951.

Edinburgh 2009
The Discovery of Spain: British Artists and Collectors, Goya to Picasso. Exh. cat. Edinburgh (National Galleries of Scotland), 2009.

Einberg and Egerton 1988
Einberg, Elizabeth, and Judy Egerton. T*he Age of Hogarth: British Painters Born 1675–1709*. Tate Gallery Catalogues of the Permanent Collections. London, 1988.

Fernández-Galiano 1990
Fernández-Galiano, Luis. *El espacio privado: Cinco siglos en veinte palabras*. Madrid, 1990.

Flavelle Monypenny 1910
Flavelle Monypenny, William. *The Life of Benjamin Disraeli, Earl of Beaconsfield*. Vol. 1. London, 1910.

Ford 1847
Ford, Richard. *A Hand-book for Travellers in Spain*. 2nd ed. London, 1847.

Ford 1998a
Ford, Brinsley. "Richard Ford." *The Walpole Society. The Ford Collection – I* 60 (1998).

Ford 1998b
Ford, Brinsley. "Family Portraits." *The Walpole Society. The Ford Collection – II* 60 (1998).

Fort Worth / Los Angeles 2002
Suzanne L. Stratton-Pruitt, ed. *Bartolomé Esteban Murillo (1617–1682): Painting from North American Collections*. Exh. cat. Fort Worth (Kimbell Art Museum) and Los Angeles (Los Angeles County Museum of Art), 2002.

Galassi 2012
Galassi, Susan Grace. "Henry Clay Frick's Galerie Espagnole." In *Collecting Spanish Art: Spain's Golden Age and America's Gilded Age*, edited by Inge Reist and José Luis Colomer, 125–47. New York, 2012.

Galassi 2016
Galassi, Susan Grace. "The Frick Collection." In *Spanish Art in America*, edited by Mark A. Roglán, 113–23. Madrid, 2016.

Garcia Vega 1984
Garcia Vega, Blanca. *El Grabado del Libro Español. Siglos XV–XVI–XVII*. 2 vols. Valladolid, 1984.

Gaya Nuño 1961
Gaya Nuño, Juan Antonio. "Peinture picaresque." *L'Oeil* 84 (1961): 52–61.

Gaya Nuño 1978
Gaya Nuño, Juan Antonio. *L'opera completa di Murillo*. Milan, 1978.

Gayo and Jover de Celis 2010
Gayo, María Dolores, and Maite Jover de Celis. "Evolución de las preparaciones en la pintura sobre lienzo de los siglos XVI y XVII en España." *Boletín del Museo del Prado* 46 (2010): 39–59.

Gerard Powell and Ressort 2002
Gerard Powell, Véronique, and Claudie Ressort, eds. *Musée du Louvre. Département des Peintures. Catalogue. Écoles Espagnole et Portugaise*. Paris, 2002.

Gerard Powell and Ressort forthcoming
Gerard Powell, Veronique, and Claudie Ressort, eds. *Expoliación y coleccionismo: los maestros antiguos de la pintura española en Francia (1800–1914)*. Seville, forthcoming.

Glendinning and Macartney 2010
Glendinning, Nigel, and Hilary Macartney, eds. *Spanish Art in Britain and Ireland, 1750–1920. Studies in Reception in Memory of Enriqueta Harris Frankfort*. Woodbridge, 2010.

Harris 1951
Harris, Enriqueta. "Spanish Painting from Morales to Goya in The National Gallery of Scotland." *Burlington Magazine* 93 (1951): 310–17.

Harris 1982a
Harris, Enriqueta. "Review of *Murillo*. By Diego Angulo Íñiguez." *Burlington Magazine* 124 (1982): 766–68.

Harris 1982b
Harris, Enriqueta. "Murillo en Inglaterra." *Goya* 169–71 (1982): 7–17.

Harris 1987
Harris, Enriqueta. "Velázquez and Murillo in Nineteenth-Century Britain: An Approach through Prints." *Journal of the Warburg and Courtauld Institutes* 50 (1987): 148–59.

Haskell 1976
Haskell, Francis. *Rediscoveries in Art: Some Aspects of Taste, Fashion and Collecting in England and France*. London, 1976.

Head 1848
Head, Edmund. *A Handbook of the History of the Spanish and French Schools of Painting*. London, 1848.

Hilles 1929
Hilles, Frederick Whiley. *Letters of Sir Joshua Reynolds*. London 1929.

Howarth 1999
Howarth, David. "Mr Morritt's *Venus*. Richard Ford, Sir William Stirling-Maxwell and the 'cosas de España.'" *Apollo* 150, no. 452 (October): 37–44.

Jonker and Bergvelt 2016
Jonker, Michiel, and Ellinoor Bergvelt. *Dutch and Flemish Paintings: Dulwich Picture Gallery*. London, 2016.

Justi 1904
Justi, Carl. *Murillo*. Leipzig, 1904.

Karge 1991
Henrik Karge. *Vision oder Wirklichkeit: Die spanische Malerei der Neuzeit*. Munich, 1991.

Kinkead 1981
Kinkead, Duncan. "Tres documentos nuevos del pintor Don Matias de Arteaga y Alfaro." *Boletín del Seminario de Estudios de Arte y Arqueología* 47 (1981): 345–58.

Kinkead 1986
Kinkead, Duncan. "The Picture Collection of Don Nicolas Omazur." *Burlington Magazine* 128 (1986): 132–44.

Kopper 1991
Kopper, Philip. *America's National Gallery of Art: A Gift to the Nation.* Washington, D.C., 1991.

Kubler and Soria 1959
Kubler, George, and Martin Soria. *Art and Architecture in Spain and Portugal and Their American Dominions, 1500 to 1800.* Baltimore, 1959.

Kwiatkowski 1991
Kwiatkowski, Marek, et al. *The John Paul II Collection of European Paintings: The Zbigniew and Janina Carroll-Porczynski Foundation.* Warsaw, 1991.

Lawrence 1974
Gridley McKim Smith, ed. *Spanish Baroque Drawings in North American Collections.* Exh. cat. Lawrence (The University of Kansas Museum of Art), 1974.

Lefort 1892
Lefort, Paul. *Murillo et ses élèves.* Paris, 1892.

Liverpool 1990–91
Xanthe Brooke, ed. *Murillo in Focus.* Exh. cat. Liverpool (Walker Art Gallery), 1990–91.

Lleó Cañal 1997
Lleó Cañal, Vicente. *La Sevilla de los Montpensier: Segunda corte de España.* Seville, 1997.

Lleó Cañal 2012
Lleó Cañal, Vicente. *Nueva Roma: Mitología y humanismo en el Renacimiento sevillano.* Madrid, 2012.

London 1895–96
Exhibition of Spanish Art. Exh. cat. London (New Gallery), 1895–96.

London 1913
Illustrated Catalogue of the Exhibition of Spanish Old Masters in Support of National Gallery Funds and for the Benefit of the Sociedad de Amigos del Arte Española. Exh. cat. London (Grafton Galleries), 1913.

London 1920–21
Exhibition of Spanish Paintings. Exh. cat. London (Royal Academy of Arts), 1920–21.

London 1981
Braham, Allan. *El Greco to Goya: The Taste for Spanish Paintings in Britain and Ireland.* Exh. cat. London (National Gallery), 1981.

London 1983
Diego Angulo Íñiguez et al. *Bartolomé Esteban Murillo 1617–1682.* Exh. cat. London (Royal Academy of Arts), 1983.

London 2015
Xavier Bray, ed. *Goya: The Portraits.* Exh. cat. London (National Gallery), 2015.

London / Munich 2001
Xanthe Brooke and Peter Cherry, eds. *Murillo: Scenes of Childhood.* Exh. cat. London (Dulwich Picture Gallery) and Munich (Alte Pinakothek), 2001.

Luna 1982
Luna, Juan J. "Exposicion Murillo Madrid–Londres 1982–1983." *Goya* 169–71 (1982): 156–61.

Luxenberg 2013
Luxenberg, Alisa. *Secrets and Glory: Baron Taylor and His Voyage Pittoresque en Espagne.* Madrid, 2013.

Macartney and Matilla 2016
Macartney, Hilary, and José Manuel Matilla. *Copied by the Sun: Talbotype Illustrations to the Annals of the Artists of Spain by Sir William Stirling Maxwell.* Madrid, 2016.

MacLaren 1970
MacLaren, Neil. *The Spanish School: National Gallery Catalogues.* 2nd ed. Revised by Allan Braham. London, 1970.

MacLaren and Braham 1988
MacLaren, Neil, and Allan Braham. *National Gallery Catalogues: The Spanish School.* London, 1988.

Madrid 2004
Javier Portús Pérez, ed. *El retrato español: Del Greco a Picasso.* Exh. cat. Madrid (Museo Nacional del Prado), 2004.

Madrid 2012
José Manuel Calderón Ortega et al. *El Legado Casa de Alba.* Exh. cat. Madrid (Centro Cibeles de Cultura y Ciudadanía, Ayuntamiento de Madrid), 2012.

Madrid 2016
Javier Portús, ed. *Metapintura: Un viaje a la idea del arte en España.* Exh. cat. Madrid (Museo Nacional del Prado), 2016.

Madrid / Seville / London 2012–13
Gabriele Finaldi, ed. *Murillo and Justino de Neve: The Art of Friendship.* Exh. cat. Madrid (Museo Nacional del Prado), Seville (Fundación Focus-Abengoa), and London (Dulwich Picture Gallery), 2012–13.

Martínez del Valle 2010
Martínez del Valle, Gonzalo. *La imagen del poder: El retrato sevillano del siglo XVII.* Seville, 2010.

Mayer 1912
Mayer, August L. *Murillo: Des Meisters Werke.* Stuttgart and Berlin, 1912.

Mayer 1913
Mayer, August L. *Murillo: Klassiker der Kunst.* 1913.

Mayer 1915
Mayer, August L. "Notes on Spanish Pictures in American Collections." *Art in America* 3 (1915): 309–20.

Mayer 1923
Mayer, August L. *Murillo: Des Meisters Gemälde.* Stuttgart, 1923.

McDonald 2012
McDonald, Mark. *Renaissance to Goya: Prints and Drawings from Spain.* London, 2012.

Mena Marqués 1983
Mena Marqués, Manuela. "Murillo as Draughtsman," 53–63. In London 1983.

Mena Marqués 1996
Mena Marqués, Manuela. "Murillo, Bartolomé Esteban." In *The Dictionary of Art*, edited by Jane Turner, 342–48. Vol. 22. London, 1996.

Mena Marqués 2015
Mena Marqués, Manuela. *Bartolomé Esteban Murillo (1617–1682): Dibujos: Catálogo razonado*. Santander, 2015.

Montoto 1932
Montoto, Santiago. *Murillo*. Barcelona, 1932.

Montoto 1945
Montoto, Santiago. "Nuevos documentos de Bartolomé Esteban Murillo." *Archivo Hispalense* 5 (1945): 319–57.

Muñoz 1942
Muñoz, Antonio. *Murillo*. Rome, 1942.

Navarrete and Martínez 2015
Navarrete, Esperanza, and Alejandro Martínez. *Patrimonio en conflicto: Memoria del Botín Napoleónico recuperado (1815–1819)*. Madrid, 2015.

New York 2003
Gary Tinterow and Geneviéve Lacambre, eds. *Manet/Velázquez: The French Taste for Spanish Paintings*. Exh. cat. New York (The Metropolitan Museum of Art), 2003.

New York 2010a
Jonathan Brown et al. *The Spanish Manner: Drawings from Ribera to Goya*. Exh cat. New York (The Frick Collection), 2010.

New York 2010b
Xavier F. Salomon. *Masterpieces of European Painting from Dulwich Picture Gallery*. Exh. cat. New York (The Frick Collection), 2010.

Noble Wood, Roe, and Lawrance 2011
Noble Wood, Oliver, Jeremy Roe, and Jeremy Lawrance, eds. *Poder y saber: Bibliotecas y bibliofilia en la época del conde-duque de Olivares*. Madrid, 2011.

Norfolk 2013
Houghton Revisited: The Walpole Masterpieces from Catherine the Great's Hermitage. Exh. cat. Norfolk (Houghton Hall), 2013.

Notice des tableaux 1838
Notice des tableaux de la Galerie Espagnole exposés dans les Salles du Musée Royal au Louvre. Paris, 1838.

Palomino 1739
An Account of the Lives and Works of the most Eminent Spanish Painters, Sculptors and Architects … Translated from the Musaeum Pictorium of Palomino Velasco. London, 1739.

Palomino 1986
Palomino, Antonio. *Vidas*. Edited by Nina Ayala Mallory. Madrid, 1986.

Palomino 1987
Palomino, Antonio. *Lives of the Eminent Spanish Painters and Sculptors (1724)*. Translated by Nina Ayala Mallory. Cambridge, 1987.

Pergam 2010
Pergam, Elizabeth A. *The Manchester Art Treasures Exhibition of 1857: Entrepreneurs, Connoisseurs and the Public*. London, 2010.

Pictures in the Collection of Henry Clay Frick 1925
Pictures in the Collection of Henry Clay Frick, at One East Seventieth Street, New York. New York, 1925.

Pilkington 1797
Pilkington, Rev. Matthew. *The Gentleman's and Connoisseur's Dictionary of Painters*. London, 1797.

Piotrovsky 2015
Piotrovsky, Mikhail. *My Hermitage*. New York, 2015.

Pollok House 1967
The Stirling Maxwell Collection, Pollok House. Glasgow, 1967.

Princeton 1982
Edward J. Sullivan and Nina A. Mallory. *Painting in Spain 1650–1700 from North American Collections*. Exh. cat. Princeton (The Art Museum), 1982.

Rorschach 1989–90
Rorschach, Kimerly. "Frederick, Prince of Wales (1707–51), as Collector and Patron." *Walpole Society* 55 (1989–90): 1–76.

Rosenberg 2006
Rosenberg, Pierre. *Only in America: One Hundred Paintings in American Museums Unmatched in European Collections*. Milan, 2006.

Salomon 2013
Salomon, Xavier F. "Review of 'Murillo in London.'" *Burlington Magazine* 155, no. 1323 (June 2013): 425–27.

Salomon forthcoming
Salomon, Xavier F. *Henry Clay Frick and El Greco*. In *El Greco Comes to America: The Discovery of a Modern Old Master*, edited by Inge Reist and José Luis Colomer. New York, forthcoming.

Sandrart 1683
Sandrart, Joachim von. *Academia Nobilissimae Artis Pictoriae*. Nuremberg, 1683.

Santander 2012
Manuela Mena Marqués. *Bartolomé Esteban Murillo (1617–1682): Dibujos*. Exh. cat. Santander (Fundación Botín), 2012.

Sanz 1982
Sanz, María Jesús. "Las joyas en la pintura de Murillo." *Goya* 169–71 (1982): 113–21.

Scharf 1877
Scharf, George. *A Descriptive and Historical Catalogue of the Collection of Pictures at Woburn Abbey*. London, 1877.

Bibliography

Schiff 1988
Schiff, Gert. *German Essays on Art History*. New York, 1988.

Scott 1973
Scott, Barbara. "The Comtesse de Verrue: A Lover of Dutch and Flemish Art." *Apollo* 97 (1973): 20–24.

Seville 2008
Alain Schnapp et al. *El rescate de la Antigüedad clásica en Andalucía*. Exh. cat. Seville (Hospital de los Venerables, Fundación Focus-Abengoa), 2008.

Seville 2016
Gabriele Finaldi, ed. *Velázquez/Murillo: Sevilla*. Exh. cat. Seville (Hospital de los Venerables, Fundación Fondo de Cultura de Sevilla [Focus]), 2016.

Soria 1948
Soria, Martin S. "Murillo's Boy and Girl, Companion Pieces?" *Burlington Magazine* 90, no. 538 (1948): 20–22.

Stirling 1848
Stirling, William. *Annals of the Artists of Spain*. 3 vols. London, 1848.

Stirling-Maxwell 1873
Stirling-Maxwell, William. *Essay towards a Catalogue of Prints engraved from the Works of Diego Rodriguez de Silva y Velazquez and Bartolomé Estéban Murillo*. London, 1873.

Stirling-Maxwell 1891
Stirling-Maxwell, William. *Annals of the Artists of Spain*. Rev. ed. 4 vols. London, 1891.

Stoichita 1990
Stoichita, Victor I. *Der Quijote Effekt. Bild und Wirklichkeit im 17. Jahrhundert unter besonderer Berücksichtigung von Murillos Oeuvre*. Munich, 1990.

Stoichita 2011
Stoichita, Victor I. "Murillo: *Two Women at a Window*." In *Center 31. Record of Activities and Research Reports. June 2010–May 2011*. Washington, D.C., 2011.

Stratton-Pruitt 2002
Stratton-Pruitt, Suzanne L. "Bartolomé Esteban Murillo, 1617–1682," 11–29. In Fort Worth / Los Angeles 2002.

Tromans 1998
Tromans, Nicholas. "Le Baron Taylor à Londres en 1837." *Revue des musées de France: Revue du Louvre*, 3 (June 1998): 66–69.

Tubino 1864
Tubino, Francisco. *Murillo, su época, su vida, sus cuadros*. Seville, 1864.

Valdivieso 1990
Valdivieso, Enrique. *Murillo: Sombras de la tierra, luces del cielo*. Madrid, 1990.

Valdivieso 2002
Valdivieso, Enrique. *Vanidades y desengaños en la pintura española del Siglo de Oro*. Seville, 2002.

Valdivieso 2003
Valdivieso, Enrique. *Pintura Barroca Sevillana*. Seville, 2003.

Valdivieso 2010
Valdivieso, Enrique. *Murillo: Catálogo razonado de pinturas*. Madrid, 2010.

Valentiner 1931
Valentiner, Wilhelm R. *Paintings in the Collection of Joseph Widener at Lynnewood Hall*. Elkins Park, 1931.

Veliz 1986
Veliz, Zahira, ed. and trans. *Artists' Technique in Golden Age Spain: Six Treatises in Translation*. Cambridge, 1986.

Vertue 1937–38
"The Note Books of George Vertue Relating to Artists and Collections in England." In *Walpole Society. Vertue Note Books* 5, no. 26 (1937–38).

Viñaza 1894
Viñaza, Cipriano Muñoz y Manzano. *Adiciones al Diccionario Historico de los mas Illustres Profesores de las Bellas Artes in España de D. Juan Agustín Cean Bermúdez*. Vol. 3. Madrid, 1894.

Von Sonnenburg 1980
Von Sonnenburg, Hubert. "On Murillo's Painting Technique—Part I." *Maltechnik Restauro* 86 (1980): 15–34.

Von Sonnenburg 1982
Von Sonnenburg, Hubert. "On Murillo's Painting Technique—Part II." *Maltechnik Restauro* 88 (1982): 159–79.

Waagen 1854
Waagen, Gustav Friedrich. *Treasures of Art in Great Britain*. Vols. 1–3. London, 1854.

Waagen 1857
Waagen, Gustav Friedrich. *Galleries and Cabinets of Art in Great Britain*. London, 1857.

Waldmann 1995
Waldmann, Susanne. *Der Künstler und sein Bildnis im Spanien des 17: Jahrhunderts*. Frankfurt, 1995.

Waldmann 2007
Waldmann, Susanne. *El artista y su retrato en la España del siglo XVII. Una aproximación al studio de la pintura retratística española*. Madrid, 2007.

Washington 2002
Sybille Ebert-Schifferer, ed. *Deceptions and Illusions: Five Centuries of Trompe l'Oeil Painting*. Exh. cat. Washington, D.C. (National Gallery of Art), 2002.

Waterhouse 1947
Waterhouse, Ellis K. "The Exhibition of Pictures from Althorp at Messrs. Agnew's." *Burlington Magazine* 89, no. 528 (1947): 77–78.

Wellington 1901
Wellington, Evelyn. *A Descriptive and Historical Catalogue of the Collection of Pictures and Sculpture at Apsley House, London*. 2 vols. London, 1901.

***Widener Collection* 1942**
Works of Art from the Widener Collection. Washington, D.C., 1942.

Index

Photography Credits

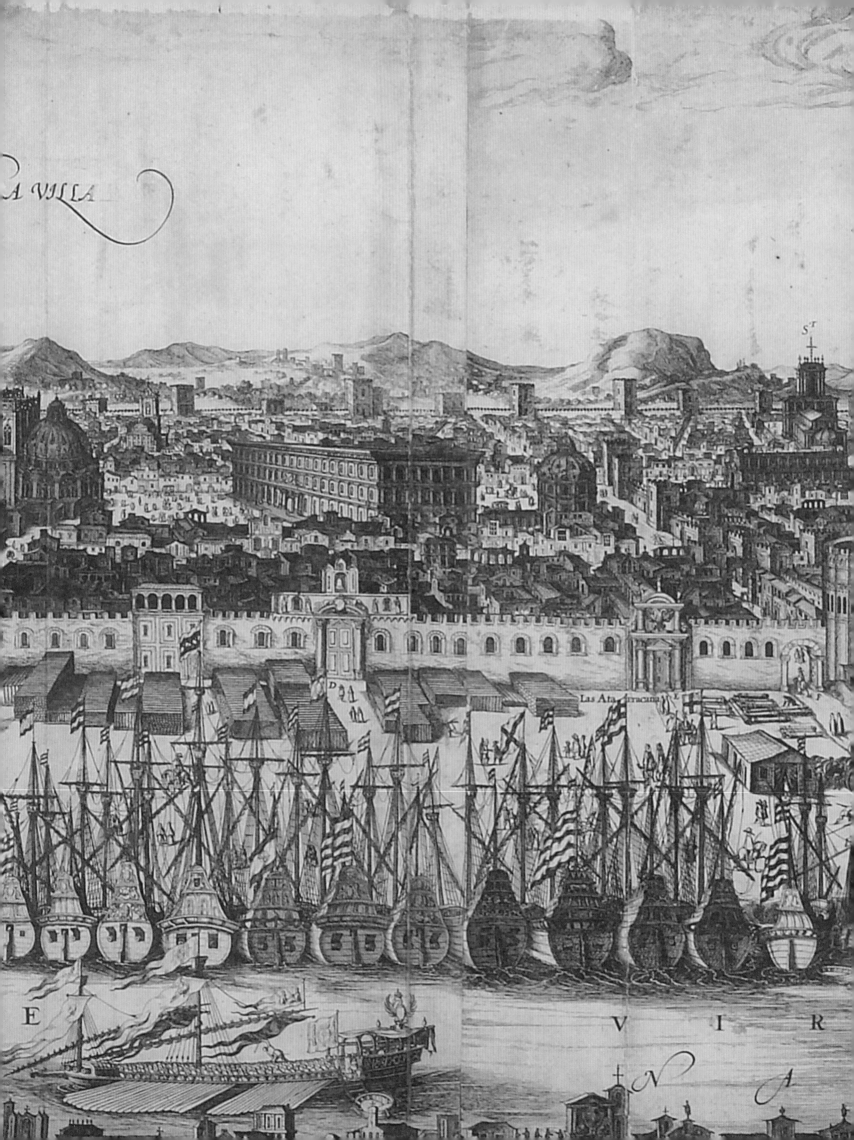

A VILLA

S^t

Las Ata arracana

D

E V I R

N A